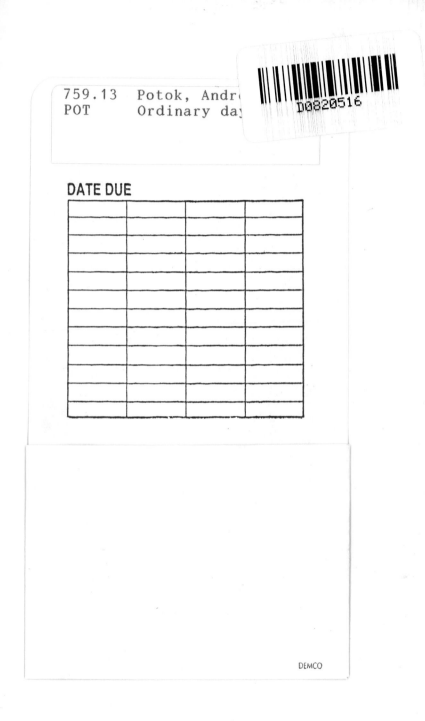

D0820516

DATE DUE

DEMCO

ORDINARY DAYLIGHT

Andrew Potok

ORDINARY
DAYLIGHT

Portrait of an Artist
Going Blind

Holt, Rinehart and Winston

New York

Library of Congress Cataloging in Publication Data
Potok, Andrew.
Ordinary daylight.
1. Potok, Andrew. 2. Painters, Blind—United
States—Biography. I. Title.
ND237.P814A2 1980 759.13 [B] 79–20900

ISBN 0–03–029821–0

"Line and Color" from *The Collected Stories of Isaac Babel* copyright © 1955 by S. G. Phillips, Inc., is reprinted by permission of S. G. Phillips, Inc.
Two stanzas from "A Cloud in Trousers" from *The Bedbug and Selected Poetry* by Vladimir Mayakovsky (World Publishing Company); copyright © 1960 by Harper & Row, Publishers, Inc., is reprinted by permission of the publisher.

First Edition
Printed in the United States of America
10 9 8 7 6 5 4 3 2 1

For my mother

Acknowledgments

The writing of this book has been particularly complicated by not seeing, and I want to acknowledge all those people who have been, in one way or another, my eyes. Their many kinds of generosity have made the book possible and the process of losing sight easier to bear.

I want especially to thank Dagmar and Ephraim Friedman and Freda and Norman Scotch for opening their homes to me; my doctoral committee at the Union Graduate School, who helped me through a much earlier version of this book—Rita Arditti, Gerald Stechler, Ruth Hubbard, Peter Lazes, and Ellen Cole; my family and friends in London, especially Stanislaw Potok, Edith Lewent, Anita Leslau, Bronka and Harold Crosse; my editors, Ellyn Polshek, Suzi Arensberg, and Tom Wallace; Mary Simons, who has always been a force in my life; my dear friends in Vermont, who were there when I needed them; Ellie Langer, who gave me invaluable criticism on an early draft; Geoffrey Wolff, who, through the Goddard M.F.A. Writing Program, made careful, perceptive commentary on the whole manuscript; Dr. Virginia Lubkin, for her careful medical reading of the final manuscript; Tom Absher, who read the final manuscript aloud to me for the better part of a week; and my

children—Mark, Sarah, Jed, and Maya—who endured my preoccupations with good humor.

Most of all I am grateful for the generosity of Liz Rocklin, who read and corrected the book with patience, faith, and love through so many versions that I've lost count; my sister, Anita Landa, who from the crude beginnings believed in the book and gave it shape through her sharp critical skills; and finally Charlotte, who endured the double difficulty of my learning to write and my becoming blind.

ORDINARY DAYLIGHT

O N E

I had come to that point in my life when I felt that no matter
what I did I had nothing to lose. The day-by-day losses of
eyesight, slow and inexorable, took with them my life as a
painter, my sources of pleasure and intelligence, my
competence as a man. Pleasures I had taken for granted—
the recognition of landscape, the coordination of hand and
eyes, ordinary daylight—were slipping away. But going
blind *and* passing forty, with dreams of youthful heroism and
virtuosity gone forever, seemed, at times, too hard to bear.

All those downhill things that happen in spite of the
marvels of science were now happening to me. My dentist,
seeing a relentless decay infiltrate the hidden crevices in my
mouth, suggested, as I lay under his bright lights, my mouth
full of rubber dams, suction tips, and hard metal, that he
pull all my teeth "so you don't have to worry about receding
gums or that goddamn plaque."

I nearly choked as I sprung up, still connected by hoses,
yelling through the spray and bubbles: "You son of a bitch!
No more losses! Do you hear? No more losses!"

He moved away to his sink and began washing his hands.
As the nurse untangled me, he leaned against a wall. "Look,
Andy," he said, "we'll try to fix the damage. We'll do the
best we can."

"Do you know what's been happening to me?" I asked. "I can't paint anymore. I can't drive or read. I feel like a castrated rooster. You can't pull my teeth."

Some forty years before, my mother had taken the train from Warsaw to Vienna to have her teeth "done," but she was a rising star in the fashion world then, sure of her powers and much in demand. Nevertheless, the bad teeth came from her. The gene for retinitis pigmentosa was my father's gift.

I walked into the waiting room where every chair was occupied by a shadow, one of which was my wife. "Charlotte?" I said tentatively, and the appropriate shadow rose, put away her glasses, then the magazine, and took my arm.

"Jesus, what happened to you?" she asked. "You look white."

"He wants to yank my teeth," I said.

"He what?" Charlotte asked as I pulled her into the coat closet.

The nurse poked her head into the foyer. "Mr. Potok, the doctor wants to know when you can come for a double appointment. . . ."

"Tell him I can't," I said. "I'm going away. I'll call when I get back."

"Where are you going?" Charlotte asked as we walked down the stairs into the parking lot, my hand clutching hers.

"I don't know. I can't take it anymore. London . . ."

"London? That's nice," she said, humoring me.

"I mean it. London. The bees . . ."

"The what?" she winced.

"The goddamn bees!" I yelled. "The *Observer* article."

"The one Mary sent?" Charlotte asked fearfully. I leaned against the door as far from her as I could and looked out at

the black-and-white jumble. We drove in silence for a while.

"You're nuts," she said under her breath. Vermont, after the long stasis of winter, was at its worst, the snow sinking slowly into barren, slimy mud.

"I can't see a goddamn thing. I hate my work. I'm no good at it . . ."

"Oh, Andy," she said softly. "You're learning. Everybody says you're terrific. . . ."

"I'm not a social worker," I complained. "My thesis stinks." Nothing was going right. My reading, a euphemism for listening to tapes, usually put me to sleep because my body wasn't engaged in book holding, page turning, and eye movement. And I couldn't stand the boring psychology texts, the soft, sweet counseling books that were eventually to give me a degree, a Doctorate of Listening or something like that. I craved movement, a leap, a risk. I remembered my Yale days when we divided the world into poets and plumbers. This patchwork therapizing felt like plumbing, Band-Aid work, makeshift coping stuff.

"People have gone out of their way to help you get started," Charlotte was saying. "And what about your group? What will they do if you leave?"

"My group? You'll see, they'll want to come with me. . . ."

We got off Route 2 in Plainfield, sloshed by the Methodist church, the village store, and onto our dirt road, heaving and swaying in the potholes and ruts. We pulled in by the kitchen door, and I crossed the road to check the mail. The mailbox overflowed with black cases full of recorded books, cartons of taped material, letters and announcements from organizations "for the blind" and "of the blind," all covered with white canes, eyes, beacons of lighthouses, the terrible

symbols of a dreaded new world. I was invited to join in the battle against blindness and disease, to send blind children to camp, to demand my new rights, to ask my congressman to support eye research. I was incited into outrage at the treatment of the handicapped. I was sent newsletters picturing happy blind students at the White House, the smiling faces of movie stars lending their names to national campaigns to prevent this, promote that. I was provoked into shock that a blinding disease such as mine existed in spite of the miracles of American medicine.

This nightmarish mail had started coming when I was pronounced "legally blind." The very first of it was a mimeographed sheet, hardly legible even to Charlotte, announcing a Christmas party for the blind of Central Vermont at Christ Church. Volunteers were to serve punch and tea. Everyone was to receive a present. I fretted about it for several sleepless nights. I was now blind, blind like them. Blind meant lonely and abandoned, cared for by special people, sanguine, dour, also lonely. Blind meant shuffling, groping, forlorn. It meant cheap paper crookedly stapled, badly mimeographed. How long could I postpone meeting others like me? I wanted to sleep through that Christmas.

I walked back to the house. My children were home for spring vacation and hard rock music shook the old walls, the hand-blown glass in the windows. A faint smell of marijuana still lingered on their clothes from the night before. Charlotte flew through the kitchen debris and into her studio. I heard the latch click. I put my record on and began pacing. A Beethoven quartet usually cleared the house of kids and cleared my head as well. I tried to conjure images of the woman in London who used bees to cure retinitis pigmentosa. Nothing worked on this damned disease. Why

not try bees? A short time before, a noted researcher in the retina field had told me, as we sat in my orchard under an apple tree, that they knew so little still about the retina or the causes or biochemistry of the disease, that "you can expect a cure by accident, maybe," he said looking around, "from the blossoms of apple trees." Apple blossoms? Why not bees?

My living room is large and comfortable. My friends like to sit in it, under my old paintings. The night before, several of us had sat here talking, brainstorming, trying to figure out what I could do with my damaged life. Careers floated about in little hermetic clouds: tactile sculpture, intellectual history, Marxist aesthetics, or the psychology and counseling I was reluctantly pursuing. All of it seemed contrived, false.

I now picked up the phone and put in a call to my Uncle Staś in London.

"Yes, Andy, dear Andy," Staś said, "wouldn't it be wonderful if it worked! I'll call Mrs. Barnes straightaway. I'll call everyone mentioned in the article. How could I have missed it? I take the *Observer* every Sunday." Staś, one of the few remaining in my once-large family, settled in London after the war, and I saw him only sporadically. I was delighted with his immediate interest in the treatment. I had finally set things in motion.

I went over to my studio, to sit alone. I had built this little studio for Charlotte when we were married, the first carpentry I ever attempted, setting windows, hanging doors, cutting hefty lumber for her potter's wheel. She now occupies what used to be my painting space, a big L at the back of the house, while my more orderly equipment fits easily here, the drawers full of paper clips, staples, Magic Markers, files packed with folders and drafts, cubbyholes of

index cards, tape recorders, and tapes. I feel like a hothouse plant with the shades drawn to prevent glare, spots of light illuminating the piles of my sprawling work. As I type, my words disappear into an inaccessible sea of paper, retrieved for me days or weeks later by readers who fill tape after tape with my awkward prose, awaiting revision. If I don't need the flow, the uninterrupted sense of a taped passage, I can still put my typescript under the zoom lens of my closed-circuit-TV system and read it with my own eyes slowly, letter by magnified letter, each 1½ inches tall.

My walls are hung with enormous sheets of paper outlining projects with fat Magic Markers, an oversized calendar, and an American Foundation for the Blind poster with three-color graphics of white canes, braille dots, and other aids and appliances of the blind. Near me is a photographic blowup of a blind phantom sitting alone in the Odeon metro station, and next to it a reproduction of Matisse's *The Painter's Family*, which, but for memory, would be a fuzzy morsel of quilting. The three-pronged heavy-duty electric cords of my old power tools—my bench saw, jointer, sander, drills—have been replaced by tangles of thin wire emerging from wall sockets to maintain, through electricity, my contact with words.

In my old studio, now covered with clay dust, tubes of Rembrandt pigments once lay in neat rows, their labels printed exotically in four languages. A stupid-looking, cross-legged Dutch boy with beret, upraised brush and palette, sat on each tube, surrounded by a border of the gorgeous tint inside. The Rembrandts were the special colors—alizarin, manganese blue, *laque de garance*, viridian—used stingily, with deliberation; the rest of the jars, bottles, and tubes were a motley collection, gathered from all over Europe and America, caked with granules of

pigment and oozing with separated linseed oil. The remains of a huge crate stood to one side of the easel. It had made several transatlantic crossings packed with stretched canvases, displaying on its surface a painted fragment of a Mayakovsky poem, read suspiciously by groups of customs agents upon each entry into the port of New York:

> I feel
> my "I"
> is much too small for me.
> Stubbornly a body pushes out of me.
>
> Hello!
> Who's speaking?
> Mama?
> Mama!
> Your son is gloriously ill!
> Mama!
> His heart is on fire,
> Tell his sisters, Lyuda and Olya,
> He has no nook to hide in.

The *Observer* article lay on the edge of my desk. It came to me by chance, and this made it even more significant. It was called "Can Bee Stings Cure Blindness?" and the Sunday it appeared, my London family, who would have spotted it, was dispersed or distracted. One was fasting at a health resort, two had gone to southern Europe to be packed in mud for the relief of arthritis, and Staś, it turned out, decided that particular Sunday to read the *Times* instead. My friend Mary in New York, looking through the foreign press, saw it and, with some trepidation, sent it to me. There was no mistaking it; the article spoke of *my* disease and of people whose lives had been similarly affected.

It was all there: the joyous testimonials of the cured and of the doctors who had been witness to the miracle. The author herself had obviously become a true believer. I put it under my Visualtek and read, letter by letter:

> At 24, Joan Casey feared she was going to be blind for the rest of her life. She went to Moorfields Eye Hospital in London, where they confirmed that she was suffering an incurable form of blindness called retinitis pigmentosa. Later the same day, in May last year, Mrs. Casey, an Irish girl living in London, went to a semidetached house to begin a course of treatment from Mrs. Helga Barnes. The treatment consisted of being stung in the head by specially medicated bees.
>
> A fortnight later Mrs. Casey said she could read newsprint with her right eye, which had been totally blind for 12 years. After six weeks, she could thread a fine needle. The side and downward vision in the left eye returned. . . .

I kept the article near me all the time. I had made many photocopies, so that some were in my desk, some in my briefcase, and others were well placed in the community to gauge feelings of public reaction: surprise, hope, pity, or scorn.

As a rule I read so slowly with my Visualtek or my 10 times Diopter magnifiers that often I forgot the beginning of a sentence by the time I got to the end of it. But not this article. I knew it pretty much by heart. If a friend or colleague had not yet read it I jumped at the chance to hear it one more time.

> Helga Barnes, 67, twice widowed, is a fair-haired bustling woman with a kindly face and shrewd eyes that tell you she's nobody's fool. She has a colourful turn of phrase, emphasized by a heavy Middle-European accent, undiminished by 40 years in England and two English husbands. . . .

. . . She talks freely about her life but what she won't discuss is the feeding secret of her bees. Several pharmaceutical firms have made her offers for the formula of her bee venom content. She is afraid people would be exploited. Although bee sting treatment may seem eccentric, she makes the point that it is as logical as a doctor's syringe and injection.

Her therapy, which she has been using for 48 years and the medical members of her family for a few generations before her, is a complicated and difficult one to implement. No one should imagine her results can be obtained through ordinary garden bees, whose stings can be highly dangerous. Mrs. Barnes's bees are specially bred and fed for individual ailments.

They are not a cure-all, and Mrs. Barnes will not take on anyone she knows she cannot help. . . .

Mrs. Barnes treated 12 blind patients last summer, charging nothing. She gave up hope of recognition from the medical profession long ago—"Tell them to go to hell" she said—and just wants to show that she believes she has succeeded where doctors have failed.

. . . "Darling, it is a heaven. You have a blind person coming in and you put your arm around him and say, 'Don't worry, darling. You will be seeing.' It is the most wonderful thing on earth to give somebody back his sight. It is beautiful for me because I beat the best men in the land!"

Parts of the article made me cringe. She had named her suburban house Sunkist Budapest and the license plate on her chauffeur-driven Daimler read: BEE 008. I wished things like this could be simple, not tacky, childish, and eccentric. I hoped these were silly, thoughtless aberrations behind which I would discover a thoughtful and original maverick.

I listened impatiently as a clinical ophthalmologist warned *Observer* readers to proceed with caution. I smiled again as a friend read:

Her work has been observed by Dr. Evelyn Ryder, consultant to the Royal London Homeopathic Hospital, who is fully qualified in orthodox medicine. . . .

"She's getting remarkably good results with retinitis pigmentosa, sometimes within a week or even two or three days.

"The balance of the glands is affected by her therapy, which is a deep systemic treatment, affecting the functioning of the whole body, and there's a change in its metabolic reactions. She is producing the most outstanding cures I've seen in fringe, unorthodox medicine."

Obsessed by the article, I had a dream: I was on a platform swaying on rickety stilts, very high above a checkered landscape. Hundreds of feet below, there was a happy scene of shade trees, lawns, water, and people, scarcely audible, splashing, singing, laughing. Moments before, the dream people had jumped, gaily, unselfconsciously, into the pool. Alone, I was becoming rigid with fear.

T W O

On Monday morning I got on the bus for my weekly trip to Boston. I was carving out a unique place for myself in the blind world. With the support of new friends, I was becoming a kind of half amateur (necessary in my capacity as role model), half professional (necessary to be taken somewhat seriously by colleagues and clients alike) friend and counselor to people who were themselves in some stage of nonacceptance of our shared blight, retinitis pigmentosa.

In this unfamiliar world of hospitals I was partly the presentable consumer, partly the curious ex-artist around whom a small legend began to form, linked to the romance of galleries, museums, *la vie bohème*. In fact, though I felt decidedly like an intruder, I did everything possible to fit myself into *their* world, to become serious and professional. I bought myself a gray suit and a pair of cordovan "doctor" shoes with metal tabs nailed into their heels. The clickers of my shoes resounded importantly in the hospital's corridors. My fleeting moments of self-assurance were largely due to the clickers' sharp, aggressive tones, though inside those shoes clattered a slowly rotting fellow who trailed the corridor walls with his fingers.

The blind people I counseled considered me happy and successful, living proof that there was hope. I listened

intently while they unburdened their grief. They could always count on a small anecdote from me illustrating some isolated triumph amid a hundred failures—a triumph of bravery in the subway system, of vanity subdued in the use of a white cane, of accepting some small humiliation that, in our previous lives, would have been clearly unacceptable. Only some of them recognized me as one of the walking, groping wounded like themselves. These wounds, as a matter of fact, were my only qualification for being there. As I urged people to lead independent lives and to accept their new blind selves, praising their strength and flexibility, I was already thinking of being home, blankets drawn up to my nose, bawling like a baby.

When I went out from my little office into the waiting room to call the next patient, neither of us could really see the other, and I could only hope that we would connect, patient and budding therapist, like a couple of chance electrons in a vacuum chamber. Still, it felt good to share the experience that isolated us all. Mostly we felt that no one could understand our confusing losses, our constantly deteriorating vision, the unpredictable course of our disease, the omnipresent threat to our livelihood, our social and family roles, our psychological integrity.

Thursday evenings my RP group met in a hot, steamy classroom at Boston University. During the winter, we sloshed through rain and snow, over icy sidewalks, crossing wide avenues, braving public transport. The trolleys outside on Commonwealth Avenue screeched, in our room the radiators banged and hissed, but somehow everyone always showed up to share one another's successes and failures as newly blinded people.

On this particular evening, I spoke first. "There's something I want to share with you right away," I said, and I

asked Freda, who ran the groups with me, to read the article aloud.

It transported the room into a children's theater, our rapt faces riveted to every word. It struck at the center of our dreams, and its message locked within our shaky collective core.

"Jesus, Andy, you should go," said Sheldon.

"And send for us," added Craig, "if it works."

Sheldon had been the only cure seeker among us till now. When he had described the difficult weekly trip to New York to have vitamins shot up his nose, we had urged him to stop.

"But he's a real doctor," Sheldon had said. "A big deal ophthalmologist."

"Why doesn't he let you take the goddamn vitamins home with you?" George had asked.

"I wanted to," Sheldon had told us. "But his nurse said that it wouldn't work at home."

We had been furious, vowing to expose the doctor and anyone like him.

Now, after Freda read my article, the group was silent for a moment. Then, snapping out of our hypnotic state, we joked and bantered, trying to cover up our terrible vulnerability to such things. The article affected us deeply. Our adolescent humor couldn't hide the total absorption of the reading, especially, I suppose, because it was I, usually the voice of reason, who planned to gamble his credibility on this new madness.

"I'm ashamed to admit how much this appeals to me," I said. "More than vitamins or ultra-sound or cortisone . . ."

"Why?" Kevin asked. "It sounds diabolical."

"I guess because it's organic," I said, finding reasonable explanations for the first time. "Because neither a drug company nor a doctor stands to benefit from it, because it's

given by a woman. I trust women. My ophthalmologist's a woman, and she's always been honest and wonderful with me. But listen," I said, "I'm waiting to hear from my uncle. As soon as I do, I'll share all of it with you."

The next day, after work, I climbed into the only taxi at the stand in front of the hospital. I was anxious to get home to Vermont for a long weekend. "Greyhound terminal," I said. No one answered. I sighed and waited, expecting the driver to return shortly. Then a thought occurred to me with a rush of adrenaline: maybe this wasn't a taxi at all. I had noticed that it was two-toned, with something sticking out of its roof. I felt around the interior. A thick wire mesh separated me from the driver's seat. Finally, scrambling for my belongings, I realized I was in a police car. A taxi had pulled up behind. "Hey, man," the cabbie laughed. "I'd stay out of cop cars if I was you." Mr. Magoo, that's who I was. I slumped red-faced into his cab.

The bus ride home was long, the bus crowded with weekend trippers, late-winter skiers. I sat in the back and took tokes off joints being passed around.

Charlotte met me in Montpelier. I was stoned and felt dull, but I wanted to be greeted as a conquering hero, unabashed by blindness. Instead, we fought.

"We read the article in the group last night," I said.

"What article?" she asked again.

"Jesus, can't you remember anything?"

"Oh, *that*," she said. "You're not serious," she added. "What did the group think? That you're crazy?"

"They loved it," I said.

"You always do go after big solutions, big drama," she said spitefully. "Why don't you ever settle for small, life-size answers?"

"Lay off me," I said, and we drove without another word until we turned into our driveway.

"There's an express letter for you from Staś on the kitchen counter," Charlotte said.

Staś had contacted the cured and those who were currently undergoing Mrs. Barnes's treatment. He talked to the article's author and to the good homeopathic doctor who had sung her praises. They all urged me to come and come quickly. "If she agrees to take you," the letter said, "everyone is certain that she will cure you."

The next day I called her. I simply dialed Helga Barnes's number in England, while Charlotte was in her pottery and the kids were out.

"I am going blind from retinitis pigmentosa," I yelled into the phone.

"And I have a terrible laryngitis," screamed Helga Barnes back at me. "I've been talking incessantly with people going blind from all over the world—New Zealand, South America, Belgium, Iran. . . ."

"I read the article about you in the *Observer*, and I am terribly excited by your treatment for RP."

"Don't be excited!" she rasped, truly hoarse. "I have to see you to know if I can help. . . ."

"Can I come then?"

"Oh, my God! All those Arabs and bloody Germans! Planeloads of them. And those filthy parasite doctors lining up outside my door. . . ."

"I can get there right away. . . ."

"All right, come then. But you must stay at the Grosvenor House, Park Lane."

"I have an uncle in London. Can I stay with him?"

"No!" she screamed. "I want you at the Grosvenor with my Arabs. Call me as soon as you arrive."

I put the phone down and shuddered. I knew I was hooked.

Trying not to blurt the news to anyone yet, I left the house and headed up the road with Charlie, my fat mutt, at my heels. Charlie and I stayed well to the side of the wash-boarded dirt road, trying to follow the hazy, uneven lines made by the gravel's edge. Old rusted-out heaps of cars hurtle up and down this road, sounding like steel bands gone haywire, tail pipes dragging, front ends shuddering, parts of fenders thrown to the grassy knolls at the sides. We passed the same houses daily, the same dogs, the same children playing outside. Charlie whined as we approached another mutt's turf, then barked and snarled, as always. Little bouncing, dancing dogs followed us, and together with a couple of stray children, we made a group of six or seven, growling and skipping our way through the Vermont countryside.

For a long way up, the land on both sides of the road is mine. I bought these hundred acres fifteen years ago, when I still saw perfectly. I was astounded to own the overgrown maples, the dead and dying elms, the birch, beech, spruce, and poplar eking out life from the ledgy soil, moss-covered and scented by pine needles.

I passed a hillock that during the sprouting summer is thick with trillium, devil's paintbrush, shasta daisies, and under all, a tangle of wild strawberries. In the summers, I see as if through wads of dirty gauze; now I heard the snow being soaked up slowly, leaving crusty islands of granulated white. The woods were redolent with the musky smells of old leaves mixed, in the early-spring breeze, with an occasional deer carcass, the thawing remains of rabbits and birds. A lumber road trails into the deeper woods, up the steep hill into the old pasture where giant trees have been

split by lightning. When the old sugar house fell under a heavy snow, I used the timbers for Charlotte's kiln shack and the gray board for the bathroom upstairs.

I settled here with my children after the breakup of my first marriage in 1963. During the nine years we were married, Joan and I had moved from France to Italy to Spain and finally to Greece, where we thought we had come to the end of our search for the ideal landscape for me to paint in, for Joan to write in. But when we separated, I was driven to find a real home, and Vermont, where my sister Anita lived, felt like a haven. As Mark and Sarah boarded the yellow school bus each morning, my fantasies of roots and permanence were satisfied. I wanted my children to grow peacefully in the ancient Vermont hills, in the rugged domesticity, tied by climate and poverty to a previous century.

I tapped the sugar maples, enlarged the apple orchard, planted a garden. I dreamed of a small Fontainebleau in this part of *my* forest, landscaped with paths, benches, lights, islands of moss-covered rocks surrounded by wildflowers and beds of velvety pansies.

The Vermont seasons, which not too long ago determined the variety of my sensual pleasure and activity, have a different significance for me now that their visual lushness has disintegrated into hazy fragments of gray. I now heed the odors and the sounds, the changes underfoot from snow to mud to dust to carpets of leaves. My face is aware of the dancing shadows of poplar leaves and the dense shade of maples. In the fall, I see no changing colors; in winter, I am blinded even more by the glistening whiteness; in the spring and summer, I am back to the blurred and broken vibrating parts of things.

Having walked a brisk two miles, mostly up, I turned back

down again. Charlie was panting harder than I. We lost the kids and half the dogs somewhere along the way. Where we turned, I saw a moving form behind a wire fence and automatically raised my arm in neighborly greeting. It turned its profile to me and I saw a large, friendly horse. But, I thought, it might easily have been farmers Perry or Batchelder, both of whom would have been insulted if I hadn't waved. Waving is an important social activity in this small town. Pedestrians wave to cars, cars to pedestrians, cars and trucks to each other. The most enthusiastic wavers are former city people, like me, who have settled here, never having waved to anyone but a taxi before. No longer able to distinguish cars or drivers, or horses from people for that matter, I keep my head down, feigning distraction; in especially happy moods though, I wave indiscriminately, too mechanically I fear to friends, too effusively to strangers.

My little bit of sight caused endless misunderstandings and confusions, but tattered and frayed as it was, it, plus memories of a marvelously visual life, was my cherished link to the sighted world. At St. Paul's Rehabilitation Center, where at the end of 1972 I studied the skills of blindness for nearly four months, we used to argue, the fifteen of us in various stages of blindness, whether it was preferable to lose one's bit of remaining vision and be finished with adjustments and hope, or to nurture what remained, use it as efficiently as possible, and thank God for it. To me, it seemed unspeakable to consider total blindness preferable to even the slightest amount of sight. Since then though, it hasn't been all that clear.

As my sight diminished even more, still tantalizing me with hints of color and shape, the voices promising an end to blindness and disease became more appealing and urgent. Why shouldn't someone somewhere—why not a beekeeper

turned healer—have found, perhaps by accident, the catalyst needed to awaken the enzyme to feed the retina?

Everyone in my family, no matter what the ailment, has always gone to "take the cure." For the relief of gall-bladder or kidney problems, arthritis, or the normal wear and tear of life, they went to the baths, where the reeking waters or putrid mud, in conjunction with sycophantic doctors, were credited with doing what was likely done by the journey, the company, and the change of air.

The rich have always pursued in leisure what the rest of humanity has attempted with varying degrees of hardship: to limp, crawl, or grope to the spa, the well, the shrine, the temple, or the witch's hut to be given exotic concoctions of herbs and animal parts, bubbly liquids, and rejuvenation pomades, to be made whole, to be made perfect, to find eternal health and happiness.

My parents went to Carlsbad or Marienbad; even I, though never sent beyond the borders of Poland, would be packed away with my governess to the mountains or seashore when I showed signs of croup or catarrh, a dry cough or wet.

A car slowed behind me. From the burning rubber and flying gravel, I knew it was Roy. "It's Roy," boomed my friend's voice from inside. "Having a good walk?"

"Listen, Roy," I said, finally able to blurt it all out. "You know that article I gave you about the bees? Well, I'm going to England. . . ."

"When?" he asked, not quite believing.

"Tomorrow," I decided. "Yes, tomorrow."

Roy drove us home, for suddenly there was no time for strolling. Charlotte was out. I went through my telephone book, calling everyone. "Look, I've got to try it," I repeated to each of them. "I've never done anything like it

before." Then, especially if I suspected some resistance: "Wouldn't you if you were in my place?"

I was troubled about divulging the intensity of my sudden faith to the professionals—the doctors, social workers, medical-school professors—the ones who had gone out of their way to make room for me, to train, supervise, accept, and support me. I felt particularly vulnerable to derision. What I feared was not that everyone would turn against me or censure me publicly, but that they would slowly lose interest and abandon me to my unpredictable whims and fantasies.

I pictured them all on a conference telephone call. Each of them sat in his or her office or clinic, feet planted firmly on the shiny vinyl or salt-and-pepper rug, each white-coated figure framed by a veritable gallery of plaques from honorary societies. "Did you hear what happened to Andy?" Dr. Stechler was asking. "Poor bastard. He's gone off the deep end."

"Yeah," said Dr. Berson while leafing through a stack of research data, "we sure made a mistake about him."

I plumbed our conversations for hints of judgment or accusation, for now that I was going blind, everyone's opinion but mine seemed to matter. They mostly wished me well. Some seemed inordinately moved, some said I was brave, some were surprised by my desperation. Everyone urged me to prepare for the terrible disappointments of failure.

Not far below my surface, I found a desire, so strong as to be frightening, pushing me toward magic, quick solutions, a deus-ex-machina ending. Helga Barnes's voice was penetrating and seductive, the voice of a woman, a European woman—my mother?—who would touch me, change me, make everything right again.

I called my mother. "Someone must go with you," she said.

"I think I'd like to go alone."

"What's the matter with Charlotte?" she asked. "Doesn't she want to go? Never mind. I'll go."

"I can really travel alone, you know," I said.

"Will you need money?" she asked.

"Not yet. Mrs. Barnes didn't mention money."

"Well," she said, "the fortune-teller predicted that this would be a very good year for you. Perhaps this is what she meant."

"I don't take your fortune-tellers lightly," I assured her. They always seemed to predict the events of all our lives.

"And your horoscope is terrific," she added.

My mother is over eighty, goes to her office, Maximilian Furs, for a minimum of eight hours a day, and is, as she has been for some sixty years, at the top of her profession.

Freda assured me that she could manage our group without me, though I heard disappointment in her voice. Dr. Lubkin, my eye doctor, wanted to be sure that I wasn't allergic to beestings.

Then I called Dagmar, the director of the clinic where I worked. When in Boston, I lived in Dagmar's house and relied on her encouragement and support.

"I can't believe it," she said, unable to control her anger. "How can you even consider this ridiculous cure? How can you sink into this emotional, unprofessional stance?" She was furious. "Have you lost your mind?"

"But Dagmar," I replied shakily, and pulled out my trump card, "wouldn't you do the same if you were in my place?"

"I certainly would not. How could I? I'm a professional." She paused a moment, then asked: "Don't you believe in science?"

"Listen, Daggie, listen," I pleaded. "In the last few years

I've seen ophthalmologists, optometrists, social workers, counselors, psychiatrists, peripatologists, braille teachers, rehabilitation specialists, and God knows who else. I have become a patient and a client. . . ."

"Of course you have," she said. "You have a horrible eye disease and you're trying to cope with going blind. . . ."

"But you know damn well," I said, "that I'm just being tested and diagnosed. I'm being taught this and that, and anytime I want it and can afford it, I can be rediagnosed. . . ."

"They have to diagnose," Dagmar said, "in order to cure."

"Tell them to stop, Daggie, because they can't cure."

This ever-growing galaxy of professionals around me made charts and graphs, they tested my sanity, evaluated my skills. They gave advice, they listened, they guided. They gave me reading services and sold lenses, devices, and special appliances. They took blood, they took urine, they took photographs. But they couldn't stop the slow, sure dying of my eyes.

Dagmar drew a deep breath. "What about your group?" she asked. "You can't just leave them."

"Freda agreed to do it alone for a few weeks. Anyway, the group wants me to go. . . ."

"Yeah. Sure," she snapped. "You should know better."

I felt devastated and afraid. I couldn't stand a single bad review.

I consoled myself with thoughts of my children. I knew that I didn't want them to remember me as bowing to the awful demands of my condition. I didn't want them to think of me as a blind man, coping as best he could. I wanted to be a hero to them. I wanted them to watch me take risks, be outrageous, reach beyond the ordinary. I had been depressed long enough, and my daughter, Sarah, who was

eighteen and who already showed signs of the disease, could use a happier, more spirited model. What if she had forgotten what I was like once? Did she remember playing ball with me or being chauffeured by me? Did she remember the motorcycle, the skis, my life as a painter? I wanted my children's respect and admiration for what I had been, not for what I was becoming.

The child inside me responded with its old passion. This child didn't want to deal with acceptance or adjustment or to be "rehabilitated." This child would kick and scream and finally get his way.

Even though some artist friends once told me, as it became clear what would happen to my eyes, that they envied my opportunity to be a blind artist, like a deaf Beethoven, I saw no way of continuing my art. If I continued, the best I could hope for would be an exhibition in the lobby of the Lighthouse or the halls of the American Foundation for the Blind. I could make the pages of somebody's newsletter, a footnote in a rehab journal. No handicapped Olympics for me. I wanted the real thing. I would go down swinging in *my* way, and it seemed that Helga Barnes ran the best show in town.

My son, Mark, home from Chicago, said: "If it works, great; if not, you can always touch those Arabs for money for RP." And Sarah, dear Sarah—if this works, I'll send for her and she too will never be blind.

I reserved two places on the 747 from Montreal and called Charlotte at her women's meeting. "Can you come with me to London tomorrow?" I asked.

"Jesus . . . How? . . . Who'll take care of the kids?"

"Let's just go. We'll share something extraordinary. God knows, we need it. If nothing else, we'll pump some new life into this marriage."

Charlotte came home with the whole women's group. They were mostly divorced or divorcing, many of them making their first sustained efforts into new careers. In this community, which reinforced variety and change, they were pushing for their own rebirth. They had already organized everything: who would stay with Jed and Maya, Charlotte's kids, who were still young enough to need adults around; who would feed the dog, keep the fires burning.

That evening a friend called to confirm the poker game for the following night. "I can't play tomorrow," I said. "I'm going to be in London."

"Right," he answered without a pause, "good thing you reminded me. I have a luncheon meeting in Buenos Aires."

Charlotte and I never did go to sleep that night. We spoke about the unspeakable, the changes I knew would come into our lives. We made love off and on all night, as in the old days, and bewildered by the progression of events and feelings, we cried.

T H R E E

England is not the landscape I would have chosen for great transformations. I might have expected miracles from an isolated hogan in New Mexico or from the ruins of a temple to Apollo found on the line bisecting the dip between two mountains in Lesbos. But this was grim and stolid London, bulging with banks and shoe stores, where even the first contact with immigration at Heathrow infects me with uneasiness, a shade of guilt for some undesirable person inside me: the anarchist bomb-throwing Jewish radical, the smuggler of two joints.

"Business or pleasure?" the man in uniform asked, scribbling something.

"It's pleasure," I said. "I'm here for my eyes. . . ."

"Are you blind?" he asked, looking for a sign.

"No," I said. "Nearly, but not blind."

"Do you have sufficient funds?" he asked. No parasite blind folks for his island.

"Oh, yes," I said. "No problem. I'm just here for a few weeks' cure."

"And where will you be cured?" he asked rather sardonically.

"Mrs. Helga Barnes," I said proudly.

"Mmmm," he said and peered at me over his National

Health Service glasses. I tugged self-consciously at a few strands of longish hair hanging over my collar.

Staś, in a natty Burberry and fedora, met us as we came through customs. My favorite uncle and I hadn't seen each other since my father's funeral in New York ten years before.

"Let us telephone Mrs. Barnes straightaway," he said, his eyes moist with feeling, his face beaming with a broad smile. He simply couldn't wait to get this bothersome problem of mine settled so that we could all enjoy our stay in London together.

Staś vanished into a phone booth, and we heard him clear his throat carefully then say in his best imitation of the Queen's English: "I'm so sorry to disturb you, Mrs. Barnes. This is Potok speaking hee-yah." He talked slowly and distinctly, appending a musical drawl at the end of his phrases, heavily accented with Polish. "Potok," he said. "Po . . . tok . . . Po, Po, Po. P as in Peter. Yes, that is correct." He paused. "My nephew has just arrived from America," he continued. "Hello! Hello! Am I not speaking with Mrs. Helga Barnes? I beg your pardon?" he asked several times, and then, with perplexed resignation, he placed the phone back in its cradle. He seemed suddenly to understand that we were undertaking something more complex than he had imagined. "I could swear it was Mrs. Barnes on the telephone," Staś told us, "but she insisted I call back in an hour. I think she was trying to imitate an Irish girl."

We got on a steamy double-decker bus to Victoria Terminal. Charlotte and Staś sat next to each other, across the aisle from me. They were making the stiff gestures and sounds of a new acquaintance, no doubt eyeing each other carefully with their peripheral vision. They gesticulated and laughed. They talked too loudly due to Charlotte's unwill-

ingness to admit that her Boston accent glanced off foreigners, and Staś's conviction that his amalgam of English and Polish flowed as easily as the confluence of two great rivers. And they got caught in uneasy silences, spent refurling their umbrellas, clearing their throats, and reaching across to touch my hand or knee.

Looking through cloudy retinas and the sooty bus window into the dismal rain, I wanted it all back: the painting, the driving, the reading, all of it. I hadn't been in England for twenty years and now could scarcely see it. Staś, I knew, would gladly make great sacrifices if I could be healed. He felt somewhat implicated in the transmission of the RP gene, which had traveled from his mother to me and thence to Sarah. And, besides, he loved me.

The roots of my blindness have been buried with the lost genealogy of the Jews of Poland. My ancestors, through their marked preference for marrying cousins, made a casserole of their chromosomes, producing no freaks or idiots but their share of depressives and the gene for retinitis pigmentosa.

In my family, we own the dominant gene, though it's an uncommon form of dominance that sometimes skips generations. As such, my grandmother passed it to my father, who was unaffected by the disease and unsuspectingly gave it to me. I, who should have known better but was afraid to ask about its genetic character or to look in medical texts, passed it on to Sarah.

Retinitis pigmentosa affects the light-sensitive cells of the retina—first, usually for many years, the rods; the cones most often late in the disease. The screen layer at the back of the eye, the retina, consists of some 140 million rods and 7 million cones. Rods exist everywhere in the retina except

the very center, and they allow us to see in dim light. Cones exist in relatively small numbers throughout the retina, but the center, the fovea, is their exclusive domain. They allow us to see color in bright light. There are finely differentiated cones, some dealing only with the color red, some with blue, some with green. Color mixing occurs in the brain, the creator of the full visible spectrum.

Sometimes RP starts early in life and devastates the entire retina in a few short years; mostly, as with me, it is relentless but slow, destroying sight over a lifetime. It generally begins its course on the edges of the retina, exterminating the normally dense rods and, with them, one's night vision. It progresses toward the center and, typically, before total blindness, leaves one with a small area of functional vision known as "tunnel vision," which describes my grandmother's condition at the end of her life, and therefore what I expected. But in my case, the centers of my eyes have also been dying, thus wiping out vision from the inside out as well as from the outside in.

About ten years ago, Charlotte and I were driving home from a concert of Mozart quintets at Dartmouth, and as I looked lazily toward the car ahead of us, the bright point of its red taillight suddenly and entirely disappeared from my vision. I jerked myself up and peered directly at it, blinking and straining, but no matter what I did, it didn't register. It came back only as I looked away. From that moment, my central vision, the area of color perception and the fine acuity needed for detail work, such as reading, declined steadily. This was the beginning of the end. Retinitis pigmentosa was taking real useful vision, and I knew that in time it would take all.

At home, I lit a cigarette, and the flame clouded then

splintered into fragments. I didn't believe my senses, and the next morning I called Dr. Lubkin to ask if my pupils could possibly have locked into a dilated position. She said no. I began to lose detail in my painting, unaware now of the texture of brushstrokes. Lines began to separate into segments, like dying, curling worms. When color—other than the brightest primaries—lost its individual character, I had lost the vocabulary of paint.

In a panic, I went to New York to see Dr. Lubkin again. I liked her enormously and trusted her implicitly. She wasn't burdened with the massive ego carried about by most of the ophthalmologists I had known. Retinitis pigmentosa was to her a sad human problem like so many others, not a threat to her profession. I sat across the desk from her as I had done twice a year since my mid-twenties.

As I played with a museum copy of an eye taken from a life-size Egyptian sculpture, she asked for a precise description of the new visual changes. I had special feelings about this beautiful stone eye because I wished eyes were all as simple as it was—a circle of black onyx set into alabaster; no blood vessels or nerve fibers, no flimsy little retinas, none of the millions of tiny parts, any of which could and did go wrong.

Dr. Lubkin looked into my eyes for a very long time with her ophthalmoscope and finally said: "Damn it! Damn it all! You're right of course. There's now a central involvement in both eyes, the left slightly better than the right." She had turned the ceiling lights back on, but I couldn't see anything through my dilated pupils, the backs of my eyes pulsating with haloed black afterimages. "Unfortunately, the cataracts are much too small to matter." Tears formed in my eyes. I tried to contain my grief and anger. I was grateful that she

was with me. "All I can say is use your eyes as much as you need to. Don't spare them. Keep painting until you absolutely have to stop."

On this visit, I had entered a new domain, that of "legal blindness," an administrative definition meaning that even with corrective lenses, central acuity is worse than 20/200 in the better eye. "Or," Dr. Lubkin said, "a visual field of less than twenty degrees. And you, my dear, qualify in both categories," she added sadly. "I'll write you a note for the IRS. You may as well start getting all you can. This isn't much, just another deduction on your taxes."

Not long after this visit, on the advice of a friend, I left fifteen slides of my paintings at the Bertha Shaefer Gallery on Fifty-seventh Street.

After years of large abstractions, I had settled into the cozy luxuriousness of nudes and interiors. Considering my background and temperament, my talents and limitations, I had a sense of belonging in this territory, a sense of rootedness akin to the roots of my house on a hill, my children's one-room schoolhouse, drapes, pillows, and the abundance of flesh.

I had come to this work after several varied and restive apprenticeships. I had learned about color from Albers at Yale. In Paris, I had studied with the neo-cubist Lhote and the neo-impressionist Brianchon. I had tried to paint like Soutine, Rouault, Braque, Matisse. I had fallen in love with deStael, then de Kooning. Then two years on a Greek island subdued my fickleness. It tempered my abstractions and laid the groundwork for the cornucopia of my new domesticity.

But after my legal blindness had been officially established in Dr. Lubkin's office, my work changed again, this time more dramatically than before. In spite of the valiant

efforts of a well-known lens maker who followed me around my studio to determine my special needs, I stopped my visually demanding interiors to launch into grosser forms: large wooden assemblages painted with pots of commercial pigments.

Then I heard from Bertha Shaefer. She liked what she saw of the nudes and interiors, and wanted to give me a show. I was very excited. Showing on the side streets of Paris, Palma, Athens, even New York, was not like showing at the Shaefer Gallery on Fifty-seventh Street. This was a main-line event. Once seen there, I would be seen again, and seen well.

Bertha Shaefer met me at the elevator. Her place had a substantial, European flavor.

"I'm so glad to see you here," she said. "Your work gives me pleasure."

We moved into an inner room where she took out my slides, held each up to the light to look again. "Did you bring more?" she asked.

"Just a few," I said. "That's all I have." I had decided to say nothing about the recent changes in either my painting or my eyes.

"I like these," she said. "I like them very much. I'll have a slot open next winter. But we will need more. I'll want to hang half of these, then I'd like to choose from, say, another fifteen. That should give us enough. Could you have that many within the year?"

I could not. Not within this year or any year. I tried to say something but I stammered. I didn't know what to say. I wanted this chance so badly, but the new things I was making didn't belong at Bertha Shaefer's, and I would never have enough of the old ones to fill the space.

"What's the matter?" she asked. She was elderly and gray

haired, and I liked her. "You know, this can be the start of a long collaboration."

"I'm going blind," I said.

"You're not joking," she half stated, half asked. She looked suddenly much older.

"I can't paint like that anymore. I'm not seeing color well, nor detail."

"What will you do? Are you painting still? Can I see your new work? Maybe we can make do with these," she said all at once.

"I'll send you new work to look at," I promised. Now I couldn't wait to leave, to close my eyes and never open them again, to run under a car.

Bertha Shaefer called a few times after that to ask how I was doing. She suggested other galleries for the new work. But the progressive loss of my eyesight distracted me from caring about my painting or my near success. All of that seemed suddenly unimportant, almost frivolous, like making frantic phone calls from my deathbed to promote the work of my youth.

I never saw Bertha Shaefer again.

Since Albers, I'd been interested in the problem of figure and ground, the interchange of foreground and background, the manipulation of objects in painted space. Suddenly the problem shifted from canvas to self, where it nagged like pain. The figure of my diseased eyes superseded all others and, having taken up residence in my body, threatened always to be there. It would neither recede into the background of my life nor be assimilated into the foreground. It was the start of a long, unfinished business, which would not permit resolution until I had finally lost every bit of eyesight or until I was miraculously cured.

Blind spots took over the majority of my retina, spreading

like the plague. Deep inside my eyes, I felt a lack of flow and metabolism, a desert, stagnation, death.

The normal field of vision, the scope of the area we see in front of us, is about 140 degrees (horizontal) in each eye. My field now, piecing together the odd bits here and there, is less than 5 degrees. Because the losses are a patchwork of dead or dying cells, my functional vision is difficult to understand. If one imagines full sight as a mosaic of millions of visual units, the vision remaining to me is determined by a small number of functioning cells unevenly distributed over the whole. I see through a small, irregular doughnut-shaped area with a little help from two thin motion-perceiving crescents somewhere near the edges. The central losses eliminate all clarity, and the peripheral ones limit my orientation in space. In the full mosaic of cells, the dysfunctional ones are not black, nor are there sharp boundaries between them and the neighboring useful cells. Blindness isn't blackness; it is nothingness. I have, there-fore, on my retina, a tiny amount of somethingness sur-rounded and influenced by a vast nothingness. There is a disorganization of the whole; everything is ill-fitting, jagged and incomplete. Such fragmented visual experience affects one's personality. Objects appear or vanish abruptly and inexplicably. Nothing makes spatial sense, so I put together visual clues based largely on memory and imagination. For me, perceived reality is spotty, appearing in a kind of charged, flickering motion. At night or in dim light, I see nothing; it doesn't matter if my eyes are open or closed. But even the darkness vibrates, sometimes with an unpleasant dance of thousands of pinpoints of shimmering light. Color retains some value (its lightness and darkness) but little hue (its perceptual scale ranging from red, through yellow, green, and blue). I picture a few cones here and there

struggling heroically to keep alive to give me the best they can: a bare recognition of the red family, almost none of the blues or greens. A maddening sensitivity to light ironically makes the very act of looking irritating and painful.

Staś called Helga Barnes again from Victoria. He was asked not to call anymore. Mrs. Barnes would be in touch with his nephew later that day at the Grosvenor House.

We arrived at the reception desk, where I expected crowds of her patients: turbaned, bejeweled, Nehru-capped, Mao-jacketed, the still-unknown hordes of retinitis pigmentosa people, lining up to register and be cured. I do tend to exaggerate, but I had pictured a small ballroom reserved for the occasion—Jews and Arabs drinking together, laughing, talking of cures and the impotence of modern medicine. In fact, no one was there. It was the slow season, and the hotel lobby was relatively empty. When I mentioned Helga Barnes the desk clerk said, no, he had not heard of her, but perhaps I should talk with the hotel medical staff, just off the lobby. But the room off the lobby contained a sleepy Pakistani doctor with a carnation in his lapel, who thought, alas, with a mixture of linguistic confusion and Eastern clairvoyance, that Helga Barnes was the name of my problem.

To make a show for Staś, I wandered off alone into the spacious lobby. I was becoming used to assuming the posture of a sighted person, pretending, almost defiantly, to be normal.

I strolled like a German philosopher, hands behind my back, head down, brows knit in thought, while my toes and ears probed like antennae, to give me clear passage. Stairs were my nemesis, though, and now Staś watched me fall down three cleverly camouflaged steps. "Son of a bitch," I

murmured as a couple of small groups of Arab ministers and UN functionaries turned to look at the clatter. This strange and difficult disease, which produces so many off-register moments, such massive confusions of identity, such improbable situations, injects an element of adventure into every excursion, no matter how commonplace. Staś rushed over to me, offering help. "You must not go off alone," he warned.

"I'm perfectly all right," I lied. "I wasn't paying attention, that's all."

We went up to our room, and in the corridors, dodged little Arab children who ran in and out of luxurious suites and played with the room-service tables smelling of kippers, parked along the walls.

A short time later, we heard from Helga Barnes. Her voice was aggressive, even annoyed. "Tomorrow I want your first morning's water," she commanded.

"Water?" What did she want? My sweat, my tears, my filtered blood?

"*Urine!*" she yelled, rolling the *r*.

At ten the next morning, she arrived, entering like a newly wound tin soldier, weighted on both sides with paper bags and leather bags, a squat, pigeonlike woman with a black homburg hat and a chic, tentlike coat. She gave the impression of being jet-propelled, chattering: "Good morning, madam. Good morning, sir. You have no idea what is going on with these planeloads of people. They are coming from everywhere, poor souls: Arabs, Germans, what-you-call-them . . . South Americans, even rogues from Australia. Good God, what I can tell you about them! But I can hardly talk, I am so full of laryngitis. And how are we today?"

"Fine, thank you, Mrs. Barnes. . . ."

"And those filthy parasite doctors, those money-grubbing thieves. They are knocking down my door, begging for a bit of this, a scrap of that. Those lying, cheating sausages! If you only knew what I go through, what they have done to me. Forty-eight years they have not left me alone. And I tell you, Mr. What-do-you-call-it . . . Potok? . . . yes . . . I will wipe the floor with them all! I will use them for doormats! Yes, my dear, they will get nothing from me. They have had their chance many times. I will take my secret to the grave with me!"

To my ear, there seemed to be an exotic element in her middle-European accent—something truly strange, like Hindi or Urdu. Her head seemed small for her body, while the rest of her was ample, even broad. The feel of her hand surprised me when she had offered it in greeting; it was soft and smooth, sensually cushioned, very special.

She was sitting in an armchair, her body totally relaxed, her sensible black shoes planted firmly on the floor, her hands making lazy circular motions. All the energy was centered in her face, her mouth darting, pecking, sputtering.

As she sat and talked, without breaking the continuity, she fumbled in one of her bags, and I knew that I would have my first taste of a beesting. She fished with tweezers in a small round container, suddenly vibrant with buzzing. Predatorlike, at the end of the silvered forcep, was a live and furious bee, ready for action. My anxiety and fear were overwhelming as she stepped behind me, and *zap! zap!*, first to the left, then to the right, two beestings unbearably painful, each behind an ear, made me sweat, feel faint, made my head reel.

"There, sir," she said. "That should do it. Tomorrow your pupils should be wide open, and I can take a good look inside. Then I can tell you if my bees will help. I don't put

those filthy drops in, like doctors do. No, my dear, it is my angel bees that will do it."

I was crazy with pain, the stingers left hanging there, pulsating. And all the time she talked, telling us about this patient, that doctor. "And can you imagine," she was saying, "that dirty Scotsman writing me he is *still* well. What impudence! Of course it is *still*. When Helga Barnes cures, it is forever!" I strained to hear every word though the burning, throbbing pain was making distracting interior static, like blood gushing through my veins. Charlotte sat ramrod straight, probably white as a sheet. "Did you read that article? Do you remember that filthy barrister saying 'That Mrs. Barnes, she must have something'? *'Must have something'*—that parasite! I cured him good and proper, and that's what he has to say. I won't take people like him anymore." She was now flushed with rage, her black shoes and her fists pounding rhythmically. "I will take only quality people, with good upbringing, cultured people. . . ." Still angry but in control, she told me, illustrating each point with hyperbolic examples, all the rules and regulations of her treatment. No resisting her cure, no reservations about her methods or results. She would be the giver, I, the receiver. No arguments, no problems. The object of my hope, my dreams, and my expectations, the present focus of my life, seemed to be a small cantankerous madwoman.

She slipped behind me again and took out the stingers. Still talking, she began packing and repacking her bags, sliding in her container of bees. This disappeared into one package and that into another, like plutonium being slipped into its casing, the outside giving little hint of the awesome energy within.

"Please be so kind as to come to me tomorrow. Your wife,

you, madam," she said pointing to Charlotte, lest we should still have missed the point, "you will not accompany him. And yes, you can move out of this hotel to your uncle's if you wish. Ah, even these hotels, once so elegant, are not what they used to be. Shabby and filthy, that's what they are now. Nobody knows how to work anymore, the lazy louts! And the clientele is now all colors and shades," she whispered. "Ruffians from blackest Africa. Can you imagine?"

She handed me a leaflet called *Notice to Applicants for Treatment,* and smiling and bowing, she waddled toward the door.

"Ah, yes, I almost forgot," she said, "hand me your water. . . . It is the first of the morning, is it not?"

After she left, Charlotte and I were speechless, not knowing whether to laugh or cry. For a moment, I wasn't at all sure if I preferred being a patient of this pain-dispensing fanatic or chalking one up to a frivolous whim, a round-trip ticket to London, a night in a fancy hotel. But as my face began to swell from the stings, I again felt drawn, strangely committed. This kind of pain, elicited by this powerful poison, was bound to shake things up.

Charlotte read the notice aloud:

> . . . I do not accept patients who cannot make up their minds as to what they want.
>
> Patients must keep strictly to my rules, not only regarding treatment, but also for times of appointments. . . .
>
> I do not intend here to elaborate on my successes. They are quite evident, since all my successfully treated patients were beyond the help of the medical profession, or they would not have come to me. I refuse to see any patient whose idiot doctor offers to "supervise" my treatment, about which, of course, he or

she knows precisely nothing. This is a clever ruse to learn whilst watching me. . . .

That evening Charlotte and I sat at the Audley pub, ordering in fairly quick succession cold lagers then warm dark beers and back again; light, dark, light, dark . . . until we could hardly stand. Our ability to judge anything at all had been clouded by mid-morning, and now we were doing our best to impair it altogether.

"Why does she want you to come alone?" Charlotte asked.

"I can't even try to imagine," I muttered. We ordered ham sandwiches, and they came with the crusts cut off. "And not one word about money," I said.

"Cultured people undoubtedly means rich people. She's softening you up for the kill."

"We've seen the obverse side of God," I said drunkenly, "and it's crude and primitive. . . ."

"Listen, honey," Charlotte said, "maybe we should go back. We can, you know. Everyone will understand."

"She's monstrous," I said. "She's also soft and vulnerable. Did you feel her hand? It's a beautiful hand, like my mother's. . . ."

"You won't even miss one group meeting," Charlotte said. "And it's almost time to plant the garden."

I moved very close to her and saw that she was afraid. "Listen," I said, "we're in England. You've never been here. The treatment won't take up all our time. Wait till you see the Tate, the Wren churches, the British Museum." She put her hand on mine. "Besides, I'm curious. My neck is throbbing, and I really want to see what happens. Just a week, maybe two."

We stayed at the Audley till closing and stumbled back to the hotel. In bed I lay awake for a long time. I thought I was the intelligent supplicant at the feet of a vulgar, crazed deity. But if I started admitting deities into my life, it was no longer farfetched to believe that I was being put to some kind of a test by them. I knew little about religious experience. Perhaps I should learn to have faith. How easy it would have been, I thought, if she were sweet and kind. But gods are arrogant and vengeful, I remembered. If I were to be cured, how would it happen? Could it happen in the single blink of my eye, or with the pleasurable drama of a camera focusing? Or very slowly, over months, even years. God forbid I was an actor in a cosmic parable that would prove once and for all that curing blindness is no guarantee for happiness. Over the last few years I had blamed everything on it, all my rage and depression, my thoughtlessness, irresponsibility, and growing misanthropy. I remembered a passage from Freud where he warns that the cure of neurosis leaves one no less susceptible to the horrors of life. With me, the cure from horror would undoubtedly leave the nagging residue of my neuroses. I smiled, wanting my neuroses. I was drifting into sleep. I felt it start to numb my head with each inhalation of air. How would I remember these fragments of thoughts? I tried to anchor the time. It was nearly April, a time for rebirth and awakening, and almost asleep I realized that it *was* April, the first of April—April Fool's Day.

F O U R

The morning felt languorous, sensual. Outside our windows,
Hyde Park, which had budded early and showed, according
to Charlotte, a patch or two of spring color, had been
enriched by the night's rain. We were rested and lolled
about, stretching on the silky sheets and fluffy coverlets.
Kippers and eggs and sausage were wheeled into our room
on a large table covered with a heavy white cloth. We ate,
then bathed in a huge old-fashioned bathtub with warm
towel racks above it. All this abundance seemed to herald an
end to deprivation. The air was full of promise, of imminent
new beginnings.

Staś called from downstairs. "A perfect English day," he
announced. "An ideal day for moving." We met him by the
front desk, where I paid the bill. Charlotte was looking at
glass cases filled with antique snuffboxes and Wedgwood
china. So suddenly transplanted to this elegant space from
our isolated hill, feeling foreign and somewhat out of place,
she had learned to ground herself in such situations by
establishing an almost religious bond with the subtle
surfaces and volumes of crafted objects. She looked beauti-
ful, like the profile of Sappho on an ancient Greek coin, a
coin I had found once in a field in Lesbos. And Old World
Staś was now pacing briskly back and forth, a dapper seven-

ty-year-old figure, deep in thought, swinging his pencil-thin umbrella in a snappy ministerial arc.

Staś and I waited for Charlotte on a long couch near the windows. Across from us I could vaguely make out a woman's form, a patch of auburn hair, a splash of cherry red on a pale face, her features shifting like a Picasso head. I saw a long expanse of stockinged leg, and shadows emphasized her breasts. I wanted to see her better, to make eye contact, to elicit a response. Once, I might have received a glance of recognition and playfulness, an acknowledgment of interest, a quick and pleasing reinforcement of sexuality. But it had gone, the contact that takes stock, measures capacity for engaging, takes directions, assumes modifications. It had gone, and its loss was one of the more difficult ones to bear.

Staś's face was very near me, and I could see it flush with pleasure. The woman crossed her legs, and the pale flesh tone of her skin sent a shock wave through us both. I couldn't bear being denied. I looked long and hard, trying to piece her lovely parts together. And then I felt her annoyed gaze. My looks were gross, brutishly explicit, indelicate. The subtlety of the game was gone; it had lost its erotic quickness.

My occasional ability to decipher detail—newly applied mascara, a wrinkle, the sparkle of an earring—depends on the momentary coming together of several ideal conditions: the intensity of light, the relationship of figure to ground, my distance and angle of sight. These momentary flashes of accurate vision combine incongruously with my inability to cross a street safely or avoid colliding with a tree on a simple country walk. The unevenness of sight confuses me and those close to me: at times I can perceive and report minutiae, at other times I see nothing.

Staś nervously lit his pipe. He puffed and tamped but

couldn't get it going. "Do you remember," he asked me, "when I used to take you out on Sundays in Warsaw?" He puffed at his pipe and looked at the woman again, now turned sideways from us. She wanted nothing more to do with us. "Do you remember the Europejska where we'd sit outside together?"

"How old was I?"

"Right up to the war," he said. "From the time you could walk until you were . . ." He puffed at the unlit pipe, and we both looked across the glass coffee table. She was standing now, talking with a man.

"I was eight when the war started."

"You were so pretty, and your governess dressed you so nicely," Staś said. "For me it was a pleasure to be with you. We would have ices and chocolates, as much as you liked. . . ."

"It's a wonderful picture, Staś," I said, "but you were a bachelor and didn't come to Warsaw all that often, did you? So why did you want to spend your Sundays with a little boy?"

"Well," he said, his pipe finally making a halo of smoke, "well, I really was proud to be with you, like a father." He seemed lost in a pleasant reverie. "Well," he started to say again, "the Europejska was very elegant. We seemed to attract women, you and I. . . ."

Charlotte had returned, and Staś blushed a little. He sat up abruptly and coughed to clear his throat. "Yes, we must go now," he said. "Let us get a taxi and go to Eton Rise."

We moved from the Grosvenor to Hampstead, "an artistic and thoughtful little suburb of London," according to E. M. Forster. Staś had insisted on moving out for however long we stayed in London. "The longer the better," he said. The night before, he had already moved in with his friend Edith,

just a few stops farther on the Underground line. "I am so happy that you are both here," he said.

Eton Rise sounded fancier than it actually was. One of three identical red-brick structures, it stood, its undecorated façade as monotonous as a file cabinet, behind a large plane tree on Eton College Road, a short quiet street snuggled in among noisy thoroughfares. Staś had chosen to buy this three-room flat because it was equidistant from Hampstead Heath and Regent's Park, in both of which he met his friends, read the *Observer* on long Sunday mornings, and strolled after work among the ponds and chestnut trees.

"You will see how convenient it is to most things," he said while we waited a moment inside the lobby for me to adjust a little to the darkness. "You walk in one direction, toward Primrose Hill, and you will find the health-food store, near the house where Engels once lived; in another direction, you will come upon Keats's house, not far from very nice shops, a block from the Heath."

The Eton Rise lobby looked simple. It was faced all around with white marble, happily uncluttered by posts or furniture. Staś's flat was one flight up; the stairs were easier to negotiate than the two tiny slow-moving elevators on the farthest wall from the entrance, lost to me in darkness. Upstairs, Staś quickly familiarized us with everything: where to sprinkle cockroach poison, where to leave the garbage, which drawers he had emptied. The whole place was small, comfortable, and sparsely furnished. We dumped our suitcases and went down to walk Staś to the Underground.

Just outside the door, dwarf tulips had broken ground under various sorts of budding bushes. "That," said Staś, pointing to one of them, "is a special variety of English lilac. It is odorless."

"Odorless?" I repeated. "Odorless lilacs?" Who else but the English would do a thing like that? Tasteless food, odorless flowers. "To a blind man that's a bit of a joke," I said. Staś turned away and began talking with Charlotte about something entirely different. He couldn't stand any references to me as blind.

We walked him to the Chalk Farm station and then turned up the long hill toward Hampstead Heath, a vast tract of land, partly open and partly wooded, all of it sprawling and wild. We strolled through old narrow streets whose elaborate Victorian houses were being slowly crowded out by modern studios with large billboards advertising their one- and two-room apartments.

As we approached the pond at the top of Heath Road, from which, on a clear day, they say you can see all of London, a black cloud appeared on the horizon and made its way toward us. The darkness moved quickly, suddenly bringing with it a bitter wind and thick snow. In a moment, the landscape was transformed into gloom and turbulence. It seemed like an omen, and it brought me back to an image of early childhood when, in the country south of Warsaw, the mid-afternoon sky turned crimson. It was awesome and majestic. My governess said in brooding tones that this was a sign and blood would soon flow. It was the summer of 1939, and war was on everyone's mind. I thought about her words a few weeks later as I lay in ditches at the sides of roads while planes dropped bombs and strafed.

The cold and melancholy spectacle of the Heath penetrated our bones and spirits. Shoulders hunched and bodies rigid, Charlotte and I clutched each other as we moved quickly down the hill and, with a common unspoken purpose, ducked into a bookstore.

We stomped our snow-covered city shoes, hung our thin

raincoats on a large wooden coat tree, and peered at this haven, three rooms of books, with anticipation. For a moment, I remembered only what it used to be like: a half day at the Paris Brentano's, looking for bargains up and down Fourth Avenue, finding some little shop with ancient leather-bound volumes tucked away in a back street of Barcelona.

Charlotte disappeared immediately, and I, feeling like a diabetic in a pastry shop, gaped at whole walls full of seductively displayed Penguins and Pelicans. I was suddenly overcome with a burning need to know what was inside those books. The place seemed nightmarishly opaque, as if under a coat of hardened plastic. But everyone else was browsing and skimming, getting smarter as I watched. "Read aloud!" I wanted to shout. "Share! We, the handicapped, demand it!"

Sundays at home are terrible. Charlotte goes down the hill to the store to pick up *The New York Times* and the members of my family sit around the kitchen counter or in front of the fireplace in the living room, reading, a section for each of them: Sarah's "Arts and Leisure," Mark's main section, Jed's "Sports," Charlotte's magazine, while Maya, who isn't interested yet, and I sit staring at the walls. They read while I listen. I listen, I pace, I get angry. I make noise puttering, I slam doors. Still, it is Sunday and they are reading, silently, lazily, yawning, stopping for a nap in front of the fire, resuming effortlessly. None of *them* know how to listen. They make Muzak out of all noise, even music. It is all accompaniment to something else. As for *me*, I am left listening to the electric meter whirring outside, the crickets, the goddamn refrigerator. I hear the typewriter hum in C major, the freezer in a low B-flat. Under ideal conditions, I

hear the difference between hot and cold running water. I
hear every new car noise, I hear who's coming to visit, I hear
the kids turning over in bed. I hear apples falling from the
trees, June bugs romping in the cellar. . . .

In the bookstore, I could barely decipher the titles. Still, I
went over to them and, from habit and pride, began to leaf
through books as if I were a normal reader. The miserable
weather outside, these warm, inviting rooms, nothing
special to do for a couple of hours all contributed to the most
perfect atmosphere for skimming, loading up on trivia, butt
ends of thoughts, ideas taken from some fragment, from
pieces of chapters, back covers, jacket flaps—the kind of
information that used to feed me, inspire me, tell me what
was happening. I could have once found out *something*
about Poincaré's mathematics, the NHL standings, or Jaime
Segundo of Mallorca. I could have caught the sense of a
novel I really didn't want to read, a biographical sketch,
some troubadour poetry. I could have learned something on
a day like this or sitting on the toilet or in the dentist's office.
Here, there were newspapers, a bulletin board full of
community announcements, new books and old, art books,
and postcards. I could have studied the Underground map; I
could have had a quick introduction to the recent acquisi-
tions at the Tate, the Victoria and Albert. I could have
considered theater in the West End, music on the South
Bank, notices of readings. Instead, these holes punched in
the centers of my eyes left enough vision to titillate me with
a thing called Bookstore, but nothing to read with. I walked
around the many tables piled high with books, touching with
my fingers. Tears of rage formed in my eyes. I felt around for
my coat and went outside.

Charlotte eventually came out with an armful of Margaret

Drabble paperbacks and a book on Athenian black figure vases. "It was reduced for clearance," she told me with a shade of guilt.

I didn't even grunt a response.

"Oh, Jesus, the bookstore got you," she said.

I said nothing.

"I'm sorry. I thought you wanted to go in. . . ."

"Why did you take so long?" I snarled. "Couldn't you see how I hated it?"

"I looked at you," Charlotte said. "You seemed to be doing all right."

"I hated it!" I yelled, holding Charlotte's arm to cross a street.

"Well, I wanted to buy some books. Everything doesn't have to revolve around you. Even on this trip," she added.

We walked home in silence. A few times I almost slipped in the newly fallen snow. Wet sidewalks or dry, I needed her arm. I gripped it tightly, squeezed it harder than I needed to.

When we were in a decent mood, using Charlotte as a sighted guide was pleasant for both of us. When we were feuding, we both resented the inequality of the arrangement. I had to walk slightly behind her, thus being forewarned of approaching obstacles. I disliked being dependent on her pace, her choice of routes. When Charlotte stopped to look in a shop window, I, like a child without similar interests, had to stand patiently until she finished. At those times, she resented having to be my eyes, which made me somewhat fearful of where I was being led—into the crack between train and platform, an open manhole, under a bus?

At Eton Rise, we had tea and scones we picked up on the way. We were on the verge of a week-long silence, a re-

treat into private bitterness and resentment. We both knew, though, that we couldn't spare a week for such a painful indulgence—not this week. Even this day still held Helga and the bees in store.

"No wonder you're nervous," Charlotte said. It was a concession that under normal battle conditions would have taken a long time coming, from either of us.

"You know what I'll do when I start seeing better?" I asked, offering my fantasies as reparation. "I'll get into the car . . . no, it'll happen here . . . I'll hire a car and explore England. . . ."

"You'll probably kill yourself driving on the left side," she said.

"Aha, so you're beginning to believe it too."

"I didn't say that."

"I'll drive you to Leach's pottery in Cornwall. We'll visit Oxford, Glyndebourne, the lake district. . . ." I couldn't stop. "Back home, I'll go down to New York, check out the galleries, the third floor of the Whitney." I paused a moment to taste the meaty part of my fantasy. "I'll sit in the garden of the Modern looking at the fat bronzes, the people, the book in my pocket. I'll go inside, without crashing into the glass doors, browse through the current exhibits, catch the afternoon movie, buy a pretzel, wander home stopping at Rizzoli's. . . ."

"Stop!" she cried. "You're being foolish. You're going to get hurt if you go on like this. Please, Andy, don't leave yourself wide open. Stop torturing yourself."

We were both fairly solid inhabitants of reason and order, Charlotte and I. Neither of us jumped to save our lives by primal screaming, rebirthing, or mind control. Instant solutions sometimes nagged at me just a little, especially when it seemed that my life was totally worthless. But I

never succumbed. Charlotte was never even tempted. Scornful of shortcuts, she needed to persevere through the vagaries and hardships of existence—her migraines, her artistic doubts, her horror of getting old—and pick up the rewards she believed were given to survivors. Yet now, here, working on my own salvation, I wanted a fellow conspirator, loose, vulnerable, fully open to change.

Staś phoned and made us write down every detail of the directions to Beckenham. Twenty minutes later he appeared at the door accompanied by a woman with a winsome, toothy smile and a fine figure. He cleared his throat. "This is Edith, my friend and roommate," he said. After everyone kissed everyone else, he added: "I have decided to go with you to Beckenham."

"No, Staś," I objected. "Absolutely not."

"Andy, darling," said Edith, "it will give him so much pleasure." She had a German accent, but spoke a more fluent English than my uncle. They worked in the same accounting firm, Edith as an assistant to one of the owners, and Staś, who had been a lawyer in Poland, was now the only older man in a room of some twenty accountants, young Englishmen and colonials on their way up.

I knew that Staś and Edith were perplexed by Charlotte, an American woman who, they feared, would exercise that bewildering American independence and allow me to fend for myself. "Charlotte and I want to go together," I said. "I'm touched by your worry, but you must stop, for soon I'll be going by myself."

"Let them go, Staś dear," Edith said. "They are no longer children, and now we can go back to work, yes?"

Walking to Chalk Farm, I held Charlotte's arm just above the elbow and was thus protected from the rawness of collisions. Slight movements of her arm and the pace of her

walk warned me of narrow passages, approaching stairs and curbs, crowds of frantic commuters. Moving along a dark corridor inside the station, she brought her arm tight against her body, signaling me to stay close, and she hesitated for an instant as we came to the head of a staircase.

We changed trains at Euston for Victoria, where we boarded a British Rail train bound for the south of England. It crossed the ashen Thames and picked up speed as the sprawl of London thinned into short rushes of country. The blurred but restful rhythm of dark and light, pines and fields, exploded suddenly and often into platforms, crossings, piles of brick, and flashing glass.

Even on the 2:05 bound for Brighton, Helga Barnes was in the air. I chatted with a pink-faced rotund fellow opposite us who said, "Yes, yes, dear boy. I have heard of her. Bees was it? Yes, of course. Stay with her and she will surely cure you." I felt transparent, like a novitiate flushed with the shameless glow of faith. Daydreaming as the train slowed, I imagined a swarm of bees hovering above me, following me everywhere, like St. Francis and his birds.

We disembarked in East Croydon, a large busy city, still half an hour from Beckenham, which we finally reached by bus. Following Helga's instructions, Charlotte waited in the local tea shop while I walked the last block alone.

The day before, I would have expected an elegant house crawling with servants, a circle of stone beehives in back, guarded by painted aborigines imported from Australia. But as I walked along rows of neo-Georgian, neo-Tudor, and California Mission Colonial houses, each with a scrap of garden, my grandiose expectations shrank. I turned at a large waist-high sign announcing Altyre Close, and though I had no prayer of seeing a house number, I did see a white-coated figure standing in front of an imitation-Tudor

semi-detached. It was Helga Barnes looking like a missionary doctor making do with native housing. I walked toward her along a flagstone path through a small rose garden. She stood stiffly, her arms tight against her body, with a barely extended welcoming hand. The feel of her hand again struck me as incongruous. Its warmth and softness belied the coarseness of this feisty old warrior. I thought I saw a reserved smile on her thin lips, and her glasses reflected the day's hazy light like flashing semaphores.

"Yes, yes, let us have a good look at you," she said inside the house. "In that door and have a sit-you-down."

I walked in gingerly. Wearing my own doctor suit and shoes, I wanted her to know that she was dealing with a serious person, someone she could trust. For a fleeting moment I thought I would bow and kiss her hand, as the men in my family used to do; but I resisted the impulse. I wanted to charm her, but there were limits.

The room I entered, with Helga right behind me, was commonplace. The couch and armchairs were fitted with flowered covers, knickknacks were crowded into shelves, and sheer curtains hung in the windows, diffusing the outside light. Two wooden straight-backed chairs stood in the center of the room, and she motioned me into one of them. A fusty smell of rented rooms mingled with the unmistakable rancid odor of decomposing fat. She had probably been cooking with old sausage grease, which did not fit my image of healers. My eyes were attracted by a spot of bright orange glowing from an electric heater on top of which lay several saucers, each with a pile of little black beads, or strands of nubby wool, or blackberries. She bent over them and took her tweezers from her pocket. It finally got through to me—for who has ever seen bees lying in dishes?—that this was my medicine.

"I choked them early this morning," she said.

"You did what, Mrs. Barnes?"

"Choked, choked, silly boy. I squeezed my little angels behind their heads to prepare them for you poor people. They're less spiteful that way."

She walked behind me and stung me four times, once beside each ear and twice at the hairline on the back of my neck. A breathy moan escaped from between my teeth.

"Now, now, Mr. What-do-you-call-it, don't whimper like a little girl. It's not so bad. I sting myself all the time."

"By accident?" I asked.

"Of course not. Just last night, I gave myself twenty stings around a bruised knee."

"And how's your knee today?" I asked.

"The bees started the fluids moving in my body, and, you see, today I'm as fit as a fiddle."

The sting of the bee causes a poisoned wound that is both a physical and a chemical injury. A barbed stinger gradually penetrates the skin through the action of two spears sliding on each other down a hollow shaft. Sense organs at the end of this shaft tell the bee when it has made contact with the skin, and the piercing lancet is then driven down by more than twenty different muscles. Once this mechanism is in place, bee venom is forced into the wound, producing an excruciating burning sensation by the chemical action of this caustic substance, which progressively irritates new nerve filaments of the skin. The area around the sting becomes violently inflamed because of circulatory engorgement and a local destruction of tissue.

Even after the stinger and the attached poison sac have been torn from the bee's abdomen, this fragment of the bee's body continues to function as though it were still part of the living insect. The sac continues to pulsate rhythm-

ically, forcing more and more poison down the shaft of the stinger. Helga left the sacs in place so as not to waste a speck of the precious venom.

After her bees were fully disemboweled and their stingers were pumping venom into my neck, she sank in her armchair and smiled a charming smile. I had now been fully initiated. We were in this together.

"You know, cherub," she said, "I can't believe that you're an American."

"I'm Polish originally. . . ."

"Yes, I knew it. You're so polite. . . ."

"Have you treated Americans before?" I asked.

"What you think?" she snapped. "I have been doing this for forty-eight years. I have treated everyone." She thought for a moment. "But those American doctors are the worst."

As I sat there in dreadful pain, the back of my head feeling as if it were being pinched by hot pliers, she again unleashed a torrent of abuse at hypocritical doctors, ungrateful patients, and except for the few, a world peopled by a flawed humanity, hardly worth saving.

"What have those American doctors done to *you*?" she asked, interrupting her tirade.

"What do you mean?"

"What I mean is what hard drugs did they fill you with—cortisone or steroids or tranquilizers?"

"Nothing, Mrs. Barnes, no drugs," I said.

"It's a good thing," she assured me, "because I won't treat anyone whose eyes they have destroyed with drugs. And don't ever lie to me about that, for I can always find you out by your water."

I wondered about pot. "You know all those kids who smoke marijuana? Could you treat them?" I asked.

"Those dirty sex maniacs!" she yelled. "The world is going

straight to hell." She wagged her finger. "Those disgusting wretches all end up in the streets, murdering and raping." And that was that. My water would be fine. I merely had to worry about a life of crime. "And now let us have a look inside," she said, lifting herself out of her chair and poking through a mess of papers for an ophthalmoscope.

Though I had felt none of the familiar blurring or light sensitivity from pupil dilation, Helga claimed that her bees had done the dilating job at the Grosvenor, and now she shone the instrument's light into my eyes. "I have different bees for different purposes," she said as she adjusted the ophthalmoscope. "Do you know"—she dropped her voice to a whisper—"I have bees for diabetes, provided those filthy doctors haven't pumped the person full of insulin. Ah, yes," she said, concentrating on me now, "anyone can see it. It certainly is retinitis pigmentosa." I had passed; I felt proud.

"Did you notice the tiny cataracts, Mrs. Barnes?" I asked.

"What cataracts? There are no cataracts! There is only the thick fungus of retinitis pigmentosa. Cataracts! Is that what those money grubbers told you? Rubbish!"

My cataracts, still inoperable, were a familiar complication of RP. Her not seeing them bothered me, but perhaps it didn't really matter. I was in the right place. She did see the RP and even asked whether there was more of it in my family besides Sarah. That, I thought, was a good question. At least she didn't think you could get it off toilet seats.

"My grandmother had it, on my father's side."

"Yes, yes, it is clear. Look Mr. Potok," she said. "I have never failed yet with retinitis pigmentosa. I am going to treat you, and we will get rid of it. How sorry I feel for you poor people going blind from this terrible thing. You know, don't you, that if it weren't for me, no one could help you. No one in the world can do it, but I can do it! And I will cure your

daughter too. With her it will be easy, two or three weeks, and I will charge nothing for it. As for you, it will be longer but just as good. How long is your wife staying in London?"

"Maybe two more weeks."

"In two weeks there should be a significant improvement. So she will be here to see it. How she must have worried about her husband and daughter, poor soul."

I was grinning from ear to ear.

"Ah, yes," she said. "You may be glad, for you are lucky to have found me. Let them all doubt it if they like, but *you* will be back to normal again. Yes, my dear, it will all be so wonderful." Still sitting beside me, she put her hand on my shoulder. "What is your painting like?" she asked.

"Oh, Mrs. Barnes, it has changed so much in the last few years. From still life to abstract collage to monumental sculpture . . ."

"Abstract, eh?" she snorted. "Promise me you won't paint any more of that . . . that . . . abstract."

"No more," I said. "I promise." She mimed sternness, wagged her finger again, and stood up.

"Before I let you go, I want to give you some letters from my patients for you and your wife to read. Also, copies of the *Observer* article to send to your friends." I waited while she got the things upstairs. "Well, there you are, cherub. Out you go now. Come back tomorrow morning at nine sharp. And don't be late!" she warned. "Cheerio!"

Clutching the pile of papers, I ran over to the tea shop, pushed the door open, and shouted into the space: "Charlotte, she will do it!" disregarding a room full of puzzled customers. She came over and brought me to her table. "I know she will," I whispered loudly. "There's no doubt in her mind at all."

Returning to London on the express, Charlotte read the testimonial letters aloud. One consisted of answers to a homemade questionnaire.

NAME AND ADDRESS.
James McDole. Glasgow.

CAN ANY TRACE OF RETINITIS PIGMENTOSA BE FOUND IN YOUR FOREBEARS?
No.

AT WHAT AGE DID YOU DISCOVER THAT YOU HAD FAULTY VISION?
37.

WHAT WAS THE DOCTOR'S EXACT COMMENT?
That I had retinitis pigmentosa and that there was nothing he could do for me at all.

WAS IT A DOCTOR OR SPECIALIST?
The diagnosis was made by a specialist, the late Dr. MacAskill of Edinburgh, whom I consulted privately on the advice of my doctor.

AT WHAT AGE DID YOU SUFFER FROM NIGHT BLINDNESS?
I had always had difficulty, but specifically since age 20.

JUST BEFORE YOU CAME TO ME DID YOU FIND YOUR ALREADY POOR EYESIGHT FAST DETERIORATING?
Yes, a marked deterioration took place over the two years before I first consulted you. I could only write for a few minutes before my vision faded completely. I could not cross the street unaided. Unfamiliar and dimly lit surroundings were impossible for me. I could not read music without a magnifying glass. Negotiating steps and stairs was a dangerous hazard for me.

"Sounds like you," Charlotte said. "And here comes the 'after' part."

WHAT ARE YOUR PROSPECTS NOW IN YOUR PRESENT CONDI-
TION?
I can confidently face the future in the knowledge that I can see
well enough once more to carry out all the duties that are
expected of me as the head of music in a large comprehensive
school.

WHAT DO YOUR COLLEAGUES THINK OF YOUR IMPROVEMENT?
They find it difficult to believe that such a transformation could
have been wrought and are astonished at my newfound visual
acuity.

PLEASE STATE THE EXACT BENEFIT YOU HAVE GAINED BY MY
TREATMENT.
I can read fluently again with reading specs, all save the
smallest newsprint. Magnifiers not needed. I can write without
trouble for as long as I need to and do not suffer from fading
vision. I can cross busy streets unaided. I can get around with
ease, no matter what surroundings or lighting. Steps and stairs
give me no problem. My distance vision has improved tremen-
dously. I can see and identify all the faces in my classroom when
formerly I could only identify the front row. I can recognize
people on the opposite side of the street when formerly I could
not tell until people were virtually on top of me. I can read a car
number plate at 12 yards instead of only 4 feet. I can now read
and write music once again with accuracy and speed. Already I
have regained my self-respect and no longer feel shut off from
friends and colleagues. I am not treated as a 'has-been' like I
was before my treatment. Life is now more relaxed, and
because of this I am feeling much fitter in my whole person.

COULD YOUR FRIENDS AND RELATIVES BELIEVE THAT THIS
TRANSFORMATION WAS FROM MEDICATED BEE VENOM?
Some accepted the explanation readily, others had to be
convinced, and none really doubted it at all. All my friends
know that I can now see so very much better since I had my

treatment, and so all must accept that the medicated bee venom was responsible.

My eyes were as glazed as a baby's suckling at the breast. "It sounds real," said Charlotte. "It's remarkable." The old skeptic was being seduced. Each time her resistance weakened just a little, I allowed myself an even deeper plunge into Helga's world. The distance between the depth of Charlotte's conversion and mine remained constant.

She read me two letters. One was from Dr. F. Singer, a Harley Street radiologist. He stated his delight with Helga's "memorable results" in the treatment of asthma, arthritis, and retinitis pigmentosa. Another letter, in an almost illegible script, was from a patient, S. Dirkson. He said that his "eye's" were "now very bright and clear," and that he could drive his car "day or night."

I was very happy to be going back to Helga Barnes the next day. She was not about to waste time, and that's the way I wanted it, too. I wanted to be given no rest. I wanted her to spare nothing, to give me her fiercest bees and plenty of them. Enough time had been wasted already.

F I V E

Very early the next morning, I poked Charlotte, who was curled around me in Staś's bachelor bed, to tell her that I was going to Helga's alone. She mumbled some sleepy worried noises.

"Shh," I said. "Go back to sleep."

The trip had taken us more than two hours the day before, so I allowed three, to be sure. With my folding white cane buried deep in my raincoat pocket, I stepped out into the cold, gray morning. I had brought to London this cane rather than my long rigid one, because, difficult as it was for me to be on friendly terms with either, the folding cane could be made to vanish.

I had learned cane technique at St. Paul's, where, three years earlier, on the safe, insular blind compound in Newton, Massachusetts, I had acquired a number of newly needed skills, blindness skills. Having just watched the last bits of a painting life trickle through my fingers, I craved successes of any kind. The cane and braille filled the need. When Linda, my mobility instructor, took me out for our daily lesson, I would have been content if she and I were to cruise along residential streets forever, me a half block ahead, earning points for my performance, she evaluating

my progress, concerned with my safety. Because I normally walked fast, she had ordered a very long cane for me so that it could probe unknown terrain well in advance of my feet. When my cane arrived, I spent hours in the shop, grinding down its plastic tip and adjusting its cork handgrip. My cane, hanging with the fourteen others from the hat rack near the front door at St. Paul's, was the longest and, I thought, the most distinctive in the group.

Leaving the grounds took courage. We were all blindfolded, whether partially sighted or totally blind. The very first time I passed through the gates onto the public pavement, I remember standing in dread for a moment to collect my wits and guts. The sudden loneliness seemed oceanic. A breeze whistled by me. I became ears and nose and one hand on the cane. I slowly gathered confidence and headed for Newton Center. It is like the first swerving, jerky bike trip, terror and freedom competing until you are upright and in control. My sluggish legs strengthened with each step as buildings, curbs, and open spaces began to etch a map in my mind. I heard the height and breadth of things, the openings of streets like cave mouths, to the left, to the right. I heard the rhythm of the trees. Linda was somewhere behind me, but I was flying solo now. I came back exhilarated.

Late one evening, Linda took me out for an unplanned, unusual lesson. In her car, I put my blindfold on, and we tore away on a crazy circumnavigation of Newton and environs. The screechy, jerky, hairpinned ride, plowing in and out of driveways, going round and round in parking lots, was meant to thoroughly confuse my sense of direction and orientation, which it did. Linda stopped at a curb on some silent street, opened the door, and said: "See you at the shoe-repair place. It's open late tonight." Then the sound of her speeding car faded into silence. I was Amundsen nearing

the South Pole, Columbus on a starless night. I stood for a
while and listened hard. What had at first been silence
became the very muted hum of continuous traffic. I took it to
be the Mass. Turnpike and decided to make that my
temporary goal. After four or five blocks, the noise of the
pike was joined by the noise of a street with stoplights. I
heard cars whine to a halt, then, all together, start again. I
knew I wasn't far from the shops. A few more blocks, and I
heard the small tack hammer and grinder; I smelled the
waxes, the resins and polishes. A Crusader, I had found
Jerusalem on the first try.

Since St. Paul's, I'd hardly used my cane.

Inside Chalk Farm station, I stopped by the news seller's
who was untying bundles of papers. It was still not cane
time, I decided. But it did occur to me to run back, get
Charlotte out of bed, and make this trip on her arm again.
Standing there, my eyes adapting a little, I saw the overhead
lights, people's shadowy movements, and I heard the sound
of the space. Walking ahead, I saw a hint of a vertical
rhythm, which I interpreted as the stair railing. I went
toward these descending stairs, which I fear as much as a
foggy landing at O'Hare airport. As the soles of my shoes
balanced precariously on the top step, I felt as giddy as when
I think of the man who walked a tightrope one morning
between the towers of the World Trade Center. But once
the top step is under control, the rest are no problem. I went
down quickly, making up lost time.

A long, windy passage and another flight of stairs still
separated me from the platform. I heard feet echoing in the
vaulted tunnel and felt totally disoriented. I took out the
cane and unfurled it into its full, extended position. I saw the
faint glimmer of tracks below, through an arched opening

that made no spatial sense to me. I began to walk, tap left, tap right, the metal cane ringing *plink, plink,* as two women with shopping bags walked by me. They turned up the circular stairs and their voices, amplified by the cavernous space, floated easily down. "Why don't they keep these people off the streets?" one of them asked the other. "Don't they have nice clubs of their own?" When I reached the platform, I put away as inconspicuously as I could the most conspicuous object I have ever known. I hated it! With it, I had become the stuff of people's nightmares.

Before St. Paul's, on one of my frequent trips to New York, I ambled over to the Lighthouse to look at a white cane close up. I bought a newspaper lest I should be confused with a blind man. In an upstairs room where canes were dispensed, I asked for one.

"Is it for you?" the lady asked. I didn't understand why she suspected.

"For me? Of course not," I chuckled. "No, not for me."

"We need to know the person's size," she said.

"It's for a friend, a blind friend . . . about my size," I said.

When she handed it to me, I couldn't believe its extraordinary length. It stretched from the floor to just under my chin. How am I going to get this goddamn thing home? I thought.

I took it to my mother's apartment on Fifty-seventh street, carrying it like a body splint, under my coat. Its neon whiteness and screaming red tip stuck out underneath and made me walk stiffly, with a slight tilt. The doorman of my mother's building stopped me to chat. "Well, how are things in New Hampshire?" he asked.

"Vermont," I corrected.

He saw the long white thing under my coat and couldn't

keep his eyes off it, looking up, then down. The crook of the cane had poked out under my chin. Neither of us knew what to say. "Well, see you later, Pete," I said, still needing to get past the man at the desk.

Waiting for the elevator with two other people, I took the cane out and began to examine it as if it were a Celtic staff with intricate carvings depicting planetary movements. But, no matter what I did, it was simply a blind man's cane. And it was in my hands.

In the apartment, I made myself a cup of coffee, while the cane leaned against an exquisite Empire damask-covered wall. One of my first paintings, a small Cézannesque landscape in an elaborate gilt frame, hung just to its right.

I practiced on the Persian carpet. I tapped and I hit things. I nearly put a hole in the satin couch. The cane got stuck under a French Provincial armchair and fell from my hand. Its clumsiness was extraordinary: it scuffed everything; it couldn't be contained. It barely went through doorways and was too large for the bathroom. Turning corners required careful planning, and my mother's soft bedroom, with its pretty crystal bottles, silver trinkets, and mirrors, was not a safe place for it to be.

I resolved to take it out for a walk in the park. Leaving my coat inside so that I wouldn't be tempted to hide the cane again, I went out into the hall. Striding down the long corridor to the elevators, I encountered, as if for the first time, the door to the incinerator. I simply couldn't go beyond it. There, my first cane fell seventeen floors into a blazing fire. I felt suddenly light and young.

Two more canes suffered the same fate on different occasions. I hoped they had an ample cane budget at the Lighthouse, because I was sure that mine weren't the first or the last to meet a similar end.

I hugged the wall now at Chalk Farm, fearing the tracks. A little electric sign a few feet above my head flashed the direction of the next train, and, by jumping a little and squinting, I saw the difference in configuration between MORDEN VIA BANK and VIA CHARING CROSS. I changed at Euston, following people along an up escalator. At Victoria, a vast shell of iron and glass, I was unable to read the enormous computerized board announcing all the tracks, times, and destinations.

"Excuse me," I said to a man with a briefcase, "could you tell me when the next train to East Croydon leaves. . . ."

"It's all up there," he said, pointing to the board and speeding by me.

"The East Croydon train?" I tried again, addressing a squat, limping woman who seemed not to be in a hurry.

"What's the matter, chappie?" she said, giving me an angry glance. "Blind or something?" And she hobbled on by.

With the cane I was clearly damaged goods, but without it I was a confusing figure. Why so slow, why so clumsy, why so many questions? It's awkward to begin my request with: "I am almost blind, madam, so would you . . ." "Blind are you?" she might say, not believing a word of it. "Where's your white stick then?"

I have said many times, "I left my glasses at home and would appreciate a little assistance," but like a kid who is too big to sneak under the turnstiles, I feel I have outgrown that one. Preying on my blind unconscious is the story, circulated among the partially sighted, about the Boston cop who beat a young man senseless for reading a paper *and* carrying a white cane.

"My poor mother is really blind, you son of a bitch," he was reputed to have muttered between blows.

I have hardly been a model of compassion and trust when

confronting abnormality. I used to be transfixed by the sight of a man without legs, pushing himself down Forty-second Street on a noisy little dolly. I sometimes followed his creaky contraption hoping to catch him being lifted into his Rolls-Royce, for a rumor went around our ghoulish teenage circle that he really was very rich. I was sure that somehow he had cleverly concealed a trapdoor in his cart, inside which he had packed his legs like flounder fillets. I watched the blind around the Lighthouse, trying to accommodate themselves to their canes, groping, smashing into delivery wagons, resting by familiar fire hydrants. I always observed but never confronted "abnormals"; until I joined their ranks, I had no idea how to behave in their presence.

When I arrived at Helga's, exhausted and spent, shaking a little and just barely on time, I met Dirkson, the author of one of the letters from the day before. He was her part-time chauffeur. He was sitting in his red Austin reading a paper when Helga stuck her head out the door and yelled, motioning him to come in. He quickly got out of the car and jogged through the rose garden, then in its first sweet-smelling bloom.

"Sit you down, you smart little Cockney and tell Mr. . . . Mr. . . . What-do-you-call-it . . . your story. Go on, tell it," she commanded.

"It happened," said Dirkson, "on the very first day, the first bees. It hurt like the dickens, let me tell you, but when I stepped outside, it was like a veil had lifted. Everything was a hundred shades brighter. It was a miracle."

Helga sat quietly, proud, as though she were Picasso listening to yet another rave review.

"Some people are just like me," he continued, "right, Mrs. Barnes? It happens real quick. Others take a longer

time, but I've seen it happen over and over again."

I thought only of getting Dirkson alone. I needed to hear him repeat it all away from her. To my delight, Helga said: "Dirkson will drive you to the train after your bees today, won't you, Dirkson?"

I got six bees, and when she finished, she spotted the folding cane, which had half slipped out of my coat pocket onto the couch. "What's that?" she asked. "Not a white stick, is it?"

"Yes, that's what it is," I confessed.

"Well, we'll get rid of that ugly thing soon enough," she said. "A white stick, eh, Dirkson? How do you like that?" Dirkson looked down a moment and grunted. "Well, off with both of you blighters now. Cheerio! Cheerio!"

"She told me you were nearly blind," I said as soon as we got into his car. "She said that you were bumping into brick walls. Is that really true?"

"Oh, yes," he said. "I thought my life had ended. I didn't know what I'd do next, how I'd support my family. . . ."

"When did it start? Are you night-blind? Who said it was RP?" I asked all at once.

"I'm now forty-three," he said. It was my age exactly! "I first noticed something wrong when I was eighteen, in the army. I couldn't see at night. After that it got worse and worse until I was bumping into things, unable to move about by myself. I went to Moorfields, and they told me it was retinitis pigmentosa."

"You know, don't you, that it's supposed to be an incurable disease?"

"Oh, yes, of course," he said. "She's told me often enough. 'I'm the only one in the world who can cure it,' she says over and over again. And she can, too."

He drove deftly through two roundabouts, which require

excellent side vision. Being driven by Dirkson, an ex-RP, made the possibility of my driving more palpable. I put myself easily in his place.

"I had six weeks of treatment," Dirkson said, "and now I can do anything. I drive day or night. I read the paper. I can see a long way." He passed a couple of cars. "See that car way up there?" he asked, pointing. I couldn't. "Well, I can read the registration plates."

I sat back and tried to relax. Why shouldn't the same thing happen to me? "Do you really know others who got their vision back?" I asked.

"Oh, yes, quite a few. I knew the Casey girls, old McDole, Heathcroft, the bank clerk. Now there's a fellow named Tom Something-or-other who's improving fast. Also a South American. Oh, yes, plenty of them."

"It might happen to me," I said.

"It probably will," Dirkson answered. We arrived at the East Croydon station.

"I was a painter, you know. A picture painter, that is. She says I'll be painting again. . . ."

"If she says so . . ." he said. "But you mustn't worry. You must be patient and try to put up with whatever she has to dish out. It can get rough in there."

"Oh, Christ," I said, "I can put up with anything. I'll stick to her like a leech." We sat in his car, at the head of a line of taxis in front of East Croydon station, one of us a veteran of the Helga Barnes story, the other on the brink of her miracle. I felt chosen, plucked, along with Dirkson, from the ailing, limping crowd. I turned to look at him, wanting our eyes to lock and bear memorable witness to this moment, but Dirkson stared out the window, straight ahead.

"Well, good-bye," I said. We shook hands. "I would like to see you again and talk more."

"Yes," said Dirkson, "and good luck."

Inside the cold, dank station, where everything required eyes—the newspapers, the schedules, the clocks, and the announcements—I knew that it would only be a matter of time before I was a fully sighted participant like the rest. I bought a paper to rehearse. I ran down the ramp to the platform. I stood close to the drop of the tracks, practicing sighted nonchalance. In the train, I initiated several conversations with travelers, whom I found charming, even fascinating. The ride passed quickly and smoothly. All my train connections were perfectly executed. I asked for help once inside the Victoria underground. A very attractive woman could not have been nicer, reading the electric sign for me with kindness and, I thought, some interest. I hadn't even realized, until I was walking swiftly along Eton College Road, that the back of my neck was growing immense with bee swelling.

S I X

At the end of the first week, I became violently ill. The back of my neck was distorted by mounds and craters, some as tight as a drum, some soft and mushy like a half-deflated balloon. Everything from the shoulders up ached with pressure, but the backs of my eyes throbbed as if the nerve endings there were plucked violin strings. I was hot with fever, nauseated, and weak. Frightening though this was, I hoped it might be the agonizing rebirth of sight.

Charlotte, who was worried, dialed Helga's number for me. "Mrs. Barnes," I murmured, the sound resonating in my skull, "I'm terribly sick."

"Thank God for that," Helga crooned. "That's what I've been waiting for! Stay in bed, darling. Now we will have results." She was exhilarated. "You see, I know what I'm doing."

"How long will this go on, Mrs. Barnes?" I asked.

"Don't worry, angel," she said, "this is a sure sign that the bees are working. They are pushing out all the filth, clearing your body. . . ."

"What are they clearing?"

"The black depression," she began, "the evil medicines, the sluggish fluids pumped by your glands, the terrible fungus of retinitis pigmentosa."

My head reeled and I passed out. When I awoke a few hours later, the room was dark, and I panicked, not knowing where I was. Charlotte came in from the kitchen. The bed was soaked, I hoped with the escaping pollution of my overcivilized body.

"She said the only medicine you were allowed to take is Alka-Seltzer, so I got you some," Charlotte said.

"Alka-Seltzer? Jesus."

"I asked if I could call a doctor, and she yelled at me." Charlotte sat down beside me and mopped my brow with a cool washcloth. I lost consciousness again.

The next time I awoke I was better, but my fingers didn't recognize my misshapen face and half-closed eyes. I ran them over my bulbous cheeks, mouth, and ears, though I was careful not to press too hard, fearing I might squish the distended flesh like an overripe plum.

I was rarely sick, and this attack made me feel wasteful and dull, as if I were all body. I was unable to distract myself, though I had brought my tape recorder and some hurriedly chosen tapes of books I really didn't want to read, books that had entered my life with my graduate work and job in the hospital. I had a box of Carl Rogers, another of Fritz Perls, a third of Yalom's *The Theory and Practice of Group Psychotherapy*. But the last thing I wanted was to focus on the "here and now," my own or anyone else's. Even recalling the sense of some therapeutic ideal seemed trivial and paltry. I wanted to skim the waves on the backs of dolphins or soar, in the friendly clutches of eagles, over strange landscapes in a distant past.

The old dome-shaped radio next to my bed picked up two channels, one thumping with rock, the other pounding and groaning with Sir Edward Elgar. I spent the evening slipping in and out of de Chirico landscapes, a delirium

accompanied by the martial ooze of Elgar. The night brought me a whiff of old childhood nightmares. I recognized the metallic odor, the tingling in the skull, the acrid taste in my mouth.

As I tossed and turned, midway between sleep and waking, a gallery of gaunt, pale figures appeared, dressed in oversized black trousers and waistcoats and large drooping bowties. They wagged their bony fingers and, through their yellow teeth, they hissed: "Sickness is a higher form of life."

"More sensitive," said one.

"More restless," said another.

"More alert."

"More precarious."

They praised a life fraught with danger and disturbance. A decrepit figure slumping in a high-backed chair, his chin resting on the crook of his cane, whispered: "Wherever something new is being formed, there is weakness, sickness, and decadence."

I stood on a podium in the center of a hall, an easel in front of me, a paintbrush dripping with color. My whole head bulged with grotesque lumps and open sores. Though I could see, I had no eyes.

"The return to health is a setback, a subversion of genius," a poet said to me. "Only illness is truth."

I slobbered paint and spittle over my canvas while all of them praised my work.

"It is obviously years ahead of its time," said one.

"Once in a generation!" someone said.

"In a century!" another corrected.

They argued about compensation and the fabulous feats of cellular regeneration. They talked of lizards, hydra-headed fish, segmented worms. They talked of the energy of

madness, the sublimation of the senses, the nobility of pain. I recognized among them little ugly Michelangelo; short-legged, syphilitic Schubert; blind, mean Milton; gimpy Byron; Beethoven, deaf and petty.

The last words I heard as I tried to shake the images from my mind were: "Without the Black Death, no Renaissance. . . ." I woke Charlotte in the next room and talked the images away.

Traffic roared by on Haverstock Hill, just outside my window. Scholars, I supposed, were already in their seats at the British Museum, artists were putting gesso on their canvases, writers were tearing sheet after sheet of manuscript from their hot typewriters.

As for me, I was undergoing a strange metamorphosis, an awakening, the first systemic reaction to a week of daily poison. I pictured the bee venom exorcising evil spirits and that internal filth accumulated from forty-three years of life. I imagined it working its way through brain disorders, incipient tumors, prostate problems, receding gums. It would, according to Helga, cause the emission of bile and pus, the eruption of boils, the exhalation of vile odors.

Two days after my bee illness, I was back at Helga's, sitting in the usual patients' chair. Her armchair was surrounded by piles of paper, some tall, substantial stacks of newspapers, some scattered mounds of letters. Helga stood framed in the doorway looking to me like a small spruce tree, her head covered with a wispy triangle of gray or yellow hair, her short, dumpy body becoming broader as it approached the floor. She stretched to step over the stacked papers and sank into her usual place.

"Have you ever seen so many letters, Mr. What-do-you-

call-it?" Some days she didn't even attempt my name. It was strange to be bound in the intimacy of our daily transactions, knowing that usually she couldn't remember my name. The absence of any name maintained a barrier, perhaps consciously constructed by her. "I tell you they are writing me from everywhere. Can you imagine, I have a letter asking for cheap accommodations. What do these idiots think? That Helga Barnes is a hotel service?" She looked for that letter, found it, and tore it into shreds, spreading the bits of paper over the whole mess. She got up, and with her large buttocks pointing skyward, she riffled through more papers. "I want to read you a special one this morning," she said. "How can I do everything all alone? Where is that stupid letter?" By now half the floor was blanketed with scraps.

I simply sat in the middle of the room. She suddenly kicked a pile furiously, scattering it like a flock of pigeons. Her face reddened. She peered for a moment and spotted it.

"Aha," she said triumphantly, waving an envelope, "here it is. Listen angel, listen to this."

She sat down again and began reading a long, articulate letter from an Englishman describing his and his daughter's retinitis pigmentosa. He was desperate. Helga Barnes was his last hope. "I would rather die," Helga read, "than accept blindness. I refuse to believe that nothing can be done."

Helga beamed. "That's what I like to hear. This blighter has spunk! Of course he won't accept blindness. All you people who simply take up your white sticks and act as if it were perfectly normal make me sick! You are being taken for fools. You have to fight!" she shouted. "I have the bloody cure, but do they bloody tell you about it? No, they don't tell you about it. They laugh at me. It's in their bloody interest to laugh at me. That way you'll keep going back to them,

begging them, 'Please try your new drug, try it on me, darling doctor,'" she whined. "They charge you twenty-five quid for an injection of distilled water. Don't think they don't! I've seen it happen."

She took a long breath and took up the letter again. Within it she found an enclosure, a letter written by an eye specialist at Moorfields.

"So this is a note from the *famous* Mr. Bach from *renowned* Moorfields Eye Hospital, is it?" she jeered. "They think they know everything, the rotters. Let's see what Mr. Bach has to say." And she read the letter, a prognosis and some genetics of RP. She read slowly, concentrating like a child, sounding out passages to herself first, her lips moving silently, then aloud to me. She plowed on bravely, then stopped in mid-sentence, encountering the words *autosomal recessive*. Her lips moved furiously, her forehead wrinkled with the effort, and finally she attacked it head on and garbled it completely. I felt badly for her.

As Mr. Bach's RP narrative continued, she began to mutter "rubbish" under her breath.

"Rubbish!" she screamed, finally in a total rage. "Carriers, carriers"—she pounded her fists rhythmically—"bloody carriers! I can cure them too." Nothing could stop her. She looked at me, and her trembling body quieted. "Bring your son," she commanded. "He's supposed to be a bloody carrier. I'll cure him of carrying, that's what I'll do!"

I sat nodding, resisting my impulse to run. She then told me the story of an old patient who had called her late one evening, during a raging blizzard. The woman was frightened by boils that had begun appearing on her legs.

"Yes, yes," Helga had assured her, "all of that filth the doctors fed you is coming up on your legs. Don't worry. The

bees are doing their job." The woman called again, with new boils elsewhere, and the third time Helga wakened the chauffeur to brave the storm in her Daimler.

"Those boils were enormous," Helga told me, "absolutely gigantic, and they began to pop. Some of them broke off from the old girl's body and floated up to the ceiling where they splattered the room with a vile liquid."

Helga had gotten up to act out the scene. "Splat! Splat! And down came torrents of putrid filth."

She ran around the room dodging the bursting bubbles. She was laughing so hard now that she was hardly able to continue, but still she danced, turning and jumping. Her face was artless and naïve. She flailed her arms, crawled through lines of enemy fire, swam sidestroke in the river of boils.

She wiped her steamy spectacles. I sat in the middle, amused and terrified, like watching the furious manic performance of a sick child. Finally she sat down, out of breath.

"So, that is what happens to drugs. If you are lucky, they pop out on the body, but sometimes they are so strong that bees cannot budge them. Never," she warned, "never let them give you *anything* after I am through with you." She began to relax. "What a night it was!" She let out a final cackle. "Let me tell you, I have never had one like it."

Added to the known levels of my healer's madness, added to her rage and megalomania, was this banal looniness, this good old-fashioned craziness. This dimension frightened me more than anything I had encountered in her yet.

At long last, she seemed to recognize me as a patient awaiting treatment. "Well, now," she said, "are we seeing any brighter today?"

"No, not yet. . . ."

"Are we seeing any cheerier then?"

"What do you mean by 'cheerier,' Mrs. Barnes?" I asked.

"Cheerier, cheerier," she repeated. "If you are seeing better, it is cheerier, is it not?"

She fetched her ophthalmoscope and sat down next to me.

The ophthalmoscope is an ingenious instrument improvised by Hermann von Helmholtz, one of the most brilliant scientists of the nineteenth century, to demonstrate to his students, for the first time ever, the live human retina. Until then, looking into the eye was like looking through a keyhole into a dark room. Helmholtz's solution lay in finding a way, using angled mirrors, to project a beam of light directly along the path of vision. The ophthalmoscope allows one to see the pink of the illuminated retina instead of the black of the interior space of the eye.

As Helga held the instrument between us, my face on one side, hers on the other, she chirped with delight: "It is absolutely marvelous! The pigment is dehydrating faster than even I suspected!" She had forgotten to turn on the light of her ophthalmoscope.

Her fingers on the instrument's handle made it sound brittle and chintzy, like a toy made in Taiwan. It could as easily have been a plastic eggbeater or a cheap rotary drill.

"Ach, it is fantastic!" Helga said. I suddenly remembered myself at age fifteen in a New York whorehouse, trying to produce, while the lady under me, who could have been dozing, exhorted mechanically: "Yeah, baby, that's the way to do it."

"Mrs. Barnes," I said, "the ophthalmoscope isn't on."

She took it away from our faces and examined it. She said that she liked to turn it on in stages. "I had it on very low," she said, flicking it on. "That's the way I like to do it. And let me tell you, I see a tremendous improvement. The film is

evaporating in the center of the right eye and on the edge of the left."

She seemed oblivious to the immensity of her blunder. I couldn't believe her nonchalance. I pictured her after my departure, hitting her head against the wall, crying: "What have I done? I must be getting senile. I have never messed up like that before."

"If the pigment is thinning," I said, "why isn't my vision better?"

"Because, you silly sod, even though *I* can see the improvement in your eyes, *you* can't possibly notice it yet. It takes time for the eyes to start working again. As that fungus disappears, the inside of your eyes steam up, and for a while your vision will get cloudy. Then the mist will evaporate. . . ."

On another day, I might have dismissed her archaic allusions as charming, even poetic, like the early Greeks who believed that the eyeball emitted rays of vision that illuminated objects in the viewer's path. I might have thought it irrelevant, for I was sure that she had no biochemical knowledge of the visual system. But on the day of the unlit ophthalmoscope, I found her behavior and language unbearable.

"I thought the dead cells under the pigment couldn't be regenerated," I said angrily. "And *what's* dehydrating? *What's* evaporating?"

"Absolute rubbish," she said. "They are very much alive, and the bees give them the push they need."

She put her ophthalmoscope away. "Ah, angel, the eyes are cantankerous. They rebel against treatment. But they can't fight it forever."

She stung me with twelve bees, the most to date, and apologized for keeping me so long. On the bus back to East

Croydon, where Charlotte waited in a coffee shop, tears streamed down my face.

"She says she can see my eyes getting better," I said, not looking at Charlotte. She touched my arm, seeing there was something wrong. I hailed the waitress.

"Charlotte," I said, "she didn't turn the light on in her ophthalmoscope."

I looked at the shadows in the coffee shop, the morning regulars. "My eyes don't feel better."

We drank our coffee in silence. I knew we had an audience, and I obliged those dark unseen faces. "Why should I give a shit," I yelled, slamming my fist on the table, "if a goddamn beekeeper understands the fucking ophthalmoscope?" The place was silent. "*Or* the visual system?"

"Andy, let's get out of here," Charlotte said.

"It's all right," I answered. "These people don't mind. We're providing the morning's entertainment. . . ."

"That's not what I mean," Charlotte said. "Let's not come back to that awful woman."

"But I can't leave yet," I heard myself explaining. "There's Dirkson and the others."

"But how can you stay?"

"What's the difference if she's . . ."

"She's a phony, that's what she is," Charlotte said. "She's going to pull you apart."

"I can take it," I said.

"I'm not so sure. Look at you now. And besides, people die from beestings. . . ."

"Not Helga's bees," I heard myself defend her once again. "Look, she screwed up. She probably wanted to tell me I was improving to get things moving. You know, suggestion, conditioning. . . ."

"Did you tell her you saw the unlit ophthalmoscope?"

"Sure. I told her right away."

"I wouldn't be at all surprised then," Charlotte said, "if *she* gets rid of *you*. You're like a witness to a crime."

"You're being melodramatic," I said, but I thought she might be right.

As long as healing instruments or healing systems exist—whether helpful or imperfect or destructive—they are used. Depending on a patient's luck and intelligence of choice, the user is more or less skillful, more or less honest, and the technology more or less benign.

When I was a child and I wheezed or coughed and couldn't be sent off immediately to the country, I would lie in my blue bedroom (painted blue to match the color of my eyes) awaiting the "cupping" doctor. Soon enough, I would hear him clanking down sedate Moniuszki Street, his black bag bulging with little glass jars. He entered my room cheerily, rubbed his hands together to warm them, and placed his jars on a small table brought in for the purpose. He attached them to my back by creating a vacuum inside them with a match and they would hang there sucking gently, pleasantly. After a while, he pulled them off, each one tugging the skin, then popping with a loud smack. Their purpose was to clear my lungs, and, eventually and invariably, because of them or in spite of them, my lungs did clear. After the doctor left, I would sneak out of bed to look at my back in the mirror, gorgeously ringed with purple circles. I loved the cups.

Helga was closer to a more contemporary medicine. Her assaults were different only in method of application, not in kind, from establishment medicine. Both were traumatic and invasive, both constituted a war on disease in which the patient, caught in the middle, was the victim. Both, I

thought, were equally inspired by ambition. I felt certain that, in spite of her antiestablishment rhetoric, had Helga been given the chance to make Grand Rounds in some fancy hospital, followed by grateful, fawning apprentices, she would have joined any orthodoxy, and her special brand of arrogance would not even have been noticed as peculiar.

A team of doctors and technicians at New York Hospital surrounded me many years ago, clawing at me, jerking and twisting my head into position to take fundus photographs, color pictures of the back of the eyes, shot through wide-open pupils, illuminated by terrible, blinding lights. The end result is primarily useful for recordkeeping, facts to be entered into their permanent collections of discolored retinas, pale with sickly yellow or blackened with debris or bursting with exotic crimson hemorrhages. The gains to patients from this procedure are doubtful; the debits are pain, stress, and, for many hours afterward, a temporary blindness, the kind produced by staring at the sun. No one seems to know for sure if the damage is permanent, but many believe one of the more promising hypotheses in the field of blindness prevention is that strong light irreparably damages the retina.

About the same time, I became a guinea pig, a statistic, in the development of human electroretinography, which measures retinal electricity triggered by light stimulation. A specific wave pattern was established as a normal response, while malfunction of the photoreceptor cells produced anomalies in the picture. Disturbances in this cell layer manifested themselves as changes in the peaks and valleys of an electroretinogram. Off-register waves, lowered apexes or unmeasurable responses, seen as flat lines, were each interpreted as symptoms of some retinal abnormality. Flat ERGs, however, don't necessarily signify blindness, as a flat

electrocardiogram signifies a silent heart and death. This technology became the most advanced method of diagnosing people with retinal problems, and though it was useful for a single diagnosis, the manufacture of the equipment assured its overuse. It, too, depends on high-level illumination, and once ERG machines find their way into every ophthalmologist's examining room, already frazzled retinas will be further battered by blinding lights.

When electroretinography was still in a crude stage of development, a wild and temperamental Yugoslav named Mikhailovich was its wizard-in-chief in the New York area. Terrified patients, whose teary, dilated eyes were held open for hours at a time with hard glass contact lenses and wired to electrodes, stared painfully at flickering lights of various wavelengths. We were immobilized and helpless, with little reassurance from Mikhailovich, who grunted angrily as he ran back and forth in his cluttered torture chamber, yelling at assistants, pulling plugs and soldering loose connections. Our comfort and peace of mind were about as important to him as an experimental rat's. The agony lasted long beyond a patient's departure from this weird laboratory. My eyes were so abused by light that for days I could hardly see through the pulsating black retinal afterimages.

Something usually went wrong with Mikhailovich's equipment, so that the procedure had to be repeated several times. The only reward for putting up with the pain of the ERG and Mikhailovich's unpleasantness was his beautiful Swedish assistant, who knew her way through the maze of wires covering me like seaweed. As she helped Mikhailovich at a workbench, I watched her every movement. Having just handed Mikhailovich a pair of pliers or the end of a wire, she would turn to me and smile. I would blow her a kiss. Hands

on her hips, emphasizing her voluptuous body, she would delicately blow one back. As Mikhailovich thrashed around a box of electronic widgets at the other end of the lab, he would tell Ingrid to make sure I was properly connected.

"I will check," she'd say, bending over me and brushing my cheeks with her breasts.

As I lay there, intricately wired and plugged into every outlet in the room, Ingrid parted the color-keyed tangles of copper spread over my face and chest to allow our hands some freedom of movement. We were hidden from Mikhailovich by a black booth into which I would soon be wheeled, and while we heard his mumbling over some immobile meter, Ingrid's mouth descended on mine while my hand ran up her long velvet thigh. We stole delicious moments in this madhouse, and on ERG days, we would meet in the late afternoons for a quick drink, and unable to bear it any longer, we would rush to her apartment to finish in leisure what we had begun with the excitement of children behind half-closed doors in the laboratory.

I found it hard to believe that these quick, erotic moments didn't affect my ERG. Mikhailovich must have suspected something, I thought, seeing our flushed faces or Ingrid's rumpled lab coat or the bulge in my pants. But he never said anything about it. Instead, he got his revenge by keeping me overtime in the black booth, flickering red, blue, and white lights at various intensities and frequencies into my eyes, making them flow with a constant stream of tears. I also suspected the results he sent to my ophthalmologist, always flat, were not mine but those of a completely blind man.

During the first couple of weeks, Helga had me call her at least once, sometimes twice a day, to report on my vision,

just to chat, and to make the next day's appointment.

"Good evening, Mrs. Barnes," it would start.

"Yes, yes, and how are we today?"

"Fine, thank you."

"I don't mean 'fine, thank you.' I mean, how are we seeing?"

"I don't think there's any change, Mrs. Barnes."

"*You* '*don't think*' there's any change? What do you mean, *you* '*don't think*'? Is there or isn't there?"

"There isn't."

"Well, that's all right for now," she would say. "It's still early. Don't worry. I have never failed yet, and I won't fail with you."

In fact, I was seeing very badly. I couldn't tell whether it was as bad as usual or worse. The light of the hazy English sky, a grayness that ordinarily would have suited me well, hurt my eyes. The blind areas seemed exaggerated, more clearly defined. I tested my vision everywhere, more and more desperate to report some concrete evidence to Helga. I spent hours at night looking out the window of Eton Rise, using the light of a streetlamp for a central point and, moving my eyes up and down, left and right, along an imaginary x and y axis, I plotted my field of vision. I hung these charts on Staś's living-room wall. On some, I filled the blanks—the blind areas plotted and sketched to represent real shapes—with black Magic Marker; on others, the shapes I saw through—the rings and crescents—appeared in black. One large wall was soon covered with these rather crude designs, which, all together, looked like Islamic mosque decorations. They signified nothing in particular, but what I saw of them pleased me aesthetically. Perhaps I'd develop them on canvas one day, I thought.

The streets of Hampstead also served as my testing grounds at night. I took new routes, stumbling over curbs, smashing into bewildered strollers on Haverstock Hill, where the traffic obscured the sound of their footsteps.

I tested everywhere. How close could I come to reading the big clock at Victoria, or how soon before its arrival could I see the 194 on the East Croydon bus? From the top of the bus each day, I would strain to see shop signs I hadn't been able to make out the day before. Little by little, the letters came together to spell RACING LTD. or WOOLRICH or POST OFFICE.

The Chalk Farm underground station, straight from a Piranesi dungeon drawing, served as a dark adaptation test. It was deep underground, where powerful winds, gusting to fifty miles per hour, shot cinders into squinting eyes and forced everyone to wrap themselves around their hats, umbrellas, and papers. It was dark and ominous. It was the kind of test Helga liked, rather than Snellen eye charts or field-of-vision graphs. All her stories of improvements alluded to the sudden mysterious reappearance of objects— roses, milk bottles, the print of her dress—on the viewer's previously useless retinas. These images were filling my mind with vivid examples of what would one day happen to me.

"You should see my Lima chappie," she would say. "He is so wonderfully happy because just as his wife was driving through the tunnel this side of Heathrow, he saw *everything* perfectly, the darling boy. It was as if a giant television set had been turned on. He is so happy, I can hardly tell you."

Helga was disdainful of patients' extracurricular activities, which meant everything that didn't pertain to the treatment. All of my efforts during the entire waking day were to be

devoted to the pursuit of my cure. She began to tire of Charlotte's presence, even though she never saw her after their meeting at the Grosvenor.

She asked daily: "Is your wife still in London? Isn't it time for her to go back?"

I wanted to devote myself exclusively to my therapy. Though I didn't look forward to Charlotte's leaving and my imminent loneliness, I did anticipate an obsessive devotion to my cure, a new fanaticism in all my daily activities.

For Charlotte and me, these first weeks in London were like a grace period in our marriage, a marriage that too often felt hopeless. Our roles as parents, lovers, and artists had become so scrambled, and our emerging roles so unexpected and alien, that we both felt cheated, bitter, and angry. We fought about everything: the children, our lack of involvement in each other's work, the dying heater in our tiny car, the bank overdrafts. Charlotte would demand that I continue to criticize her designs, not wanting to understand how visually vulnerable and impotent I felt.

I wanted to be taken care of, read to, provided for. I wanted her to arrange for new lighting, to discuss my thesis with me, to give me advice on my counseling efforts. My blindness blinded me to Charlotte's needs: *she* wanted to be cared for, even by the likes of me. Everything triggered a fight, and a fight usually meant many days of glaring, passing each other without a word.

London was a respite, but when the surface was scratched, we felt driven into our old stances. For Charlotte, Helga represented the abhorrent world of magic, of intolerable egos and temperaments, of all-demanding, all-consuming wills. This other woman, this witch, this threat, wanted all my time, all my attention, and I was happy to

oblige, grateful for the opportunity to deal with nothing but myself.

Afraid of losing me altogether to these demonic forces, Charlotte urged me to go with her to concerts, the theater, even museums. We explored much of the Heath, Hampstead and Highgate, the area that would be most accessible to me after her departure. Accompanying Charlotte to the British Museum or the Victoria and Albert, I often had to slither away into a taxi, to go home quickly and dump myself into bed, exhausted from whatever the bees were doing with my body. I went to museums grudgingly anyway, finding them increasingly frustrating, but once in a while, I felt the urge to go, just to be in the presence of something exquisitely handmade, eye-made. In the manuscript room of the British Museum, just being among pages from the notebooks of Conrad or Keats or an illuminated medieval manuscript or a Mozart score made living even a damaged life easier to bear. Being human, like them, was enough.

Standing in front of a Sung-dynasty bowl, Charlotte would pick out the stingers, those small, barely visible fragments hanging from the back of my neck. Like *bandarillas* hanging from the neck of a bull, these venom sacs, stuck there for a few hours after treatment, humbled me until they fell to the marble floor. I fantasized a sleuth investigating a theft, identifying the strange bits of carbohydrate that could only be the emptied poison sacs of *apis mellifera*, the honeybee.

Being in London was certainly one of the attractions of this "cure," even though being nearly blind there was like being nearly blind anywhere. Getting around, enjoying the discovery of a new place, presented the same daily frustrations as it would have in even less exotic spots. Bloomsbury remained just another section of town with uneven sidewalks, construction barriers, fire hydrants; Charing Cross,

with its marvelous bookstores, was just another street in which to lose my way, where crowds surged toward me like tidal waves. On Shaftsbury Avenue, where I would sometimes go to surprise Charlotte with theater tickets, I collided unpleasantly with pedestrians and shadowed them to cross the busy streets.

As often as possible, we went to the Royal Festival Hall, where the concert season was in full swing. We usually sat in the middle of the second balcony, where the acoustics were exquisite, listening to Barenboim, Zuckerman, the English Chamber Orchestra. But as I listened, my eyes wandered to the grid of lights overhead, and I tested fitfully, first one eye, then the other. Looking at the center of a line of lights, I strained to see any of the six or so others on either side of it. I never saw more than one and the faint glow of another. I missed whole movements as I contrived ever newer eye tests, scoring for glare, field, and acuity. Down below, on the stage, no matter who was playing or how many there were, I saw an annoying field of vibrating browns and blacks under partial eclipse.

On the occasion of a benefit concert for Vietnamese refugees, we sat very close to the piano at the Royal Albert Hall, a large dark space with the atmosphere of an immense riding school. We heard an extraordinary playing of a late Mozart piano concerto, with the soloist teasing from the piano the most heart-rending sounds, alternately mournful, rich, and delicate. The music took me into a rare place for which I have no name; it created a completeness and a peace, an equilibrium between the weight of the world outside and the interior pressures of my heart.

But as we walked, after the performance, to the Kensington underground, I felt unsure of my responses, suddenly so

unsure of everything, as a matter of fact, that I panicked. Just as the intense visual examinations had utterly confused me, so now my other judgments seemed entirely unreliable, dependent on mood, on whim, on strange interior battles over which I had no control. Everything was in flux, and I could no longer count on sight or hearing or mind. That must have been it, I thought: art was unclear. What seemed momentous inside the studio, like the presence or absence of deep space on the surface of a canvas, or the hint of a figure in the midst of apparent turmoil, wasn't all that significant outside. How clear it would have been to demonstrate against the war again, to run along the steps of the National Archives building in Washington, with club-swinging riot police in pursuit and a phalanx of masked troops shooting tear gas from below.

On the way to the Kensington station, I had to crouch down against a building. I felt weak and nauseated. People walked by toward the trains and taxis.

"I don't know if it was good or bad," I said to Charlotte. "I don't know if anything is good or bad. I'm going to be sick."

"Just stay like that a moment," she said. "Don't worry. It'll pass."

It passed, and we walked through a long tunnel, leading to the station. Along the way, a hippie guitarist strummed a Beatles song. It sounded awful, yet people gathered around him, dropping coins into his guitar case.

"Let's listen," I said to Charlotte.

"It's pretty bad," she said. And her words could not have been more comforting at the moment.

Toward the end of April, about three weeks after starting treatment, Charlotte and I walked up Haverstock Hill to buy

a ready-made dinner in one of those rank take-home chicken places. We bought plenty of beer and looked forward to a dopey evening in front of the TV. It started to rain, and clutching the greasy box and the loose cans of export lager, we ran back down the hill.

The sky was charcoal gray, and the sidewalk gleamed like a mirror. We ran a block before I realized that I wasn't holding Charlotte's arm. I looked up and saw her occupied with keeping dry, her raincoat draped over her head, running as I rarely see her run. I ran also and saw all the curbs, the imperfections in the cement, the overhanging trees.

It was pouring now. Umbrellas rushed past me. The space between us was visible space, safe space, not a prickly blackness full of spikes and elbows, collisions and curses. In the street, the hum and splash of tires had three-dimensional entities called cars riding on them. I saw them behind the glare of headlights.

"Here's my arm," Charlotte said.

"Charlotte!" I roared. "Do you see what's happening? I'm doing it all alone!" Charlotte stopped and turned.

"What did you say? What do you mean?"

I bent my head back to let the rain wash my face. The gray sky was restful to look at. I bathed my eyes in soft, warm grayness.

"Andy," Charlotte said, tugging my sleeve. "Tell me what's happening. I mean exactly."

I jumped and yelped some insane cheer. We hugged and kissed, climbing over each other, the chicken grease trickling down my coat, the beer hissing, ready to explode. I ran ahead, crossing the street easily and down the darkest section of Eton College Road.

Charlotte was behind me, yelling, "Wait, wait! Andy, what's happening?"

A clangorous din erupted in sleepy Eton Rise as we charged up the marble stairs. The door across the way opened, and I smiled at a neighbor who seemed ready to do battle. I lifted Charlotte out of the corridor onto Staś's gray shag rug.

"Is it real?" Charlotte asked. "Tell me everything."

"Oh, God, I don't know. I think so. Yes. Everything's clearer, the curtain in front of me is gone."

Charlotte took the *New Statesman* off the coffee table. "What can you read?" she asked. And, with the print about a foot from my face, looking long and hard, I read a few words, that's all.

"I should call Helga," I said. "She'll be so happy. Finally . . ."

"Maybe you should wait. It's late. Wait till morning," Charlotte said.

"I'll call Staś and Edith," I said, but as I picked up the receiver, I thought that maybe I had become especially sensitive to normal fluctuations I'd never noticed before. Maybe it was my mood or the slow osmosis of suggestion. What about the level of pollution or the barometric pressure? Or the bees? I put the phone down and decided to wait.

The next day we got up very early and took a bus to Pimlico, then walked back through Chelsea to King's Road, where we looked for gifts for friends back home. In an antique mall, I saw my way through a labyrinth of old furniture, china, silver, and gold. Objects sparkled with pinpoints of light, their rich textures soothing and clear. Nothing vibrated, and my eyes felt stroked by a gentle

clarity. The surfaces of things seemed soft and absorbent, brilliance giving way to a plushness of matte reds and blues and yellows. It was like *The Night Watch* before and after cleaning, where the old, dark Rembrandt suddenly lost the soot of ages, revealing colors and details beneath the deep shadows unseen for centuries.

We walked, skipped, and danced through Belgravia to Hyde Park and home again. "Do I seem different?" I asked Charlotte. "If you were to write home now, how would you describe it?"

"It seems that there's a difference, but who knows? That would be for you to say."

"I hope it's just the beginning," I said. "A sneak preview. The spectacular's still to come."

When we got back to Eton Rise, Charlotte lay down on the couch, one knee up and her legs crossed. Her hands were behind her head feeling her new short haircut. She yawned loudly and looked at the ceiling. She stretched her legs, and as she closed her eyes, she said: "I wonder if you'll paint again."

I wondered if I'd paint; I wondered if I'd stay at home, with Charlotte. I'd probably leave, I thought, at least for a while. I wondered how safe Charlotte had felt with my dependence, whether she feared my leaving, whether she had feared or even seriously considered that this would happen. I ached to be whole.

I looked at her, sleeping now. Her face was chiseled and strong. She was built like a boy, without a waist, and she was quick, like a boy. A warm, comforting surge of love came over me. If I were to be unburdened of my blindness, if I were to feel uncomplicated and light again, it was Charlotte who deserved me, if she wanted me. She had put up with a lot.

I called Staś and Edith, who were overjoyed with my improvement. "I knew it would work," they each said.

For the first time, I thought about writing. I opened a notebook and wrote down the words to see what they looked like: "Once, when I was blind . . ."

SEVEN

I continued to write in my journal. "Who will ever believe me," I asked with a wide-tip Magic Marker, "though even Charlotte says it's so?" But my language sputtered and coughed; my words weren't equal to the miracle. I tried to write a model letter to send to everyone I knew, but I could only think of poker images: pulling to an inside straight, investing so much in the pot that I couldn't fold, and only my poker friends would understand that the metaphors weren't meant to trivialize my dilemma and my triumph. My heart pounded now just as it does when I squeeze the winning card into my hand. I had to go outside to breathe.

I quietly let myself out and ran down the stairs, two steps at a time. I walked down Chalk Farm Road to Camden Town, through swarms of shoppers, into Euston Square. I walked into quiet streets whose row houses stood behind low ocher walls and weedy little gardens. As I penetrated unfamiliar terrain, I felt confident that I would soon possess all the advantages of the sighted, that I would soon go anywhere, read signs, recognize landmarks. My routes would again be guided by architecture. I would again be seduced by forms and colors, move along visual lines of force. I felt quite ready to take my place again among all

those people who interpreted signals and symbols, who were, because they had functioning eyes, receivers of the most interesting, the most complex, stimulating, comprehensive, informative, and provocative system I could imagine: the visual.

I walked into a store called Lady Jane, where I saw racks aglow with chromatic gradations of blouses and pants. Yellows, reds, blues, and greens each occupied their own spinning carousel. I thought I could distinguish between pinks and oranges, blues and greens for the first time in years. The blues alone ran from the palest most powdery hues to deep cobalts and ultramarines. It was like being back in Josef Albers's color classes, where our medium was a box of 220 colored papers, each one delectable to the eyes and to the touch. Holding a fresh box of those papers was like sitting at a finely tuned harpsichord. We acquired the power to manipulate color, to make nauseating greens and disgusting browns modulate and sing.

I chose two blouses—rust for Charlotte, navy for Helga— and then I called Helga from the store. I expected squeals of delight; instead, it was like reporting the day's events to General Patton.

"Yes, yes," she said, "that's what I've been expecting. It's about time."

She was standing in the hallway just outside her examining room. I knew from her tone and volume that a patient was sitting in the patient's chair, listening intently to every word, as I had done on many occasions already, grateful for the interruption and dreaming of his own cure. Perhaps she had a bee on the end of her tweezers as she stood, proud and erect, saying too loudly: "You are seeing perfectly well, are you?"

"Well, no Mrs. Barnes, not perfectly . . ."

"Wonderful, wonderful. That is good news," she said. "You see, I will cure the whole bloody lot of you."

"Yes, I hope so, Mrs. Barnes, because I still can't . . ."

"And listen to this," she continued in a comradely, jovial voice. "Old Mrs. What-do-you-call-her . . . you know," she whispered, "that dumpy blind one . . . what is her filthy name? She is completely blind," she mumbled. "Well, never mind," she continued, in good voice again, "she called me this morning to say that she was walking through her garden . . . poking around with her stupid white stick, no doubt, kicking up the flowers . . ." She paused and chuckled. "Suddenly she saw a big red rose. . . ." Another pause while a big red rose appeared in my mind's eye. "A big red rose, do you hear? She saw it with her bloody blind eyes, where there was nothing but blackness before."

"That's wonderful, Mrs. Barnes," I said. "You must be very pleased today." I didn't want to talk about old Mrs. What's-her-name, I wanted to talk about *me*.

"Even the chappie from you-know-where, what-you-call-him . . . Lima . . . my Lima chappie . . . he is better. . . ."

People were beginning to collect around Lady Jane's lone telephone, which sat on a desk with the cash register. To its right I noticed a basket of women's panties, individually wrapped in cellophane with silhouette illustrations of numbered erotic positions. With one hand I started to leaf through them. I put number 19 aside for Charlotte. It pictured a male form bent in a toe-touch. His head blended pleasantly into the lower parts of a lady doing the Plow. Helga droned on. "Harold Macmillan knew," she said. "I cured plenty of *his* friends! *He* knew!"

"Mrs. Barnes, I am in a little store and they need the

phone," I said, intrigued now by a silhouette of a kind of flying rear entry, straight from the Ice Capades.

"If he had recognized me, everyone would have the cure. But not now," she said. "It stays with me forever. . . ."

"I'm afraid I must give up the phone. . . ."

"Yes, yes, angel. I understand. Take the day off and call me tomorrow."

On my way back home, I bought six bunches of flowers, half daffodils, half narcissus, at the Chalk Farm station. Walking on Eton College Road, I wondered how to celebrate events of this magnitude.

Charlotte laughed as she opened the door. "There's only one vase in the house," she said. We filled it and stuffed the three glasses from Staś's cupboard with most of the rest. The remaining flowers perched, without water, around the rim of the umbrella stand in the hall.

We sat down and smiled. She leaned back on the couch, while I grinned foolishly. Charlotte reached into her woven shoulder bag and pulled out a book of Isaac Babel short stories we had brought. It made for wonderful short spurts of reading aloud. "Here's a really short one," she said. "See what you think of it."

In the story, Babel is walking in the woods with Alexander Kerensky. Kerensky seems to miss all the beauty of the place by refusing to buy a pair of glasses for his shortsightedness.

" 'Just think,' says Babel, 'you're not merely blind, you're practically dead! Line, that divine trait, mistress of the world, eternally escapes you. Here we are, you and I, walking about in this magic garden, this Finnish forest that almost baffles description. All our lives we shall never see anything more beautiful. And you can't see the pink edge of the frozen

waterfall, over there by the stream! You are blind to the Japanese chiselling of the weeping willow leaning over the waterfall. The red trunks of the pines are covered by snow in which a thousand sparks are gleaming. The snow, shapeless when it fell, has draped itself along the branches, lying on their surfaces that undulate like a line drawn by Leonardo. In the snow flaming clouds are reflected. And think what you'd have to say about Froken Kirsti's silk stockings; about the line of her leg, that lovely line! I beseech you, Alexander Fyodorovich, buy a pair of glasses!'

" 'My child,' Kerensky replied, 'don't waste your time. Forty copecks for spectacles are the only forty copecks I've no wish to squander. I don't need your line, vulgar as truth is vulgar. You live your life as though you were a teacher of trigonometry, while I for my part live in a world of miracles, even when I'm only at Klyazma. What do I need to see Froken Kirsti's freckles for, if even when I can scarcely make her out I can see in her all I wish to see? What do I need Finnish clouds for, when above my head I see a moving ocean? . . . To me the whole universe is a gigantic theater, and I am the only member of the audience who hasn't glued opera glasses to his eyes. . . .' "

Babel's story ends when, six months later, he sees Kerensky again. This time, June 1917, Kerensky is ruler of Russia.

"A rally has been called at the House of the People, and there Alexander Fyodorovich made a speech about Russia—Russia, mystic mother and spouse. The animal passion of the crowd stifled him. Could he, the only member of the audience without opera glasses, see how their hackles were rising? I do not know. But after him Trotsky climbed to the speaker's tribune, twisted his mouth, and in an implacable voice began: 'Comrades!' "

Charlotte couldn't have just stumbled onto this. She must have been planning it as an object lesson of some sort. Obviously, blindness was not a prerequisite for living in Kerensky's clouds, his world of miracles; yet until Trotsky's stark entrance, I was seduced, while listening, into wanting to dismiss sight, like truth, as ugly and vulgar. With Trotsky's instant recognition of reality, I realized that I had to hang on to Helga's cure, to adhere to its strictest requirements, to submit to its wildest contradictions, so that I, too, could sum up the visible world, to understand it, instead of taking umbrage in the ocean of clouds overhead. If Charlotte intended anything at all by the reading, though, it was probably to link Kerensky's myopic love of miracles with the tenuous miracles of Helga Barnes.

Charlotte was scheduled to leave in a week, which alternately brought on premonitions of great loneliness and hopes of finally being able to devote myself entirely and without reserve to the cure. As her date of departure neared, I halfheartedly talked about her staying. Charlotte might have been more interested in staying if we were signed up in some research institute where precise measurements could be noted daily of the changes in my early receptor potential or the peaks of my retinal beta waves. To me, the bees were a perfect cure with the possibility of a beehive in every basement and two bees every morning with coffee and orange juice. To Charlotte, bees were strictly from the horror movies and were to be carefully avoided. She wanted her nostrums sterile and packaged, a well-kept secret between her doctor and her druggist. As she presented her case for leaving—work, children, and unattended odds and ends—I began making mental lists of self-imposed health

regimens, plans for hiring readers, schemes for exploring London, and fitful fantasies of meeting fascinating women who would rub the wounded back of my neck with Nivea cream (the only balm Helga allowed).

"You've got to be careful what you tell people about my improvement," I said. "After all, we're not absolutely sure that it will last."

"Yes," Charlotte said too quickly. "That's right."

"On the other hand, it's going to be hard not to tell all, not to spill the happy news the moment you get off the plane. Maybe you should just hint at it. . . ."

"Right," she said. "I'll hint at it."

"But you should call Ben at the Foundation. Also Dagmar and Freda. Perhaps even Eliot Berson and Dr. Lubkin. Or you could wait a week. . . ."

"Perhaps so," she agreed. "I'll wait awhile. But in the meantime," she added, "you should give some thought to coming back with me. . . ."

"Going with you?" I sat up. "How can you say that? The bees are getting to me. I'm getting better." But the improvement felt fragile, and I feared that a good dose of cynicism would make it vanish. I wished I could swear out a testimonial like the Casey woman in the *Observer* article. I wished I could thread a needle like her or read fine newsprint. So far, none of that. Just a joyful run in the streets.

"Still," Charlotte said, "try to keep an open mind."

I had begun to miss home, the kids, the warmth of the familiar. But it was painful to project myself back in all that as an unchanged, unseeing man. I felt that my presence in that idyllic scene was disruptive. It interfered with the

normal unfolding of lives; it slowed things up, created blank spaces, disturbances, anomalies.

I could only reenter the Vermont summer changed, seeing again. I could picture myself in the garden with its thick cover of scratchy cucumber leaves, the lush smooth fullness of ripening tomatoes. I thought of the smell in the cedar woods and the huge maples, the path through them, soft and springy, vaulted and dark, the sound of a stream, and the taste of blackberries at the other end. The memories were overly tactile; that, of course, would have to change.

I thought of the meadow behind the house, through a break in the stone fence, near the butternut trees. I would sometimes sneak out to a hidden spot in that field where, buried in the tall grass, alone and unseen, I would indulge in fantasies of sight. It was like masturbating, obliterating reality, entering the magic of the sighted world. I would fall into a delicious place, as if gently rocked and lapped by waves. My eyelids, as I remembered from childhood, would become domes of soothing orange sunlight. Images of my former life would race across that sunbaked screen. I would feel giddy and light as I ran surefooted down carpeted stairs, over bumpy fields, as I drove my blue motorcycle along the Mediterranean in and out of the shadows of the eucalyptus trees, as I skied the lovely Vermont slopes, spraying a shower of snow as I turned and twisted. . . .

A small center of joy would gather momentum inside me. It accelerated to such speeds that the iron shades over my eyes would burst, and I would be witness to my own rebirth. Just then, my eyes would always begin to hurt. Under my lids, the light would brighten to lemon yellow, then become splotched with white hot phosphenes. Sharp lances of hay would begin to hurt my neck and elbows, bugs would crawl

inside my socks. I would open my eyes slowly and see the blazing, painful bombardment of white unfiltered light, alive with pulsating fragments of the gray hills, the tops of trees, the stalks of weeds towering over me. I would lie there and weep.

In that landscape, the day I stopped painting I cut the lines connecting me to the outside world. The year's work, a series of eight large assemblages, was hanging in a gallery. I built racks to store my remaining canvases. I packed some of my materials into cardboard boxes in case any of my children felt the desire to paint. The rest of the tubes of color, the gessos, oils, resins, and varnishes, the boxes of junk I had accumulated from Canal Street and Los Alamos, the plastics, glues, and chalks, the gouaches, paper, board, the jars of acrylic, I gave to painters and would-be painters. I had lent my bench saw to a friend who was building his house, while the jointer, drills, and hand tools went to my eldest, Mark. And then I felt the grief of irreplaceable loss. I had stripped my physical space of the tools of my trade, to keep pace with my eyes. I could no longer even attempt to do the one thing I knew how to do.

In a strange sense, I had also felt relief. I was no longer responsible. I didn't have to struggle. I didn't have to be excellent or successful. Even the grimmest Soviet doctor supervising production workers in a tractor factory would have excused me from labor. I had a note from home, valid for life, permitting me to do nothing.

The next day, I got ten stings at Helga's.

"I will have to start introducing you to some of my other patients," she said, "now that you are feeling better." She put the horrible little insects on my neck rather abruptly. All

ten were placed and relieved of their stingers within a few seconds.

"I must leave for the hotels right after my next patients, the pair from Manchester," she said. She was wearing a feathered hat, a city dress, and lipstick. "Well, off you go now!"

"But Mrs. Barnes," I begged, "tell me something about my improvement. Can I expect it to get better still?"

"What you think?" she snapped, stuffing things into her handbag. "Once it starts like this, it can only keep going. It is the miracle of my bees."

Walking down Altyre Close to the bus, feeling frustrated, unfulfilled, I passed two women—one old, one young— heading toward Helga's. They looked dejected and I supposed they were her Manchester pair. I worried about Helga's indifference to my improvement. She should have reinforced my good feelings. I felt betrayed.

I met Charlotte at the entrance to the Heath, and we walked through the lower part along Parliament Hill, to make a pilgrimage to Marx's grave in Highgate Cemetery. The day was clear and balmy. For the first time since our arrival in London, the Heath was alive with screeching little soccer players in short pants, babies sunning in open prams. The great space amplified the distant sounds of cars jammed up on West Heath Road, a wailing ambulance, the whistle of a train near Hampstead station. The other side of the Heath seemed suddenly Mediterranean, the flavor of an English settlement on Mallorca. Near the cemetery, we heard the prim, elegant sound of a tennis game. It went on without exuberance: no one shouted, no one grunted. The ball just bounded in a polite volley.

There was a commotion inside the cemetery though. A

group of demonstrators, dressed in black, tried to dramatize the plight of Soviet Jews by heckling Marx's admirers. We took our place around the grave, laying our bunch of flowers with all the rest. I walked close to the monument with a huge disproportionate head of Marx on top. I asked Charlotte to read me the inscription. "The philosophers have only interpreted the world in various ways," she read. "The point however is to change it."

I felt particularly foolish and self-indulgent standing in front of a monument to this paradigm of rationality, this warrior against privilege, *his* opera glasses glued right on. My lips started to move, shaping silent words, and I made Marx a promise. "Listen, Marx," I said, "if she fixes me up, I won't rest until everyone has the cure." I closed my eyes and pictured the Cure-Tour, a package including round-trip air fare, a rooming house in Beckenham, and sightseeing after the restoration of dormant photoreceptor cells. I would arrange it all.

"Once I can really see," I continued, "I will be a truly responsible person again." I had always envied people being able to leave their guilts at some altar. It felt good, and I walked down Highgate High Road refreshed.

When we got home, I wanted to call my few remaining relatives. Having planned for Charlotte's departure, for the propagation of the cure, and for my exemplary behavior afterward, I felt ready to meet the handful of survivors from my previously large family who had settled in London. I wanted to tell them that I'd paint again. I wanted to celebrate this improvement about which I was feeling less and less certain. By sharing it I would substantiate its existence. I wasn't sure what, if anything, they knew about my blindness. If it had been up to Staś to tell them about it, then I suspected that they knew nothing. He left the room

every time Charlotte or I mentioned blindness, to pace in the hall or out in the street. He liked hearing about Helga and the bees, but he had no heart or vocabulary to deal with this kind of loss, to him a horror worse then death.

The image of me that remained with the survivors of my family—after all these years, after invasions, occupations, slaughters, and migrations—was of a charmed, blue-eyed miracle firstborn of aging parents.

"Och, Andrzej," an old cousin passing through New York said to me recently, "what a beautiful child you were. Like a little prince," he announced.

"A god," corrected his arthritic wife. They said I was sent by heaven.

"Where else would you have come from?" asked a Warsaw neighbor, now living in Australia, "with those eyes, that Polish nose."

My blindness was too incongruous for them to understand. Had I faced them as a blind man, I would have expected them to turn away with repugnance. I wanted to face them when I was indisputably sighted.

"Why don't we wait awhile," Charlotte suggested, "before calling them all. Let's wait until we're absolutely sure."

The last time I had seen a large part of my family together was in the fall of 1939 when I was eight years old.

In the early September morning, I heard the drone of airplanes and ran out of our house to see them. The sky was gray, and the ground was wet from the night-long rain. I heard the sound of distant thunder. Hanging from a branch of a pine tree near the house, my caged owl screeched. The owl and an English bicycle, leaning against the still unfinished summer house, were my birthday presents from earlier in the year. I saw planes with the red-and-white

checkerboard of the Polish insignia approaching over the treetops. There were three, five, six of them, flying low, so low that I could see the pilots' faces, and I waved joyfully, not knowing they were German faces. I saw things fall from the planes and all around me bombs exploded. Behind me, the owl's cage crashed to the ground and parts of the woods caught on fire. I screamed and ran into them, away from the open fields. When my mother caught up with me, she carried me back to the house. Still hysterical, I had to be calmed with drugs.

Later in the morning, my parents paid off the cook and the gardener and drove back to Warsaw.

Much of my family gathered in our apartment that night to make desperate decisions about getting out. They had come from Krakow, from Lodz, and from Będzin, a town full of Potoks, large parts of it owned by them. They stood in groups or paced. There were many people. I held my governess's hand tightly, and from time to time, my teeth chattered.

The men raised their voices, yelled at one another, until someone shushed them. Then everyone whispered in the dark, by candlelight. My uncle Max shouted about the business while my father paced and picked at his fingers nervously. "Don't pick, Leon," my mother kept saying. The skin around his fingernails hung loose and bloody. He was ashen white.

Neighbors had come over too. Like us, they were rich Jews allowed by the Poles to live and prosper. Like us, they were seldom touched by pogroms, because they and we performed essential services for the Poles. My mother and my uncle Max made furs that were more beautiful than anything the wealthy Poles could find elsewhere, even in Paris.

Throughout the night, my mother's voice was quiet. What she said was always sober and selfless, though the men often took credit for her ideas. She had built the business, and her persistence had kept it going. Everyone knew that. The men, especially her brother Max, indulged in flights of theatrical rage and bombast, which they seemed to need as they needed their extravagant cars, their suits tailored in Vienna, their luxury apartments on the Vistula. They knew that they could depend on my mother to bring them back to reason.

I slept on and off, at times in my room, at times at the long dining-room table. The grandfather clock ticked loudly. The rich, dark wooden floors creaked ceaselessly from the pacing feet. Off and on we heard sirens and far-off explosions.

My cousin Anita, Max's daughter, with her governess, was beside me the whole night. Since then, we've always lived near each other and have become, by our own declaration, brother and sister.

I awoke often to hear the sound of voices, whispers swelling to crescendos, then falling away again.

"The men and the children go," I heard my mother say with authority. They had told me, and I even heard them say to one another, that this war would stop in a day or two. England would stop it, maybe France, then we'd all be back as before. "I will stay to take care of the business," she added.

Max and my father agreed. Everyone else was silent. Tears filled my eyes.

Then I felt a surge of a new kind of strength. "I won't go without you!"

The noise level rose again. Hands were stroking my head and face.

My mother always incorporated the wishes of the men,

and for that instant, I had become a man. "Yes," she said. She came over to me and kissed me. Her cheeks were wet. "We will all go. We will go together." And that night, at four in the morning, we drove out of Warsaw, which was already half destroyed. My cousins Marylka and Bronek were there; they have since settled in London. Anita came with us. Most of those who met in our apartment that night stayed and died in the Holocaust.

Trajanowski, the chauffeur, drove the Citroen van that belonged to the business, and my uncle Max drove the elegant Packard with its silver, red, and white hubcaps. We headed southeast, toward Lublin, planning to wait out the war there. Caught in the caravan of creeping carts, wagons, and trucks, we inched our way through obscure towns— Otwock, Garwolin, Dęblin, Puławy. At Lublin, we heard that German and Russian tanks were converging on the town, so we turned north and headed toward the Lithuanian border.

All along the way the endless procession of refugees was bombed and strafed by German planes. We would leave our cars at the sound of plane engines and run for cover at the side of the road. When each raid ended, those of us who had survived would creep out, push the disabled vehicles off the road, and continue. The first time, my parents tried to hide the dead from me by covering my eyes, but I was curious and, after a time, indifferent.

Sometimes we traveled at night, sometimes we slept in barns or farmhouses. We traded sapphire rings for bread, a mink coat for a tank of gasoline. And when there was no more gasoline to be had, we abandoned the beautiful 12-cylinder Packard. The men couldn't bear leaving the car, and my uncle Max, exhausted, said he was going back to Warsaw to stand guard in his office and fight the Germans.

"My whole life is there," he said.

"You won't have any life," my mother replied. "Now your life is only inside your skin. We must keep going. Don't turn back. Forget the car; forget Poland." And we went on, though the men continued to argue with her.

When we reached Wilno, the crossing point into Lithuania, it was storming. We passed columns of retreating Polish soldiers, and artillery was booming in the near distance. Tens of thousands of people and cars were on the road and in the fields, waiting to cross. We were among the last to leave before the border was closed.

We managed to get to Latvia, then to Sweden, where we waited for American visas. In February 1940, we sailed for New York on the *Bergensfjord*, the last boat out of Norway.

Staś, who was in Lwow when the war started, was captured by the Russians and sent into hard labor not far from the Finnish border. After two years, he was released to join the Polish army being organized in South Asia. He trekked with them through Iran, Iraq, Palestine, Lebanon, Egypt, and finally to Italy, where he fought alongside the British in some of the most ferocious battles of the war. Afterward, he settled in England.

In New York, I hid under beds when I heard airplanes overhead, and I often woke up screaming with terror at night. But I also quickly took in the newness of America. A few days after our release from Ellis Island, I remember walking back from P.S. 166 on Amsterdam Avenue, where I had just been told my name in English. Andrzej changed magically to Andrew, and I said it, rolling the *r*, for the first time. Within a month, the *r* was entirely Americanized; my English was without accent. My parents were obsessed with freeing me from our bitter European history. They were delighted, each time they came to visit me at some boarding

school, that my Polish was being exiled by English words, and they laughed with pleasure at my Americanized mispronunciations of my native tongue.

My parents and Max rebuilt their fur business: they were in their forties and they had escaped the Nazis. Max lived an energetic and successful ten years more. He felt liberated and excited by New York. "I love America," he said often. My father, who had a long history of depression, sank deeper into it. He died in 1965. My mother was the most successful and grew the deepest roots. Her last fifteen years, productive and well rewarded, have been, I think, her happiest.

Now about the same age as they were then, I was struggling with another kind of torment. I wanted to destroy it before it destroyed me. In the back of my mind, I knew that perhaps I'd have to learn to live with it, to live in spite of it. I knew that I would probably have to stop dreaming and believing in miracles. I would probably have to rebuild, carefully and deliberately, in my own New World, in order to survive again. They had done it with remarkable courage and energy.

E I G H T

The next morning, I opened my eyes and saw haphazard motion superimposed on the darkness. Vibrations emanated from the interior of my eyes, according to their own unique rules and reasons, unrelated to what others saw. I saw little more with my eyes open than closed. I closed them to try again.

When I opened my eyes a second time, the charcoal gray of the bedroom window had lightened a shade. The day before, the window had been rectangular, but now there was nothing geometric about it. The dull, slate light spilled over its edges, rounding corners, distorting the straight sides.

The harsh light of the bathroom hurt my eyes, and the mirror reflected a shadow again. I couldn't remember how I had looked the day before. This reflection wasn't mine. I stood anonymous, blinking my eyes, shaking them out; I nodded, I turned from side to side, but I couldn't see the movement in the mirror. I had certainly seen better than this.

Charlotte was still asleep, and I crawled into the bed beside her. My tears wet her face and woke her. She put an arm around me and understood, without words, what was happening.

As the sun's rays nicked the roofs of the buildings across the street, my eyes felt pierced by little spears of light. By breakfast, it was even worse and, very frightened, I called Helga.

"You may come right away, angel," she said. "And don't worry. Once it has started, it will come back again."

We got dressed slowly. "But didn't you see me run down Haverstock Hill, then across the street?" I asked Charlotte. "Didn't you see me handle myself like a tightrope walker along King's Road?"

She said nothing for a while. She stood in front of the bathroom mirror applying eye makeup. "I don't know how it would have shown up on an ERG," Charlotte finally said. "I saw you happy. You were more perceptive, more acute, but I've seen you do some pretty amazing things before. You don't miss a trick at the poker game. And you always seem to know when there's a sexy woman around."

Later, as Helga was putting fourteen bees in my hair and down my neck, she said: "Yes, cherub, that is how the bees work sometimes. Especially on you poor depressed people—and who wouldn't be depressed going blind? It will go up and down, up and down, then the ups will be longer and the downs shorter, and one day soon, it will be *whoosh!*" and she stepped in front of me and made an arc from floor to ceiling with her arms, like a conductor driving an orchestra to the final tonic chord, "All up, angel, all up!"

For a brief moment she seemed to recognize my despair, though always in her own special, cranky way. "You know, I could see it all in your water," she said. "I could see the depression fighting the improvement all the while. I feel so sorry for you. Me, I would have killed myself long ago if I were going blind." She fell into some private thoughtful place for a minute. "But the improvement will win, you will

see." Another thought crossed her mind, for, like a child, she couldn't hide the passage of a mood, an idea, a whim—not even from me. She always percolated, often erupted, and her silences were like a prolonged bar of rest in a tempestuous musical score, charged with anticipation. "Don't you ever lie to me about improvement," she warned. "I know how sneaky you people get. I know what to do with people who hide their improvement. Out they go, right out the door. . . ."

"But why would people want to hide their improvement?" I asked.

She didn't answer for a moment, not believing my innocence. I felt her eyes examining me. "They leave without paying," she snapped. "But I can always see improvement in the water, so don't you think of trying to fool me."

"Do you charge people only if they improve then?" I asked.

"What you think?" she snorted. "Everybody improves! Everybody pays." She was thundering now. "I don't do this for nothing anymore. No fees, no bees! I have learned my lesson. They are rotten if they pay and rotten if they don't. You know that lying, cheating rake in my book?"

"Your book? What book?"

"My book, my book," she snarled. "Didn't I show you my book?"

"No, Mrs. Barnes. But I'd love to see it."

She had already slid out of her chair and started up the stairs. "Yes, yes, two books," she was saying, "I have written two books." She came down with them and handed them to me. "Here, take them home and have your wife read them to you."

As I left, I knew that I was already in the process of

becoming a part of the Helga Barnes legend. Other patients were surely being told: "You should see my American chappie. He is seeing beautifully, and he's so wonderfully happy!"

No one was home at Eton Rise. I paced the floor, dying for a look inside the books. One was called *Disgrace in the Clinic* and the other, *Storming the Distant Tower*. I laid them down and waited for Charlotte. My neck and ears hurt and itched; they were swollen grotesquely. Thus far, I had been stung by over 160 bees.

Staś's flat, which just two days before felt like the center of the universe, changed hourly into a dark hovel on the edge of some suburb. A forlorn photograph of his wife, taken years before in Zakopane, leaned in its tarnished filigree frame against the wall at the back of the dresser. Next to it lay a Polish-English dictionary, its hard cover long gone, the pages brittle and yellow. Ancient calling cards were strewn in a chipped dish, along with bent collar stays and loose vitamin pills. Even the narcissus from the day before was fading prematurely. I was flooded with memories.

Through my father's lifelong bouts with depression, he stamped each of our several New York households with gloom. As my mother became more successful, she refurbished our ever-fancier apartments, but my father managed to make even the Fifty-seventh Street place, their last and most elegant, appear untouched by either grace or Parke-Bernet. He always sat slumped in a soft chair, his head supported in his hands or flung back on a doily my mother put there. My mother never kept house, but the back rests of couches and upholstered chairs were watched by her with a keen eye for the stains made by my father's scalp. With that doily, she insulated whatever she could from his "Potok

character." ("It hasn't affected you, thank God," she often told me.) The "Potok character" was, I think, a mixture of depression, paranoia, and a shabbiness spawned by misanthropy and the renunciation of pleasure.

Their life together was full of incongruities. On my father's way home from Maximilian Furs—which he opened up every morning and closed late each afternoon—he often stopped at the Automat for a cup of coffee, from which he'd return with packets of sugar or napkins, because, he said, he couldn't bear to see useful things thrown away. The collected objects he brought, the wrapped cakes of hotel soap, the trial packages of free cigarettes, the coasters, swizzle sticks, and artificial sweeteners, lay in a dresser, two drawers down from my mother's, which were silk lined and scented, full of Dior blouses, Balenciaga scarves, and pearls from Van Cleef and Arpels.

He sat listening to the radio or reading the newspaper, cursing my mother for talking on the telephone too long or the maid for making too much noise. Periodically, he walked through the house to turn off lights and check for dripping water faucets. Everything—even the basic ingredients of life—irritated him.

My father's aloneness always affected me deeply. I wanted him to be loved; I wanted to see or feel his love. When I was very young, I savored the times he glowed with pride or demonstrated his love for me by moving his lips across my forehead to be sure there were no signs of a fever. Later, the love I felt turned to pity, shame, and finally dread that I would be like him. When friends from school came home with me and he sat at the radio, his eyes closed, his mouth slightly open, one hand on his forehead, the other hanging limp off the arm of his chair, his suspenders loose, his shirt

collar frayed, his fingers scarred and scaly from picking on them with his fingernails, I burned with embarrassment and anger.

My father's genes had given me retinitis pigmentosa. The despair that accompanied my struggle with blindness, each depression, each selfish act or unkind motive of my life, held an additional terror for me: the fear of having inherited his "Potok character." Even when I was young, my "moodiness"—to my early girl friends a kind of romantic, artistic brooding, to others a well-known characteristic of a Cancer—came dangerously close to my father's "sickness." My eyes excluded others, just as his "sickness" kept people at bay. The darkness he cast around himself was not, I had to keep reassuring myself, the same darkness that was creeping into my eyes.

My father watched wrestling on television and occasionally went to St. Nick's Arena to see it in person. Wrestling was, as far as I knew, his only pleasure, probably satisfying some deep need for violence that surfaced at home only in impotent rages directed against my uncle Max and toward my mother. I wished that he had an interest more attuned to mine. He had once gone to the university, read books, heard Lenin lecture in Montreux, voted for Norman Thomas. I thought I remembered overhearing his talking about Gorky to someone, I don't remember who or where. I wished he loved theater or movies, played bridge or poker, kept a mistress or knew about opera. I wished he drove a car, did crossword puzzles, collected stamps, worked at a meaningful job. But the wrestling was what there was, and I was grateful because even that made him more human, normal, less a helpless victim of his terrible neuroses. Still, what I considered his wasted life loomed large before me.

As my father lay dying, transformed by cancer into a

skeleton, my mother would come home several times a day to discuss his changing condition with the day nurse. She felt bound by duty to the end. "I always acted correctly," she told me, "no matter how hard it was." At the end of thirty-five years of marriage—miserable, incongruous, anomalous in every way—he lay dying in their pastel bedroom under a soft, pink nude painting of mine that he never liked. The maid dusted the Empire furniture, the French Provincial armoires, the delicate Chinoiserie in the other rooms, where the walls were also crammed with paintings my mother bought in little galleries off the Faubourg St.-Honoré, all of which he would gladly have lived without. My mother worked hard, though, for this touch of elegance and congeniality, which, by its sheer weight and perseverance, finally won over gloom.

As I paced inside Eton Rise, I wondered if my father would have been happier here, living alone, like Staś, in this frugal little place near the parks, away from the threatening world my mother created, away from New York, which had offered him nothing but memories of better times in Poland.

Charlotte returned from her morning's outing. I didn't budge from my place on the couch, and she came over to give me a kiss. The cold London air on her lips gave her an aura of energy, movement, purpose. The contrast made me feel like a lump of dough. She handed me a couple of icy ceramic tiles she'd bought from a crafts shop on Flask Walk. "They're from a medieval English monastery," she said, throwing down her coat and going into the kitchen to make coffee. Charlotte's sudden energy had brought back one particularly vivid image of childhood: my mother standing in the vestibule of our Warsaw apartment, the dark brown bristles of her mink coat emitting a faintly noxious odor of

lamb stew, and bringing in with her all the bitter cold of the Warsaw winter. Within those frozen animal hairs she brought a whiff of her busy, adult world, a world that excluded me.

"We'll have a cup of coffee," Charlotte yelled in from the kitchen. "It's bitter cold outside." I fingered the tiles carelessly. They were brown or gray. They were dun or tan or earth color. They were mud. There are no brain cells for remembering mud.

"It was surprising," Charlotte said. "A quaint little shop full of careless hippie stuff. I know that English pottery is better than that."

I said nothing.

"You should have come," she continued. "Gorgeous narrow streets. And those tiles aren't bad, are they?"

"How should I know?" I said, my voice cracking.

"Oh, come on," she said, peeking her head in, "You're good at that, you still have a feel for form. . . ."

"Shit!" I yelled at her disappearing face, "Shit, shit, shit! 'Feeling for form,'" I mimicked. "What a terrific blind man. He feels form, hears trees grow, thinks lofty thoughts. . . ."

"Some mood," Charlotte said, coming out with two cups of coffee. She touched my hand, then saw Helga's books on the table. "Good God! What are these? I don't believe it!" she said examining them both. "The Helga Barnes Press with an HB logo no less." She opened *Storming the Distant Tower* at random. "Jesus, listen to this."

Fifty-four hazardous river crossings, hair-raising captures, escapades galore, and the backing of my staunch and wonderful band of helpers, to whom I shall ever be grateful, had finally triumphed. Thanks to their unfailing, alert and skillful watchfulness, their tender care and honesty, not a single treasure was

lost, stolen or damaged, and I wriggled from the clutches of swooping bureaucracy by their "sang froid" or my own infernal cheek. They and good luck were with me to the end . . .

The book was a picaresque account of Helga's efforts to smuggle furniture, art objects, and other family treasures out of postwar Austria and Hungary. Her massive belongings were safely collected in Czechoslovakia and sold with the intention of financing a medicated-bee-venom clinic in England. A picture of a quick, clever, and resourceful woman emerges from *Storming the Distant Tower*, a woman who delighted in trickery, stealth, and masquerade, single-mindedly driven, no matter what the odds, by her final purpose.

The second book, *Disgrace in the Clinic*, contains twenty-six anecdotes of Helga's encounters with doctors, mostly rheumatologists, who appear incognito in search of treatment for themselves or their arthritic families, trying to steal her secrets, and generally go about their devious, dishonest ways, confounding and robbing humanity.

His stony heart was not aching for the suffering sick but that bottomless pit, his pocket, was gaping wide for all the cash he could grasp from them. . . .

Helga was everywhere, turning up rot and treachery wherever medicine was practiced, wherever arthritis raged. Doctors and patients alike sucked up her funds and slowly, surely tarnished her generous heart.

I couldn't bear to listen to more, and I asked Charlotte to stop. We, her patients, would all be twisted into some tale, as an example and a warning. And if the treatment left us as diseased as when we first appeared on her doorstep, the

failure would be blamed on some flaw or weakness in us.

Charlotte continued reading to herself and after a few minutes of silence, I begged for more.

> Once upon a winter's day, I gazed out at the summer's faded remnants on the rock garden before the window of my consulting room, and beheld two old women, nearing eighty, fumbling at the gate. One was a peroxide blonde, the other raven dyed, and, both attired in ragged coats, hiding tattered costumes and torn jumpers . . . The tale they told was lamentable. Having heard of my cure with medicated bee venom, they had spent their last few shillings to crawl to me and they implored my pity plus my treatment to relieve them of their suffering.

Helga paid the women's taxi, visited them daily, brought them food. They lived in a friend's sumptuous house. One day, Helga arrived without warning and saw them as they really were: wealthy women, splendidly dressed, "awaiting their stock broker."

"Though I'm rarely at a loss for words to deal with any situation," Helga wrote, "on this occasion I was rendered limp and dumb."

"The Rake," the story Helga had mentioned earlier that day when she had first asked me if I remembered it from the books, turned out to be "an eighty-year-old Adonis," who lied to her about his improvement. Tipped off by the friendly nurses in a private nursing home, Helga discovered him in bed, mocking an arthritic relapse. He had, of course, been playing around with the nurses.

> "Mrs. Barnes, I haven't been able to move out of bed for three days! I'm so bad there's no hope for me!" . . . I strode boldly over to the bedside, and gripping the bedclothes beneath the

writhing man's chin, I tore them down in one go. There the agonized wretch lay fully dressed with his boots on. . . . He writhed and shivered, while I nearly had a rigor too. . . . "You double-crossing old rat," I shouted. . . .

Charlotte read on, and when her voice gave out, she continued reading to herself. I went into the bedroom to lie down. I wondered if this was a genre, the healer's complaints, published by vanity presses the world over since the beginnings of medicine and quackery. I could picture Helga dictating these tales to some patient enlisted gratis as secretary, sitting through endless evenings, collecting these weird bits of Victoriana, these penny dreadfuls, these turgid battles of good and evil. They were cautionary tales, sets of rules for proper patient behavior. The books were as devastating a blow to me as the ophthalmoscope and the disappearance of my improvement.

"Charlotte," I yelled into the living room, "tell me it's okay. It doesn't matter, right?"

I heard the book hit the floor. "It's horrible, disgusting stuff," she said.

I went to sit beside her. "I want to continue in spite of the books," I said. "I mean . . . the books have nothing to do with the cure. I should go on, don't you think?"

"Go on if you want to," she said. "Do what you like. But I think you're mad."

"Well, okay, I'm mad," I said. "Nobody knows that better than you do. But say a few nice words of support. You know, humor me. Like in ancient tales of husbands and wives. Come on. A little lie. Tell me I'm wonderful. . . ."

"I tell you you're wonderful when you're wonderful," Charlotte said without humor.

"Oh, come on," I begged. "Because the next thing I'm

going to ask you to say, just say, is that I must stay in
London, that I'd be a fool to leave now. . . ."

Charlotte was not amused. "I love you," she said sternly,
touching my shoulder and rubbing it back and forth
absentmindedly. It was, I knew, married love, the
"preceptual" love from Judaic decree. "I understand your
coming here and even admired your energy. But now I think
you should leave. . . ."

"Charlotte, just say it," I teased. "God won't strike you
dead. Say: 'Andy, you should stay.' That's all. You could
leave a note saying you didn't mean it."

"It's not funny," Charlotte said.

"I suppose not. If we have to be serious, I'll pull my hair
or cry."

"Don't pull me into your craziness," Charlotte said.
"Admit you're wrong and come home."

Suddenly I thought of my father again. I thought of him
sitting and groaning in his chair, and as my mother walked in
from work, seeing him like that, she would ask: "What's the
matter, Leon?" He would say nothing, as if too weak to
answer, too pained, too slighted and ignored. "Call the
doctor," my mother would advise. And he would disappear
into the bathroom, shuffling past her in his slippers, to peer
into his bloodshot eyes and pour out another headache
powder.

My uncle Max, on the other hand, didn't even have to
complain. My mother helped furnish his apartments, find
him women, make him rich. All of it quietly, secretly, with
total devotion. When he shouted at her as if she were at
fault for some setback with women or partners or custo-
mers, she stayed up nights, planning and scheming to make
things better. She connived, persuaded, and sacrificed
for him.

But he was glamorous. He played cards for high stakes, and often all night; he drove fancy cars and entertained beautiful women at El Morocco. He was a dashing, elegant figure at Maximilian Furs. He was bigger than life.

My two father figures were outrageous extremes. But, I thought, I would have to stop bitching and act like Max if I wanted to be treated like Max.

"What about Sarah?" Charlotte asked. "Surely you're no longer thinking of bringing her here."

"Why not? Of course I am."

"Andy," Charlotte said, "there's a limit. Don't interrupt her now. . . ."

"I'll wait till the school year is over."

"Andy," Charlotte threatened.

"How can I not?" I asked. "How can I feel even a day's worth of improvement and not send for Sarah? If there's anything at all to the bees . . ."

"There isn't," Charlotte said.

"If there's anything at all to the bees," I repeated angrily, "it'll work even better and faster on Sarah. She's just starting."

I had witnessed Sarah stumbling around at night ever since she was a little girl. I didn't see her really, but I heard her, and I couldn't bear this perfect little girl hatching her way into a spoiled life like mine. I would turn away. So would Joan, who thought Sarah was faking. "She just wants to be like her daddy," Joan would say.

"But I can't see," Sarah would whine.

"We're leaving," Joan would say from the car. She had to do all the night driving. "Hurry up there, pumpkin." And I would hear Sarah's little body bump into the back of the car, her hand trailing the fender to find the handle of the back door.

When Sarah was sixteen, two years before London, Dr. Berson said there was no question about it anymore. Sarah had RP. He then told her, somewhat prematurely, that she should no longer drive, breaking her heart in the process.

"I'm not even going to wait for the end of the school year," I told Charlotte now. "I'm going to send for her right away."

Charlotte flipped through one of her Margaret Drabble paperbacks and started to read. I turned on the BBC louder than I needed to. They were playing a Smetana string quartet I hated. It was soupy and autobiographical.

"Oh, Jesus," Charlotte muttered and took her book into the bedroom.

"Hey," I yelled, struggling to keep us talking, "let's try the Indian restaurant Edith told us about."

We avoided touching each other as we got ready to go. We walked twenty minutes in silence to the Taj Mahal.

The restaurant was very dark. The odors were exotic, spread about by a large fan hanging from the ceiling. Except for the loud scraping of chairs from a far corner, there seemed to be no one there.

"All the waiters are getting up and putting on their jackets," Charlotte said as I dragged behind her between tables and chairs.

A large waiter panted as he led us to a table. Then he stood, occupying, I sensed, a great deal of space. We ordered drinks, and he moved away in the dark like the Queen Elizabeth slipping from her berth in the middle of the night. I myself felt like some prehistoric reptile on whose primitive retina a hint of movement had just barely registered. My eyes felt heavy. It was hard to keep them open.

The waiter came back with our drinks. I felt the breeze of

a menu being handed to Charlotte, and I shot my hand out to intercept mine. I knocked over my Scotch. "Another Scotch, sir?" he asked. His tone seemed disdainful.

The menu was extensive, and as Charlotte read it aloud, each item forced the preceding one from my mind, as if I had room for just one at a time. I felt terribly old.

Lights pointing upward from behind some potted palms caught the edges of the four-bladed fan rotating languorously in the center of the room. Like a moth I was drawn to the moving cross of light. As Charlotte read, I stared at the fan.

"Come on, honey, let's order," she said.

She seemed delicate now, sharp and decisive, like a cat among mastodons.

"Let's try some stuffed *somosas* and an order of onion *bhajees*, whatever they are," she suggested.

They came together with other little saucers filled with delicacies. My fork, with all the odds clearly in its favor for spearing *something* delectable, entered my mouth over and over again with a slice of a lemon or a hunk of burning ginger or a goddamn decorative herb. Charlotte began removing the inedible debris from my plates and offered me forkfuls of tasty morsels across the table. "Mmmm. Taste this," she said pleasantly, dousing me now with cool yogurt and cucumber, now with a pungent mango chutney.

A buzzing, cheery English party came in and took a large table not far from us. They knew just what they wanted, making the waiters scurry from all the corners of the room. They brought drinks, then breads, stuffed and spiced and buttered.

"It takes sight to be in control," I said bitterly.

Charlotte said nothing.

"My mother brought me up to take charge in restaurants,"

I said, "to snatch the bill from Madame Harper's Bazaar, to signal the waiter with a manly nod, to direct, to host. Well, look at me now." I had no idea if she were looking or not. "*You* can do anything," I said, "whatever you want. . . ."

"Bullshit," she finally said. "My limitations are as real to me as blindness is to you. I'm getting old, not as desirable or promising as I once was. I'm afraid of dying. . . ."

My mouth burned, my bowels steamed; I felt immensely sad. "Maybe I should go back with you. Maybe I should stop being ashamed of the way I am, but I don't know how to do it. I hate myself the way I am."

Charlotte touched my hand, then stroked my fingers lying somewhere among the saucers.

"I'll try to help more," she said. "I know I haven't been all that great."

"I'm such a pushover. Everyone is a threat to me. I'm losing my grip. . . ."

"I'll help more. I promise I will."

"What can you do? I've got to help myself, and the only way I know how right now is with Helga. I don't want to stay. I'm scared, but I've got to stay."

Charlotte's fingers stopped caressing mine. "I can't help, I can't even participate in any way if you're here and I'm at home."

"I know."

"You should try to examine your reasons for staying though. More than you have," Charlotte the teacher advised. "We don't know a single person who would have survived those books. You know," she added, "you always did have a soft spot for magical cures. Like the encounter sessions . . ."

"But just that. Nothing else," I protested.

"Oh, but you were tempted by everything that promised to make life better."

"I resisted them all," I said.

"All that self-actualization crap," Charlotte said with great disdain, as if she were addressing an incorrigible, unrepentant offender, an addict. "Along came some cockamamie new shrink, some drooling guru, and you listened. You daydreamed about having your life put in order. . . ."

"Who doesn't?" I asked.

"I don't," she replied without hesitation. "You though, you'd like to think the answer lies in better breathing, deeper massage, grunting and wailing."

I may have daydreamed of perfection brought about by lovely maidens rubbing me with fragrant oils on the cliffs of California, but in fact, my two noteworthy excursions looking for help were to St. Paul's Rehabilitation Center and to a month-long colloquium of my graduate school in Florida.

When I arrived in Sarasota, I hadn't been painting for over a year and I was desperate to find an occupation, anything to keep me from the madness of inactivity. Late the first night, as I lay in shorts on my bed, listening to a tape of Friedell's *Cultural History of the Modern Age*, big Zeke, my roommate for the month, loped in through the door. His movements were clumsy and loud. He was a passionate bioenergeticist.

"It's nice to leave Vermont in January for this weather," I said.

"It's a drag to leave California," he answered.

We sat facing each other, and he leaned forward, his elbows on his knees, his chin in his cupped hands, looking me over shamelessly.

"Stand up," he said and looked some more. "You have rotten posture," Zeke informed me, breaking through formalities.

"Yes," I admitted. "I've been told that I stand strangely, with my knees locked. . . ."

"It's not strange," Zeke said, "it's sickening! We'll work on it though."

When I told Zeke about my eyes, he wasn't surprised. "No wonder," he snapped. "Just look at the way you block up here"—he poked my knees—"and here"—a chop to the neck. "It's a wonder your juices are flowing at all. We'll improve your eyes," Zeke promised, "as well as every other goddamn thing."

I thought Zeke himself was as loose and relaxed as a human being could possibly be. He had spent many weekends at Esalen, he had been stroked by thousands of busy, humanistic fingers. He was well-grounded in the here and now. Zeke's belly hung comfortably over his belt, and his walk was as loose-jointed and unselfconscious as an ape's. Every morning he sprang out of bed, darted into the bathroom, and stuffed his fingers down his throat to clear his system for the new day. Nauseating noises erupted from our room into the sunny stillness of a Florida morning.

During the month we spent together, Zeke poked at me, made me slouch and grunt, bellow and shriek, but nothing seemed to happen. And he wasn't the only one there with a formula for self-improvement. I was urged by fellow students to walk with the armies of Krishna, to dive into the caverns of my unconscious, accompanied by music, exercise, or massage, to bow to the sun, to bury the old and rejoice in the new. At the end of the month I went home still not knowing what to do with my life, as uptight as ever, and slightly blinder than when I'd left.

Charlotte and I had worn out the Taj Mahal. No place seemed big enough to contain our dilemma. "Let's get out of here," I said; "let's walk this off."

It was a lovely, late Sunday afternoon. We walked for a long time, then found ourselves, happily, in Pond Square in Highgate. The asphalt island in the middle of the square was teeming with soccer games and weaving bicycles. Gay, chattering clusters of people sat on a low wall across a narrow street. Others congregated on the sidewalk in front of them, like a wedding party outside a church. There were brownstone houses on all sides. Everyone looked as though they belonged, as though they owned the place. We felt particularly foreign and conspicuous.

We sat on a stone parapet in the middle of the open space. A pigeon at my feet fluttered suddenly upward as a white soccer ball whizzed by. A troop of little boys followed, careening past us to boot the ball back to the other end. It was their square, their village. A roar of laughter rose from some people who were standing in front of a pub that had just opened.

"I'm terribly thirsty myself," I complained.

"Go get yourself a beer then," Charlotte answered impatiently.

I tried to chart the field ahead: bicycles strewn about, kids everywhere, babies on the loose in danger of being trampled. I walked in the direction of the laughter. A soccer ball sailed by my head, a bike swerved, a kid went headlong into me, or I into him. I assumed a bemused, distracted air as I sauntered into the dread black cave of the pub.

Inside, I stood still, surrounded by words and laughter. I felt dizzy and thought I would fall. I held on and navigated through islands of conversation toward the spill and flow of liquid, the clink of glass. The soft padded edge of the bar

stopped me. I felt the center of attention, as if all eyes were riveted on my clumsy walk. I gripped the railing around the bar.

"A pint of lager," I said, hoping someone was there. I waited with a pound note held in front of me. It was soon pulled from my fingers, replaced with wet, sudsy coins. A thud indicated that my pint had arrived. My hand swept the counter for it, and slowly, carefully, I headed for the block of light framed by the doorjamb. Outside the pub, I stood still for a moment. I was exhausted.

"I should do this more often," I told Charlotte. "It's like Orpheus in Hades. . . ."

"Yes," she said, "you're right. That's exactly what you should be doing. Like at St. Paul's. Not waiting around for that insane bitch and her goddamn bees."

Charlotte took sips of my lager, and soon we were finished. After Charlotte's total support, which seemed to be eluding me, the best thing was another beer, perhaps several. I pointed in the right direction once more and cut my way through. Someone must have said to someone else: "Let's see how the old boy makes out this time." This time, it was a little easier. I didn't care quite so much about upsetting other people. I spilled a little foam off someone's pint, but a few heart-felt pardons took care of it. I emerged triumphant again, two tall lagers in my hands.

I had promised to call Helga in the late afternoon and reluctantly went to the red phone booth behind us. I dreaded her "And how are we today?" and my obsequious, "Fine, fine, what a lovely day, isn't it, Mrs. Barnes?" She turned out to be cheerful enough, but crowded my head with more Arab chieftains, Belgian aristocrats, South African diamond merchants, all being stung by bees. "Tomorrow

morning at nine," she said, "and don't be late, because after you I'll be meeting the Foreign Minister of Abu Dhabi and his whole bloody cabinet!"

After my phone call, Charlotte dug into her bag for a pair of sunglasses. "I like it when you take things into your own hands, like the pub. You can do anything once you set your mind to it, once you get over your fears."

I had conquered, it was true. I was pulling whatever I needed from the black cave. I felt invincible.

"Charlotte," I said, "I'm staying. I'm staying not because I can't cope but because I choose to take a chance. It's okay if I come out the fool." I felt quite loose now, in the middle of Pond Square. I stretched out along the parapet wall, not caring about the soccer balls, the dogs, the low-flying pigeons. Charlotte put her hand on my cheek.

We sat there sunning and drinking in the sunlight for a long time. I felt braver on each of my trips into the pub. Twice I carried on little conversations inside, slurring my words a bit, but happy. I stumbled slightly along the familiar path, two lager mugs balanced and spilling over. Pond Square became our village.

Charlotte and I walked home, drunk and exhausted. We made love, not on the bouncy foam couch or Staś's narrow bed, but on the floor, banging into the blond oak coffee table from Heals, the two handsome chairs that Edith had picked out. I felt sure of myself and in control. We rolled into the hall where bits of dust clung to the moistness and smells of the beer, the sweat, and the sex. We bathed in Staś's giant bathtub, soaping each other and soaking in the hot, hot water, even those parts of my neck and face that Helga had forbidden me to soak, warning me that the heat would dehydrate those fluids the bees had set in motion.

The peace Charlotte and I had made with each other seemed genuine. It felt strong enough to tide us over our imminent separation. We didn't know how long it would be—a couple of weeks, perhaps months—but at least we had made enough of a connection to sustain us.

N I N E

A few days later, Charlotte and I took the bus to Heathrow. There, at the bookstore, she bought a thriller for the flight, a book she would read in peace, without my constant bitching. We stood and hugged and cried.

I love airports and piers and train stations. I love boarding and being en route, the risqué lawlessness of duty-free shops, the carefree meetings, the danger and coincidence stirred up by movement.

Charlotte disappeared into the departure doorway, as inaccessible as if she had already crossed the ocean, and I was alone. I looked down from the balcony into the teeming confusion of ticket counters, baggage carts, and lines everywhere. I had to thread my way through this massive chaos and begin my solitary life in London.

From the bus, everything looked dreary and gray. Everything suddenly translated into loneliness. I wanted to share my thoughts, which seemed fascinating, even brilliant, but there was no one to talk to. I craved Charlotte's company. I felt the full weight of my aloneness and recognized its special character. I had been there before.

On a bright August afternoon, not quite three years before, Charlotte deposited me at St. Paul's Rehabilitation Center

in Newton, Massachusetts. I had become incapable of dealing with my approaching blindness, and I signed up for a four-month residency with others also going blind. We all wanted to learn, with varying degrees of desperation, how to survive. It was my first contact with blind people and with the extensive blindness empire.

St. Paul's Rehabilitation Center for Newly Blinded Adults had in its name the most revolting connotations. I imagined Spencer Tracy in *Boys' Town*, silent busy nuns in bare-bulbed corridors, forlorn clinics with nailed-down furniture, fluorescent green offices stacked with case loads. But as difficult as the word *rehabilitation* was to handle, the word *blind* was worse. It was fraught with archetypal nightmares: beggars with tin cups, the useless, helpless, hopeless dregs of humanity. It was a word I still couldn't say, not to my friends or my family, and when Dr. Lubkin first said it to me, *speaking of me*, I wanted to scream.

Our old orange VW was crammed with my reel-to-reel tape recorder, the cassette player, tapes of books and music, the bulky, knobby glasses and lenses that for a brief period of time had helped me paint. As Charlotte and I turned off Centre Street at the sign that said *Catholic Guild for All the Blind*, we were surprised by the elegant estate with splendidly manicured lawns, enormous trees, and flowering shrubs. Within the complex of stately old buildings, the parking lot was already filling with candidates for rehabilitation. Family groups with little girls in taffeta, boys in their Sunday best, dogs, parents, old people, clustered around each vehicle. The focus of all this activity, standing in the center of each family constellation, was a slow-moving, clumsy blind person. Self-consciously, almost furtively, Charlotte and I joined the flow.

The Center's staff stood around the entrance to the St. Paul's building, a richly gabled, arched, stone structure, greeting and directing us. They looked perfectly normal, in print dresses or shirt sleeves, smiling, cheerfully shaking hands. There seemed to be no nuns or priests among them, no missionaries or wardens, no life-renouncing shut-ins or ruddy-cheeked fund raisers. There was, rather, a garden-party atmosphere in which the dejected clients-to-be looked strangely out of place, like Hasidic Jews at a DAR convention. As for me, I felt as though I were the strangest of all, in my Vermont Levi's and boots, a three-week stubble of beard sprouting on my face.

I deposited my bags just inside the entrance. Three or four blind people sat there in isolation. They looked broken. Charlotte and I left quickly, managing to avoid the welcoming committees.

"It's pretty here," I said.

"Yes," she agreed, casting frightened glances, her eyes darting, her arms pulling me away from St. Paul's. We walked with short nervous steps over the fancy estate, and all the while, Charlotte eyed her watch and our car in the parking lot.

"Well, Andy," she finally said, "it's time for me to go. I hope this is good for you. It's certainly strange." She left, waving and throwing kisses from the car. Terrified but curious, I was alone, as alone as I'd ever felt in my life.

Inside, a tall, blond man offered to help me bring my belongings upstairs. "I'm a mobility instructor," he said. I recognized him from a St. Paul's brochure.

"Take my arm," he said, and led me upstairs. Seven of us were to live in two converted closets and part of a narrow hallway. He seemed to find nothing extraordinary about

these accommodations. "A bit cramped," was all he said, thinking perhaps that the blind are liberated from aesthetic concerns.

"I'll show you how to get to the bathroom," he said, taking my arm firmly. "As you get out of bed," he said, "turn right and take three steps." We did it. "You're now in the hall," he said. Of course I was. I saw the cracked and peeling linoleum, the big old radiator under a large sooty window, the pipes running along the ceilings. "Be careful here," he warned. "You must turn left immediately because of the open staircase. Take three more steps and right again."

"But look," I said apologetically, "I can see the bathroom," pointing to it.

"Well," he said, "you'd better remember anyway," and frowning, he took my hand to place it on the door of the toilet stalls. "Four steps to the left is the shower," he said, and bringing my hand along to the sinks: "four washstands."

I felt out of place. I wondered if they had ever dealt with people who could see as much as I could see. Perhaps they had made a mistake accepting me. Again, I was the refugee boy, sent away too early, too scared, too confused. As for blindness, I qualified on paper. And, anyway, I would soon be as blind as they expected.

My sight had been going downhill fast. Print looked as if it had been soaked in a bathtub. On my bad days, it looked eaten by acid. Sometimes, I could see headlines, but even they swam in and out of blind spots. Everything else appeared as in a dazzling snowstorm—gauzy and colorless. Already the blind areas, the scotomas, were widening considerably, like puddles in a heavy rain. I was frightened by the blanks, the no sight, which registered only by the notable absence of things I knew were there. Still, there was so much I could see and do compared with people I

considered blind. I could get around in decent light, I could go most anywhere without too much help, and because I was adept at hiding my impairment, I appeared ridiculously normal, especially at St. Paul's.

I hung a few things on wire hangers behind an old paisley cloth that was unhemmed and coming apart on the sides. I slid my listening equipment under the bed and went downstairs. The lobby had been cleared of visitors. It was depressing, this checkered linoleum floor with four rows of chrome and vinyl chairs, a standing ashtray at the end of each row. It had become the domain of the blind.

No one was talking. Three women sat in one row, one or two empty chairs between each of them, and several men, equally separated, slumped sadly two rows away. I thought of a desolate Hopper painting of a waiting room in some Greyhound station at three in the morning.

The place was so strange that I was at a loss as to how to start a conversation. "Have you been here before?" or "Nice day, isn't it?" Would they even know how nice the day was? I mean, really know.

I saw a long-legged young woman. "My name is Andy Potok," I said. I had wanted to say: "What's a pretty girl like you doing in a place like this?"

She turned to face me, almost in my direction, eager to engage, smiling. I saw darkness around her eyes. "Margie Dawson's mine," she said.

"Are you blind?" I heard myself asking. I felt really stupid.

"Yes, I am," Margie said.

"But you're . . . you're . . . " I stopped myself from blurting that she was too lovely. "You're so young," I said.

She had an apple-pie prettiness, spoiled only by the puffiness around her eyes. She had a pert button nose, a

heart-shaped mouth, an oval face with cascading blond locks.

"I can just see light with one eye, a little movement with the other," she said.

"Jesus," I said. "How did it happen?"

"I'm a diabetic," Margie said. Her eyes were half closed, sometimes opening wide, though with effort; sometimes closing gently, like a bird folding its wings. The flesh under her eyes was blue or purple or gray. "What about you?" she asked.

"I have retinitis pigmentosa," I said. I think she hadn't heard of it. She waited politely for an explanation, and her eyes fluttered, as if to say, "How nice . . . how nice to meet you. . . ."

She was her disease and I was mine. Diabetic retinopathy meets retinitis pigmentosa.

"What do you do?" Margie asked. "I mean what *did* you do? You are blind, aren't you?"

"I was a painter . . . a picture painter. . . ."

"Really?" Margie said. "I illustrated greeting cards."

Her smile kept vanishing, too suddenly, draining her face of expression; then just as suddenly it reappeared, her eyes darting left, right, up, down. The effort to look interested and attractive seemed too much for her. It seemed to unlink her features, like a puppet with tangled strings.

Margie told me how diabetes had made her blind, hemorrhages exploding inside her retinas, eventually leaving little but scar tissue. Margie had had a series of operations attempting to seal, weld, sew, scorch, and freeze the tiny delicate webs in the back of her eyes. The operations didn't work, but the surgeons kept trying. She would have another while we were at St. Paul's and a final one after.

More than half of our group was diabetic, and the scope of their problems dwarfed mine. I felt lucky to be only going blind. The diabetics had their terrible frailty to deal with, replacing twice daily the insulin their bodies had stopped producing, watching over their fragile limbs and eyes and vital organs, their constantly threatened lives.

I moved around in the row with the women. It was apparent that I was physically better off than anyone there. Many eyes here were disfigured, with eyeballs bulging, puffed with swelling, darkened and lined by surgery, eyes turned in opposite directions, or fixed in benign, lifeless stares, some open, some closed, some covered with a milky film, some gone altogether. I felt healthy. My eyes were bothersome, irritated, somewhat disturbed, but they were the eyes, suddenly, of a sighted, not a blind, man.

I began to move from row to row, speaking with the men and the women. I felt so slow-moving at home and so speedy here. Soon everyone was drawn in. We couldn't contain all we had stored for so long. We were finally with people who understood.

"I could see perfectly well until a month ago," Rosemary said. "I was so afraid to come here."

"Kee-rist," said Ray. "I sure didn't want to leave my wife and baby for four goddamn months, but I've got to get myself ready for a new job."

"It's been hell at home," Tommy said. He had an enormous bull neck, and his eyes looked barely attached to his skull. They bulged in opposite directions. He said he was disfigured because of steroid injections meant to help his eyes. "I can't stand just sitting around doing nothing," he said in a lovely Irish tenor. "Boy, am I ever ready to go back to work. That's why I'm here too."

Our voices rose in pitch and loudness. Most of the people

who had already gone to bed, swearing that they would never come down, never join in, swearing they would leave this weird place first thing in the morning, now started to straggle down the stairs in bathrobes or T-shirts. Soon we were emptying our clogged hearts of the terrible burdens we hadn't been able to share with anyone.

Margie couldn't stop smiling. "We're all going to be part of things again," she said.

"My mother didn't want to let me out of the goddamn house," Hank said. He had a fancy little tape recorder playing Mantovani into his ear. "She'd want me to just sit there. 'You'll hurt yourself, Hank'—that's all she ever said. Christ."

Betty and Norma, Fred and Hank were all twenty or younger. They seemed to wear their sexuality on the surface, swaggering, boasting, provoking, wrapped tightly in their double-knits, doused with skin bracers and colognes and pimple creams, suffering the pain of an exploded adolescence. Had it not been for their blindness, they probably would have been revving up their twin carburetors at that very moment, leaving black rubber tire tracks in the streets of Providence or Arlington or Fall River.

"Yeah," Betty said. "Just because we can't see doesn't mean we're not normal. You know what I mean?" She turned and muffled a laugh with her arm.

A very large, older man, also named Fred—we dubbed him Big Fred, the other, Little Fred—told us pathetic stories of his family. "They don't know how to say nothin' to me no more. They don't know what to say to a blind man." Herman and Norma recognized the problem and nodded. "And the kids on the block call me 'the blind Greek.' Jesus, I don't like that."

Dot roared with laughter as we told stories of our clum-

siness, of banging into everything, feeling one another's newest bruises, shattered calves, scarred foreheads. "Open doors get me," Dot said. "They just come right out of nowhere."

"Kids' shoes," Kathleen added.

"Stairs, stairs going down," I said.

"Yeah," a chorus of voices agreed.

"Fire hydrants."

"Dogs."

"Low branches."

We complained for hours—about talking to an empty chair when someone leaves the room without warning, about being dragged across streets against our will by well-meaning people wanting to help; about being yelled at because we're presumed deaf as well as blind.

We were a bedraggled, motley crew, the fifteen of us, grotesque and fascinating. I felt more comfortable that first evening at St. Paul's than I had felt for a long time, even at home. I belonged here, and I began to love *my* group. I swore that I'd do anything in the world for any of them. They were *my* people.

I couldn't sleep for hours the first night. I had met my blind demons and they were Dot and Tommy and Ray and Margie. I felt the thrill of beginning love affairs. I wanted to protect them all with my superior vision. As everyone snored in our narrow, squalid space, the women on the other side of a thick fire door wired to an alarm, I thought of their wrecked lives, for the first time in a long time not thinking about my own.

I tried to fall asleep with music, which I always carried on buses and trains, even on the shortest trips. I felt that my music defined me, reminded me, even at lost, unhinged times, of my identity. Above all, I kept my Beethoven

quartets near me, and now I tried to fall asleep on the back of a lilting section of the C-sharp-minor Quartet. Images of Tommy's left eye wouldn't leave me. In the loud snores of my dorm mates I interpreted diabetic pathologies no internist had ever dreamed of; with my new friends' tossing and turning, I feared the last spasms of hypoglycemic convulsions. I awoke later during that first night to hear only the spinning of my empty tape reel, and when I shut it off, all was quiet.

Our days were very tightly scheduled with classes, meetings, and counseling sessions. We learned cane technique, braille, typing. A shapely young woman from the neighborhood came in once a week to lead the group in yoga. "Hey, Andy," Little Fred whispered. "She must have some tits."

"How do you know?" I asked.

"I rubbed against her," he admitted, grinning from ear to ear.

Miss Freid seemed to enjoy soothing us with her mellifluous voice, exciting us with rumors of her terrific body. Big Fred's bones creaked as he tried to raise his legs slowly. Dot was game for anything, stretching and straining, laughing at her own gracelessness.

Felix, a fencing instructor from MIT, came on Friday afternoons just before the start of our weekends. We dressed in padded vests and screened face guards to lunge into the air in front of us, yelling "touché."

"It teaches you to locate the source of sound," Felix told us, "to be sensitive and quick."

Little Fred got to be so good at it that Felix took him to MIT one Friday to fence with a blindfolded fencing master. Fred creamed him.

We were blindfolded for all of our instruction, even

Techniques of Daily Living, led by a Brookline housewife who tried to teach us table manners. Mrs. Steinberg's dainty etiquette provoked us into catapulting lima beans from the ends of our knives. We carried on heated debates about the propriety of using mashed potatoes as a mortar for peas. We poured coffee from a giant urn into our paper cups while Mrs. Steinberg watched, noting those who sneaked a finger into the cup to feel the rising liquid.

"Do it by weight," she cajoled, as Rosemary, a proper middle-aged lady from Milton, held her cup under the spigot, the coffee flowing like the cresting tides onto the floor below.

Mrs. Steinberg gave us long lists of organizations that provided the blind with aids and gimmicks for signing checks, handwriting memorandums, labeling our colored pairs of socks with little tin tabs brailled: *bl* or *bk* or *br*. Through her we learned of the industries providing us with brailled watches, noise-making carpentry levels, brailled knobs and rulers and measuring cups. We practiced dialing the telephone and counting bills and change by feeling the edges of coins, folding the bills in several ways depending on denominations. Mrs. Steinberg teamed up with Miss Kluski, our typing teacher, in an interdisciplinary effort to have us write to the various businesses providing materials for the blind. Over our awkward signatures we typed the same laconic message: "Please send me your catalog. Thank you in advance."

In the kitchen we had individual lessons from Stella, an obese young woman who was as lonely as many of us had become. Much to the displeasure of the administration, Stella made friends with the trainees, her fatness being a stigma in the world like our blindness. With her, we tried to identify herbs by smell, though her perfumes, lotions, and

deodorants made a musky goulash of rosemary and thyme. We learned to use specialized kitchen equipment, to peel vegetables, to trap a slippery fried egg, to listen to a medium-rare hamburger. I baked a challah, my crowning culinary achievement at St. Paul's, and when everyone asked for the recipe, I practiced both my braille and typing in a real-life exercise.

At night, alone on my little cot, plugged into Pharoah Sanders or a Mozart quintet, I wondered how my community back home would ever understand my new pleasures. How would those theoreticians, those woodsy intellectuals, and doyens of progressive education respond to blind Big Fred or the joy of a solo trip to Newton Corner or a neatly eaten meal, no peas rolling down the table, no long red stains down the shirt front.

The classes we had with Mr. Cristofanetti, an old sculptor, were the most interesting and original of anything taught at St. Paul's. He himself looked to me like an El Greco, gray bearded, noble, on the edge of ecstasy. With his eyes turned upward, he lived, at least part-time, in a spiritual realm unknown to me. His profound and genuine concern with blindness anchored him, prevented him, I thought, from rising beyond reach. He called his exercises "videation," the visualization and conceptualization of unseen things. We were asked to focus all our senses on an object or a territory, then to use it and know it, as we might have done with sight. We charted the placement of trees and poles by feeling a kind of sound-shadow on our faces. We climbed over park sculptures to form extravisual impressions of them. Across the street, at the College of the Sacred Heart, where, with him, we were never trespassers, he made us walk blindfolded from one soccer goal to the other, a hundred yards away.

Later, as I'd step onto a curb after crossing a tumultuous intersection, I'd thank Cristofanetti for helping me to set my interior gyroscope.

We studied small raised-line maps of the area and transposed them into full-scale landscapes that became as familiar as they would have been with sight. He spun us in revolving chairs and raced us insanely through the St. Paul's lobby to teach us that we need never be disoriented. His was an artist's organization of space, a rage for order from the chaos we inhabited.

At times, my mind seemed fuller than it had ever been, cataloging empirical clues—the wind, the sun, the time, the overhanging dangers, the textures underfoot, the openings and closings of space, the flow of people and traffic—while constructing a map, a plan, a purpose, and an order. Like painters and sculptors, we organized not only the reality we could feel through the touch of the sun on our foreheads, through the presence of mass or the sound of emptiness, but also the colors and shapes of our dreams now that color and shape existed only in that sphere.

"Remember color," Cristofanetti would urge. "Actively, deliberately recall it. Do mental calisthenics to bring back the bright blue sky, a bowl of lemons, limes, and oranges. Otherwise," he warned, "you'll lose it forever."

Because of him, we didn't have to settle for just the shrunken world we could reach and touch. As clouds and mountains receded to the realm of memory and trees became the piece of rough bark under our palms, or houses became the step we stumbled over or the doorknob we held in our hands, Cristofanetti urged us to bring the clouds and mountains back, reconstructing with us in our minds' eyes the roofs and windows of houses, the architectonic shapes of

trees. He made blindness so challenging that I sometimes found myself tingling in anticipation of further proof of my own ability to overcome another obstacle.

The Center operated by the rules and philosophy of a priest, now dead, named Thomas Carroll, who had dedicated much of his life to the understanding of blindness. Total blindness was the condition the Center staff felt best equipped to handle, but because the arbitrary legal definition of blindness brought them people just over the edge of the 20/200 category, like me, they blindfolded us all, even those in the group whose optic nerves had been severed. This ardor to equalize us overlooked the needs of the partially sighted, who wanted to learn how best to utilize their remaining vision. But St. Paul's, like the Boston cop who beat the "ersatz" blind man senseless, felt that if you're going to teach the blind, they damn well better be blind. And so we were asked to wear the black plastic occluders everywhere. They were like fancy ball masks except for the absence of slits to see through.

My superior vision didn't seem to be resented by my fellow trainees, but the staff, dedicated as they were to the truly blind—they tolerated light perception—made me feel guilty about seeing. Miss Hennessy, the psychiatric social worker who was virtually in charge of all St. Paul's activities, made sure I felt like the privileged impostor in a world of blackness and woe.

"Please get your occluders, Mr. Potok," Miss Hennessy reminded me several times a day. On mobility lessons, in Newton or Boston, the occluders made perfect sense. Not only did they give me the immense satisfaction of being able to tackle the tumult of congested streets while completely blind, but also, in traffic, my little bit of sight was dangerously distracting. I was safer learning to listen hard than to

strain to see the blurred car coming through one of my blind spots. But during the few minutes between classes, strolling leisurely on the grass near the rosebushes, or even in the insipid ugliness of the linoleum lobby, it seemed preposterous to deny myself the last vestiges of vision, vision I expected to keep for a while longer.

Once you have reduced everyone to an equal blackness, the next step, according to old Father Carroll, was to allow the grieving process its time and space. Because blindness was considered a death of the eyes, Kubler-Ross–type grieving stages were deemed appropriate, even essential, in our rehabilitation. There were indeed those among us who were severely depressed and who needed time to deal with the depression, anger, shock, or denial; but there were others, like Dot and Tommy, who were dealing mostly with the frustration and inconvenience of blindness.

Miss Hennessy was in charge of the grieving process. She was driven by her profession's thirst for underlying causes. Whatever the cause, Miss Hennessy was quick to rationalize its place in our rehabilitation. Our reactions and subsequent adjustment of blindness would be deftly linked to some intimate bit of submerged material that she had pried away from us. Though we were presumably at St. Paul's to learn the skills necessary to lead independent lives, the blindness was often assumed to be a "presenting problem," the tip of the iceberg, under which it seemed to us that Miss Hennessy, with the religious fervor of the Inquisitor, was looking for the behavior and history that had provoked God's wrath in the first place.

Miss Hennessy seemed sculpted out of polyester resin or epoxy. A sculptor named Gallo had created lifelike full-size figures that I liked very much. Miss Hennessy seemed to me

a Gallo sculpture. She seemed to inhabit a face and body mask, carefully composed with black eye pencil, cerise lipstick, and permanently waved jet-black hair. She sometimes wore little gold earrings, which spoke of a tender, yearning woman behind the constructed exterior. I wanted to gently blow into her ears and suck her earlobes, thinking that the whole Miss Hennessy might thus come to life. Her bosom, and it was a single entity, solid as the Green Mountains, was held together by unyielding armor. Nothing protruded; all was fused into one solid form. Even more than her ears, I fancied airing out her breasts, letting them hang loose, taking them to the beach to put color into what I imagined to be white and unhealthy, creased by the snaps and buttons of her protective covering.

Her office was a monk's cell located directly to one side of the main entrance, thus giving her a splendid view of the many activities that took place there. She saw us all as severely depressed, and if we acted to contradict her assumptions, we were offering her proof of our denial and had to be moved more forcefully along the craggy path of our rehabilitation. Her God-given calling was to mold us with her consummate professional skills, with her credentials, training, protective jargon, and secret assumptions. She wanted to be the midwife at the birth of the newly socialized blind person, to be that mother duck who is first seen—in our case heard—and forever followed by the hatched ducklings. For that purpose, in weekly individual sessions Miss Hennessy prodded our aching unconscious. She was on the lookout for slips of the tongue, for our areas of uncertainty, as she listened intently for clues betraying what she thought were our real problems underlying blindness.

"Well, Mr. Potok," she would start. By the end of the first week, everyone at St. Paul's was on a first-name basis except

Miss Hennessy, who insisted on this professional distancing. "How are things going for you at home?"

"I haven't been home much since I've been here."

"Yes, I know, Mr. Potok. That's why I ask. Are you staying here over weekends because of troubles at home?"

How I wanted to share everything with her, to say: listen Bridget, I feel so desexed, so powerless, so repulsive. Take me in your polyester arms and stroke my limp psyche. "Things are okay," I would say. "Blindness isn't easy. . . ."

"You're sexually compatible?" she would ask.

"Like rabbits."

"And your daughter, Mr. Potok? You must have some pretty strong feelings about passing the RP on to her."

"She's just having trouble at night now. . . ."

"Yes, but we know that will change. She'll be as blind as you. . . ."

"I know," I said feeling weepy in spite of my resolve not to let her get to me. "She still has a long sighted life ahead of her. . . ."

"Not that long," Bridget Hennessy said. Just outside her small window a section of the braille class gathered, smoking and enjoying the perfect fall day. Linda, my mobility instructor, had just brought Margie back from a lesson. Everyone was joking and laughing. "You have to deal with your guilt, Mr. Potok," Miss Hennessy said. "Just because you are educated and probably have some idea of the process of the unconscious, don't think you are exempt from it. . . ." I wanted to twist her smooth neck, hang her by her rosary beads. "Well, that's all for today, Mr. Potok. And by the way, Miss Dawson says that you've been talking with her about her mother. I think it best if you leave all the therapy to me."

My position at St. Paul's was equivocal. Nobody knew that

as well or capitalized on it as much as Miss Hennessy. My background was urbane, privileged, even exotic. Miss Hennessy periodically felt compelled to reestablish her authority, to smash suspected competition. It must have been partly my imagination and partly my own feelings of insecurity on the subject, but I was convinced that she thought it a grave error in judgment for St. Paul's to have accepted me in the first place, not only because of my residual vision but also because she must have known from experience that it was always irritating to deal with clients who asked too many questions, thought themselves too knowledgeable, and pestered authorities about their rights. Every time Miss Hennessy and I passed in the hall, I thought I detected a faint sardonic smile that said: you're as manipulable as anyone else as long as you're here.

People like me had been a very small minority in all the years of St. Paul's existence, not because the institution discouraged our attendance but because the privileged blind usually chose to learn blindness skills at home. A banker I know with RP visited St. Paul's but could not make himself stay. The dinginess, the constant Mantovani on the record player, the notable absence of his kind sent him home, where he hired a chauffeur and built himself a house with ramps and sliding doors. Some of the privileged blind people I know have hardly felt an interruption in their lives. The menial tasks are done by others, and travel is difficult only for the poor. When a tenured university professor I had met began to lose his sight, another secretary was added to his staff, and even though blindness is never easy, it is certainly easier for those who have money and those who need not change their work.

At most any time of the day, sitting in the lobby between classes, I could expect to see a teary, flustered trainee bolt

out of Miss Hennessy's office, having just painfully disclosed some delicate information about early masturbatory habits and now in mortal fear that it would become public knowledge. In staff meetings, in fact, she would insist on entering into our files all the damaging material she elicited from us about our politics, drinking habits, and sex lives. These files were open for all the staff to see, as well as our rehabilitation counselors back home whose funds had enabled us to attend St. Paul's. Because, much to Miss Hennessy's horror, I had made friends among some of the staff, I was sometimes told the content of my own file, in which there appeared, among many other things, a record of the time I tacked an antiwar poster to the wall of the staff room. After much discussion, and over Miss Hennessy's protests, it was allowed to remain because it was "good for his rehabilitation."

Once a week, we were required to meet as a whole group with Miss Hennessy and a consulting psychiatrist named Dr. Gruber. We met in the musty basement where six large Formica-topped tables were pushed together to make one vast white area around which our chairs were pinned in place, pressed against the walls. It was a rather ingenious way of capturing fifteen unwilling blind analysands.

We straggled into these evening sessions like kids to chapel, the last ones having to sit next to Miss Hennessy or Dr. Gruber. The two leaders entered together, after most of us were settled. They sat down, spread their notebooks and papers, looked around for signs of mood, and waited. We always started with a long silence, sometimes ten minutes' worth, by my watch, disturbed only by squirming and tortured clearing of throats. Miss Hennessy sat very straight, while Dr. Gruber, an ardent emigré from Budapest, slumped in his chair, his hair slightly mussed, trying to look

relaxed. He seemed as relaxed as a banker meeting with the Palestine Liberation Organization.

Some of us, like Dot, wore occluders even down there. Though a powerful overhead battery of fluorescent lights hurt my eyes, I refused to wear occluders. I was assigned by the group to watch as best I could, then to report, after the session, any visual clues such as meaningful looks between our two leaders, their frustration, nervousness, or pleasure.

Often, someone like Little Fred came in late and squeezed his way by to find a seat, past Dr. Gruber, to Miss Hennessy's right. En route he would collide theatrically with the back of Betty's chair, and the ensuing antics— Fred's writhing with pain, Betty's giggles, Hank's guffaws— would buy us a few more minutes. Then the giggles ended and we were inside the tense silence once more.

Miss Hennessy started. "Mr. Papadopoulos, would you care to tell us why you were crying yesterday?" Big Fred had cried because an old buddy of his died. As he answered now, he began to sob again. Big Fred was the oldest among us, perhaps sixty. He had told a couple of us about his dead friend, his confidant of long standing. "Did you feel a special closeness to your friend, Mr. Papadopoulos, because you were in the middle of grieving for your eyes?" Miss Hennessy asked.

"I don't know," Fred said as he blew his nose loudly.

"Don't you associate the death of your friend with the death of your eyes, Mr. Papadopoulos?"

"I don't know," Fred answered. "I guess so." He was being set up for things he didn't seem able to handle, at least not now. The rest of the group started to stir uncomfortably. Miss Hennessy's measured questions continued.

"Are you crying for your friend or are you crying for your blindness, Mr. Papadopoulos?"

Fred's face contorted into a kind of shocked puzzlement, eyes and mouth wide open, exposing by the light of the fluorescents his newly installed teeth, alabaster white in the center of a wet, twisted face. A pitiful, defeated moan came from that mouth.

"Why don't you leave him alone?" blurted a strong voice on my right. Miss Hennessy flushed and glared at Ray. He was tough, with a boxer's pummeled nose and gruff voice.

"Mr. Long," said Dr. Gruber, speaking for the first time, "why are you so angry?"

"I'm not so angry," Ray snapped, "but can't she see he's crying? I mean, give the guy a break." Miss Hennessy was scribbling furiously now. I could see it, everyone else could hear it.

"Tell us, Mr. Long," she said, controlled but bloodthirsty, "you were a childhood diabetic and now you are quite blind. Tell us if you will, Mr. Long, why, in spite of the obvious dangers, you and your wife are about to have a baby."

Pandemonium erupted in the cellar. Ray was pale and unintelligible, others were yelling in his defense. Some argued and some sat silently with their heads lowered, wishing this were all a bad dream. Words like *cocksucker* and *motherfucker*, uncommon in mixed company at St. Paul's, pierced the humid cellar air. The pipes banged and whooshed. Miss Hennessy's ears were red, but she sat through it like a trouper. They had engaged us, and I could almost see the triumphant expressions on their faces as they dutifully awaited a lull, to start again on a more cooperative level.

Their technique was dizzying. They now offered us their understanding, and we ate from their hands. We listened as they pronounced judgment on Little Fred's denial, Ray's and my guilt, and everyone's fear and depression, as they

acknowledged, with smiles and supportive phrases, our stories of misunderstanding and neglect, our bitterness for having lost whatever equality or superiority we might have once had.

Miss Hennessy did what she was supposed to do. She provoked and dug below the surface. She was the only one who had the courage to inform Tommy that he would look better if he covered his ghoulish, bulging eyes with sunglasses. Her training and her years in tiresome agencies for the blind hadn't entirely eroded her humanity. The whole St. Paul's staff must have wearied of the same recurring problems, year after year, group after group: the skills learned and forgotten, the jobs almost won, the suicides and early diabetic deaths, the promise gone sour, the short-lived hope vanished.

I paced constantly at St. Paul's, inside the building, round and round the lobby, through the creaky wooden corridors, in and out of the empty braille room, up and down the cellar stairs. I walked through the cold, unlit cellar room that housed some half-dozen typewriters on which we had lessons three times a week, and back upstairs into the TV room, where I often found Big Fred and Herman with their ears turned to the tube, listening to the Danny Thomas show or Lucille Ball reruns. "That's got to be Andy," Fred would say as the floorboards grumbled and I stood on the threshold looking at the two of them. I would often fix the flickering vertical hold on the old set and go back into the lobby, where I had rearranged the chairs into a circle, an innovation that met with Miss Hennessy's disapproval. "The rows were good enough for all the groups before you, Mr. Potok," she had said. But everybody liked the geniality of the circular arrangement, and Miss Hennessy had to give in. I

would sit for a moment next to Ray or Margie or Hank to chat, and then spring up again to pace or walk outside under the big old trees that spread over the ample grounds. I often left the estate altogether now and, slipping on my occluders, practiced with my cane on the deserted side streets of Newton.

I knew that Kathleen was particularly aware of my restlessness and energy. She seemed to enjoy the breeze that swept across her cheeks as I flew by, and she often interposed with a request or a comment. "Hey, Andy, run down and get me a Coke, would you?" and I'd fly down the back stairs to the soda machine. "Sit down a minute, speedy," she would whisper, blushing, "and let me feel your beard"—which had grown an inch or so since my first day there. And as she took a sip on her Coke, she brushed a cold, wet fingertip along my ear and let it slip tenderly to the side of my neck. Kathleen liked my nervousness, especially since no one else moved much in the first weeks of our training. And the one who moved least was Katie herself, who would sit like a proper matron with her legs tightly crossed and her sleek black hair pulled severely into a bun. During the day, she hoped to go unnoticed so that she could avoid the exertion of a mobility lesson in Boston traffic or even a braille class, for which she was often unprepared. She would hail me on one of my rounds of the building to whisper into my ear, her hands cupped around it and her breathy voice exciting me: "You sit next to me in braille class, sweetheart, and when that deaf old bat calls on me, for Christ's sake, help me."

Succeeding as a student at St. Paul's was terribly important to me, not so much because I couldn't get along in the world without these blindness skills, but because I simply needed to succeed at something. For a long time, I felt that

there was nothing much in my life to praise. Since painting had gone and its possibilities for rewards with it, I craved any reassurance and success. I felt physically damaged, professionally finished, visually dying, but at St. Paul's I could shine in mobility, braille, videation, typing, and techniques of daily living. Speeding down Centre Street, crossing after a moment's careful listening for cars, turning as the street curved, going as fast as I normally would, that was triumph, that was worthy of praise. I wanted Linda to fill my file folder with superlatives, I wanted to be challenged by ever tougher problems. I wanted Cristofanetti to invent ever newer, more grueling events for me to excel in. On those mornings when Linda decided that I was getting too far ahead of the others and asked me to sit with her in a Watertown coffee shop to tell me about her tangled love life, I felt cheated of new citations for distinguished service or bravery.

In braille class, I wanted to be the best. The "deaf old bat" was Mr. Prendergast, an ex–high-school football coach from Lexington, now in his eighties. He was neither blind nor a braillist. As a matter of fact, he corrected our braille assignments by holding them obliquely to the light and, instead of feeling the raised dots with his fingers, he read the tiny shadows each dot cast on the paper. He wasn't a particularly good example for us, who were struggling to feel each little cluster of dots with whatever was available—the pads of our index fingers or the edge of our fingernails.

In the braille room, we sat at desks pushed up against three walls, while Mr. Prendergast paced slowly in the middle of the room, his large shoes shuffling. The arrangement wasn't supposed to bother the blind. We didn't need a view, that was true, but we felt the odd use of space as a kind of irritating thoughtlessness. "Shit," said Ray, "it's like being

stuffed into an undersized coffin." Prendergast tried to get
us to learn as he must have begged and beaten his ninth
graders sixty years before.

"What's the matter with you, Kathleen?" he rasped.
"You're not entirely stupid. Why don't you study?" Katie
mouthed obscenities under her breath while I tried to find a
way to communicate the answers. I reached to write it out
on her leg or whisper into her ear but couldn't always be
sure of Prendergast's whereabouts.

"Okay," Mr. Prendergast finally pronounced, "tell her,
Andy," and as I muttered: *"Dad fed Gabe a bad beef bag,"*
the old coach would smack me on the back, saying, "Atta
boy, Andy, way to go!"

When I first laid the palm of my hand on a brailled piece
of paper, it felt like gritty sandpaper. To distinguish a single
raised dot in a sea of others seemed at first as impossible as
distinguishing a grain of sand on a beach. It took a lot of
touching, touching in a way so delicate as to have no
analogues in my experience, to learn to separate the whole
mass of them into clusters and then to interpret each cluster
of one to six dots as individual letters, numbers, or
contractions of several letters. We heard fantastic stories of
speed-reading braillists who could scan a whole page in
seconds, both hands working with great finesse and speed,
but to us whose fingernails scratched the little embossed
dots off the paper in trying to prove their very existence, the
tales seemed apocryphal. Braille wasn't easy for those of us
whose hands were callused, nor for the diabetics, whose
extremities suffered from poor circulation. But we all
learned rudimentary braille, not good enough to read books,
but sufficient to label tapes, records, files, cans of food, the
dials and knobs of appliances.

After Katie stopped denying the fact that she was blind,

she learned quickly and well, but in those first few weeks, she would plead an upset stomach or lower-back spasms or menstrual cramps to get out of instruction of any kind. We all knew she was still traumatized by the accident that had cut both her optic nerves, but we also knew that quite often she was tending to hangovers produced the night before at Howard Johnson's or a grubby little bar in Newton Center. The Cokes I would bring her served as a diluting bath for the gin consumed the night before.

Evenings, we sat around in the lobby, the only common room we had. We talked or played penny-ante poker. With poker it was no contest. I would read everyone's up cards to them, while they searched for the braille dots on their hidden cards.

"What d'you say, Andy, a queen of what?"

"Queen of spades for Fred, little deuce of hearts for Ray, jack of clubs for Hank, and I've got a big ten of diamonds."

"Deuce of what?" Ray would ask.

"Hearts, Ray."

"And me?" Katie wanted to know. "Jesus, Andy, I forgot. And listen, honey, some son of a bitch scratched the goddamn braille right off this hole card. . . ."

Poker was exhausting, as was chess, especially since there wasn't a complete set of pieces. Memorizing the whole board anew with each move was too much for us mediocre players.

Late at night, we often ordered pizza, brought by taxi, but the best evenings were spent drinking in the neighborhood bars. I much preferred to go with only one or two people, feeling self-conscious and stigmatized when we went as a large group. I could sometimes see the barman's perplexity or revulsion as he stared at six or seven blind people with

white canes tapping their way merrily into his place for an evening's entertainment. During those evenings, after a couple of drinks, Katie would often tell me stories of her sighted life, stories of cruising with the local cops or the local hoods or both, stories of shakedowns and roundups and high adventure.

During the first couple of months at St. Paul's I didn't much want to go home for weekends, even though everyone else in our group went. I felt cozy where I was and feared the discomfort and threat, even with my own family, of sighted, "normal," life and expectations. On those weekends at St. Paul's I practiced cane travel, listened to my tapes of C. Wright Mills's *The Marxists* or Rudolf Arnheim's *Visual Thinking*, studied braille, typed, did exercises on a broken-down stationary bicycle in the cellar. I ate alone or with some of the old people at St. Raphael's, which housed the geriatric blind. If friends came to visit, I'd have a coffee or drink off the property with them and impatiently hurry back to the Center alone, explaining that I had unfinished work there. I knew I'd be back in the real world soon enough.

Sometimes, over the weekends I spent at St. Paul's, Katie would call from a noisy bar in Fall River or Providence. In these drunken, sexy calls, she would attempt to describe in her gravelly whiskey voice what we might be doing together at that very moment if either she were back at the Center or I were with her in the bar. As the weekends came to an end, I would eagerly await everyone's return, especially Katie's. She would usually be brought back in a long black Cadillac that stopped right in the front of the arched entrance. A small heavy man with black wavy hair would get out slowly from the driver's seat, walk around the car, help Katie out, and walk her inside. She wore her most sedate clothes for

these occasions: heels, stockings, a little furry animal around her neck. The short man would lead her by her elbow, help her into a chair in the lobby, deposit her overnight bag under the rack of coats near the door to the women's quarters, and, without turning toward her again, walk back to his car and drive away. She sat for a while, listening to who was present, and if she heard my voice, she'd ask for a Coke. She later told me that her companion was Frankie.

"Oh, yeah? Who's Frankie?" I asked.

"You know," she said. "Frankie. I told you about Frankie. He's the big man in the area."

Katie was the only one in our group who was completely blind. She saw nothing, not light, not shadow. Not only were her optic nerves totally cut in two, but some months after, recovering from the accident, she walked, eyes first, into the prongs of a wall telephone and had, she confided to me toward the end of our stay at St. Paul's, two prosthetic glass eyes.

My feelings of belonging were undermined by the people who sometimes came, unannounced, to visit me during the week. Each person in our closely knit group had come to represent a heroic struggle, victory over overwhelming odds, a frightening and sorrowful tale. But when we were seen as a group by an outsider, I felt us as inmates in a grotesque zoo, institutionalized freaks in an asylum. When visitors entered the portals of our weird institution, they saw Little Fred groping, a hand extended in front of his face, fluttering his inoperative eyes uncontrollably, defending himself with each step against some hidden enemy. As he moved, his jerky motions, his suspicious sweeps of an area with his cane or his hand, his fitful starts and sideways detours conveyed not the assured student of a new indepen-

dence but a confused macho swagger gone wrong. Or these visitors saw lovely Margie rising from her chair to smack into a half-opened door or to be snarled up, like a fish in a net, among a rack full of hanging coats. To an outsider, these scenes were confusing and wrong, unseemly, even shocking. Seeing one stumbling blind person has its own tension and fascination, I thought, but intruding on a herd of us, bumping into one another, into walls and doors, tripping over canes, seemed to me like kicking over a rock to find a bunch of albino lemmings scurrying for cover.

When my friends Pat and Paul, who lived nearby, came once or twice a week to read aloud to me, I made sure to wait for them outside. The moment they got out of their car, I whisked them through the lobby and down the stairs into the basement, where we sat among the clattering pipes, sipping the bottle of Scotch they sometimes brought. Over the four months of my stay in Newton, we read all of Kropotkin aloud.

After one very busy day, crammed full of mobility, braille, shop, Cristofanetti's videation, and the technique of daily living, I went to bed early and was falling asleep to the Cavatina of Beethoven's Thirteenth Quartet when I heard a crash and loud voices downstairs. Katie was back from Howard Johnson's, and she was lusciously, wantonly drunk. I heard my name. I heard the canes hanging on a rack near the front door hit heavily, making a sound like distant firecrackers. One of the standing ashtrays fell with a thud and rolled grittily down the linoleum floor. "Andy, where are you, you son of a bitch?" I heard her wail. Ray was with her, and I felt sure that he would quiet her and put her to bed. But Ray wasn't doing well either. He growled and groaned and hit the wall with a terrible thump. When he, a

diabetic, was that drunk, it usually meant trouble. He caromed off the walls of the stairwell going up, fell into bed, and began to snore heavily.

"Wait up, you bastard," Katie yelled as she reached the door leading upstairs to the men's dormitory. "Where the fuck is Andy?" she bellowed as the hydraulic closer slammed the door to the stairwell shut behind her. She stood silently for a moment. No one answered. Then I heard the *whoosh* of her cane. It smacked the wall hard. She was furious; furious for not seeing, for feeling horny, for being denied the pleasures of the eyes. We were all furious about that. "Come on, baby, let's do it," she said. "Say something, goddamn it!" She began to climb the stairs, her cane bouncing behind.

My reactions came up from the gut, as true and primitive as if I had met a hungry bear in the woods. I was scared and, God help me, repelled. Not because we were seven men in a small space, almost on top of one another. Not because I had qualms about being with women other than Charlotte. Not because Katie was unattractive. She was soft and round and wonderfully loose. I gulped for breath. I was repelled because she was blind. I wanted to scream with the horror of this revelation. I wanted to punish myself, scratch out my own eyes.

I turned to the wall and tried to stop breathing. I was absolutely still. Little Fred, in the bed next to mine, whispered, "Hey Andy, you want me to stop her?"

"Tell her I'm not here," I murmured.

"What?" Fred asked.

"I'm not here."

He stood up in his shorts and felt around for his pants. Katie had reached the top step, panting and muttering: "Come on, baby." Fred was now in the hall, trying to deal with her. "Not you, you son of a bitch," she howled.

"He's not here," Fred said. "He's out. Away for the night."

"Bullshit," Katie roared.

"He's gone," Fred said, and then he whispered in her ear and she smacked him with her handbag. Then they were both on Fred's bed, and I heard the rustle of clothes and soft curses.

The door downstairs slammed again, and heavy footsteps came up the stairs. Snyder, the nighttime supervisor, there to help the diabetics in case of emergency, stumbled drunkenly up. Big and gawky and grubby, Snyder walked into a night he would never forget.

Fred and Katie untangled easily. He escorted her to the women's dormitory, where she knocked the toilet off its moorings, flooding the downstairs. He put the toilet back together only to be yanked away to deal with Ray, who was convulsing with a serious insulin reaction. It seemed the Day of Judgment had come. In the convulsions, the deluge, the upheaval, I stood in my shorts, full of self-loathing and shame. Horrified, I witnessed Ray being carried out on a stretcher. His jaws were clamped shut and all his muscles rigid. He was handed down the stairs, making incomprehensible gurgling noises. They brought him back a day later, his chemistry fixed for the moment, ready again to drown his fear and anger.

Katie never talked about that night. When, a few days later, someone spoke of her apocalyptic binge, she said: "I guess I really tied one on."

I didn't recover, not really, for a very long time. It turned out to be a matter of years before blindness—hers, mine, all of ours—became, quite simply, the inability to see with our eyes, nothing more. But as I faced the wall that night, trying not to breathe, I saw only scooped out rotting sockets, decay

everywhere, and heard horrendous sounds, like fish eyes popping in a hot oven.

On our last day at St. Paul's, having "graduated" more or less successfully as bona fide blind people, Katie's cheeks were sopping wet from the tears she shed for not knowing, as none of us really did, how to live away from the safety of St. Paul's and the fourteen others who were more like her now than anyone she knew. I kissed her wet cheeks and cried myself, because our worlds had come together for this strange interlude, but they were so very far apart that chances were we would never see each other again.

Coming home to Vermont, I felt worse than I did before I left. I had learned the skills of blindness. I felt assured that even when the last bits of my vision disappeared, I would still walk in the streets, ride buses, read, take care of most of my needs, and remember the sighted world. I knew that there were thousands of others like me, even worse, and they were people of all sorts: smart or dumb, rich or poor, radical or reactionary—and blind. The knowledge of all that was comforting, but I couldn't adjust to my community— those gifted, bright, and creative friends who could see. More than I had ever imagined possible, their very existence threatened me, their expertise and imagination struck me dumb. I craved isolation or a place in a blind community, to face only the blind and the limited problems of blindness. The revulsion I felt about blindness I turned against myself, and with fierceness, certainty, and nausea, I hated myself for being blind.

T E N

During the first few days alone in London I experienced a lightness of step I took for a slight visual improvement. I began to allow myself an unashamed immersion in my total health. In the first week, I had dinner a couple of times with Staś and Edith, once in Edith's house in Golder's Green and once, at my insistence, in a small health-food restaurant near Regent's Park. I stopped smoking the day after Charlotte left and felt righteous. It was easier to stop than usual, and so I jumped at the chance to piggyback onto my ever-pinker lungs the prospect of body-wide regeneration, including ever-pinker retinas. I spent a lot of money in a little natural-vitamin shop near the health-food restaurant, stocking up on vitamins and minerals I knew existed in the eye, returning later for those I'd never even heard of, just in case. I walked back to my neighborhood and stopped into Sesame, the local health-supply shop, for a bag of sun-dried raisins from Afghanistan, a large jar of Rumanian honey, and a vegetable sandwich for lunch.

The other people inside seemed to know one another. They were weighing out seeds and nuts in brown paper bags, discussing the merits of ginseng, sprouts, tofu. Everyone seemed straight and healthy. I did my best imitation of a fully sighted person, making believe I could read labels at the distance I estimated as appropriate for my

age. I smiled and noisily crunched the huge raisins plump with seeds. I started on the flat bread filled with bean sprouts, carrots, and cucumbers, as I waited on line to pay.

A voice behind me said: "Digestion begins in the mouth." I turned to see a very thin girl. "Chew it well," she advised, and smiled. I decided right then to satisfy my pursuit of health in private, perhaps stealthily, without group reinforcement. Outside, I crossed the street to listen to a minor brawl in front of the pub.

I carried my packages to the top of Primrose Hill, where I finished the sandwich, popped a few more gritty raisins into my mouth, and washed it all down with a bottled nectar. I wanted a cigarette desperately and was about to bum one from an old man sitting on a bench not far from me. Instead, I stretched out on the grass and listened to the muffled noises of the city below. It occurred to me that with this cleansing, health-producing arsenal—and I intended to add yoga to my regimen—I wouldn't know which, the Afghanistani raisins, the yoga, or the bees, would be responsible for the return of my sight. I sat up and laughed. The man smoking on the bench smiled at me. "Nice day," he said.

"Very nice," I replied.

"American?" he asked.

"American," I admitted.

"Just visiting?" he wanted to know.

"Actually, I'm here for my eyes. . . ."

"Harley Street specialist?" he asked.

"No, a rather . . . a strange . . . a fringe method . . ." I said.

"I see," he said, becoming more interested. "I see, I see." He stubbed out his cigarette and leaned forward, his elbows on his knees. "Shall we say a spiritual quest?" He paid no attention to my protestations. "Primrose Hill, on top of

which we are both sitting, is one of the spiritual centers of the world." He pressed his eyes closed with his fingers. "I come often, just to sit."

"Really?" I said.

"As you may know," he said, "Boadicea, at the head of the native tribe of the Iceni, fought and was soundly defeated by the Romans on Hampstead Heath. She was the first to establish the long British tradition of stoutly opposing the inevitable. . . ."

"Oh, my," I said.

"Yes, and her sacred bones are buried in the barrow under us. People come from everywhere to this very spot for spiritual refreshment."

I was willing to hear anything, believe anything, but I was glad Charlotte wasn't present.

That evening, as I stoked up the pot of brown rice, I fantasized a wonderfully uninhibited sex life that might spice up my self-absorption, but as I sat there, stuffed and smiling, I decided that this would be a celibate time—spiritual, healthy, and free of entanglements. After my supper, I took the train to Piccadilly Circus to see a movie. I needed help finding a seat, but once placed I thought I saw the film better, without the customary static swimming before my eyes. Usually, in the front row with Charlotte, both of our necks stiff from being bent backward, she would start reading the titles.

"Hey, you didn't read that one," I'd say.

"Just the makeup man," she'd assure me.

By the end of the film, she would have shifted to the far armrest, irritated by my impatience and stupidity, while I seethed, not knowing what was happening on the screen. Most of the people at St. Paul's, I remembered, loved going to the movies, to be surrounded by dialogue and sound

effects. I hated missing all but the grossest gestures.

As I inched my way to the Piccadilly underground after the film, I couldn't really say precisely what the movie was about.

I wrote letters daily to Charlotte, keeping my health addiction to myself but scrounging for details that might suggest improvement. I wrote a jubilant letter about the movie. The mail was slow both ways, and by the time she received a glowing letter, the hint of improvement had disappeared and I was in the depths of despair again. Soon I learned not to try to communicate moods or suspected changes in eyesight, which left little to write about. But at first, while depressed because I was seeing badly again, I would open an air letter just slipped under the door to make out huge-print CONGRATULATIONS for an improvement that had faded days before.

I called my mother in New York. "How your eyes are?" she asked. "Charlotte says it is up and down."

"They're getting better," I lied. "I don't know what else Charlotte told you, but Helga Barnes is a remarkable woman. The bees hurt, but I'm sure I'm seeing better."

"How Staś is?" she asked. I was puzzled why she didn't want more news of my eyes.

"He's fine. You should call him. He's very pleased about what the bees are doing to me." She was silent. "I asked Charlotte to send Sarah here right away. Mrs. Barnes has agreed to treat her too."

"I talked to Sarah yesterday," my mother said. "She's in school. . . ."

"Why?" I asked. "She should be preparing to come here. She should come immediately."

"Do you really think so?" my mother asked. Charlotte must have been more negative than I imagined.

"Of course I think so. Mrs. Barnes is performing miracles. Didn't Charlotte tell you about all the cured people? She says it will be much easier with Sarah than with me."

"Well, if you really think so, I'll call Charlotte. . . ."

"Yes, right away," I begged. But my mother's remoteness unnerved me. It wasn't like her to question alternative methods like this. She went to fortune-tellers all her life, and to astrologers. Not that tea leaves had much to do with healing bees, but just the same . . .

I pictured my mother after we hung up, sitting at her desk at Maximilian Furs, surrounded by chrome racks of coats and photographs of me and Mark and Sarah and Audrey Hepburn and Sophia Loren and a pope, a few popes back, examining an ermine cape she had made for him. She would no doubt be bothered and get up to sit in the showroom under a fiery red nude of mine. The large painting dwarfed my mother, who wasn't quite five feet tall. She looked old when she was troubled, though at eighty, she was still youthful and vigorous. I imagined one of the tall, thin models approaching her, asking: "What's the matter, Madame Potok?"

"Nothing, Nanette," she would say. "Andy," she would add.

"Ah, yes, poor Andy. . . ."

After I'd been alone for ten days, Sarah arrived. I took the bus to Heathrow to meet her and pushed my way to the rope, hoping to be able to pick her out of the crowd. I didn't see her, and after half the plane had emptied, Sarah, with a big orange rucksack on her back, her long blond hair braided on top of her head, in jeans and white blouse, tapped me on the shoulder, laughing and kissing. "You're going to see again," she said as I hugged her.

"We both are," I said, although Sarah was seeing quite well.

We spent the afternoon in Regent's Park, strolling among the newly transplanted tulips. Sarah was eighteen and in full bloom. Only her round cheeks and big blue eyes still reminded me of her as a child.

"Was it hard getting out of school early?" I asked.

"In a way," Sarah said. "I just started making new friends with the theater and dance crowd. It was hard to leave them."

"I'm sorry, honey, I hope this is going to be worth it. I think it will be."

Sarah pointed to a gash on her forehead. "If it puts an end to these, it'll be worth it."

"Christ, what happened?"

"I was walking back to the dorm at night after play rehearsal," Sarah said, "and I crashed into a fence. It knocked me out."

"Oh, Sarah," I said. "Why were you alone?"

"I was the only one going to my dorm," she said. "I didn't want to bother anyone."

We sat on a bench and Sarah stretched out with her legs in my lap. We faced a pond full of noisy ducks.

"If I'm cured, no more scars," Sarah said. "Do you think she'll really cure me?"

"She seems pretty damn sure. I think she will too."

"Ugh, Papa, tell me about the bees. How much do they hurt? They sound disgusting."

"They hurt," I said, "but they're bearable. And the prize at the end is sensational."

"I was thinking on the plane," Sarah said, "that it's really strange to be cured of something that's hardly made a huge difference yet in my life."

For the first time ever, we began talking about our RP, our shared disease. I had tried, unsuccessfully, in the past, knowing it to be my duty; but I dreaded talking of blindness, *our blindness*, with my daughter.

"When did *you* first know you had it?" Sarah asked me.

"I discovered I couldn't see at night soon after we arrived in America. I remember being scared walking down Seventy-first Street until my mother told me that I actually had something wrong with my eyes. A doctor had told them."

I'd just learned recently about that first doctor, whom I didn't remember at all. Till then, I remembered some vague talk of shell shock; that my night blindness would disappear with my adjustment to America. But apparently we did sit, my parents and I, at a doctor's office, and he told them the whole story, the only true one until Dr. Lubkin, almost twenty years later. I try to picture the scene: a middle-aged Polish Jewish couple, speaking practically no English, and their little boy, anxious to please. They had just escaped the war. The doctor had seen the first darkening of the retina, the little chicken scratchings on the expanse of healthy pink. I wonder what he said to them, if he said the words *retinitis pigmentosa* or if he wrote it down for them. I wonder if my father took the piece of paper to the library or to a friend for translation or if he lost it. That doctor did convey the concept of blindness to them, for my mother says she knew I'd be blind from that time.

"I guess I knew all along, too," Sarah said. "You and Mama never believed me, but I couldn't see at night. When you took me to Dr. Lubkin, she didn't tell me anything either, but I was pretty sure I had it because she looked so hard and long, then she spent hours testing my field, and she seemed to be disappointed."

"She didn't tell me you had it either. Just that she suspected something and when you were grown up she would recommend an ERG."

"I guess she was right. I didn't need to know then. I probably wouldn't have understood anyway."

We got up to walk again, and with our arms around each other, we made a few heads turn. A pleasant breeze blew ripples on the pond.

"I remember a lot of eye doctors," I said. "German ones with pince-nez glasses, fat Viennese ones, rude Spanish aristocratic ones with hyphenated names who rushed from one examining room to another. I knew, from the time I was little, that these were important excursions, the ones to ophthalmologists, because they were the only ones that Nona, your grandfather, and I ever made together."

"Really?" Sarah asked. "Not even to movies?"

"We'd sit in these fancy offices awaiting Herr Doktor's verdict. He always spoke in whispers, as if to some higher power, while my parents craned their necks to catch every syllable."

"They didn't understand English all that well," Sarah suggested.

"It wasn't in English," I said. "It was mostly German, which *I* didn't understand. And I was never told a damned thing."

"Didn't you ask?"

"They'd say: 'the doctor said you have to take your pills,' that's all. I hated the pills. They were nicotinic acid, which made my face flush a deep red and my stomach ache."

"And *my* diagnosis, Papa. What a horrible day that was."

"I couldn't bear seeing you plugged into all that equipment." I confessed. "You seemed so delicate, so pretty, in that dark little room crammed with machines."

"I didn't mind that," Sarah said. "But Dr. Berson was all business. . . ."

"I guess," I said. "But he has a hard job, telling people they have RP." Sarah had been taking driver's ed. at the time and loved to drive, when Dr. Berson told her she couldn't.

"I knew damn well I had RP without all that fancy machinery," she said, "but not to drive, that was too much."

After her diagnosis, I couldn't get Sarah to discuss RP, nor her future, nor anything. I had tried for two years, but she'd just give me a dirty look and turn away.

"I bet you don't even remember what you said to me to make me feel better," Sarah said.

"What?" I asked.

"You told me that both of us having RP would bring us closer together."

"I did?"

"You did. And I hated you for it."

This saucy little girl child, so blond and pretty, had felt like a bit of a stranger then. Perhaps her mother's child, I had thought, closer to Tulsa, Oklahoma, than Warsaw, Poland. Perhaps I was claiming her that day.

"When he finally agreed that I could drive in the daytime," Sarah said, "I had Rachel memorize the eye chart for me, just in case. I saw it perfectly, but I also knew it by heart."

"Anita memorized it for me when I got my first license," I said. The arms around each other tightened, and Sarah put her head on my shoulder. What a wonder it was to have grown children, I thought. Each of us had a childhood in our past, and like friends, we could compare them. It felt precious and rare.

"At school once, they had an eye doctor check our eyes,"

Sarah said. "When he looked inside mine, he called his nurse and said: 'Have a look at these, they're covered with pigment.' I was terrified. That son of a bitch," Sarah added.

"When I had my army physical, I was classified 1A because they didn't look carefully enough. I had every intention of being a hero, but chickened out as I imagined my throat cut in some dark Korean trench. I went back to tell them about the RP. The doctor looked again and did the same thing your school doctor did. He called his buddies, and they all clucked about how terrible it looked."

We sat down under an enormous oak. "I'm so happy we're going to be cured together," I said.

"Me too," Sarah said. "Helga sounds a little bananas, though."

"You'll see soon enough."

Sarah took over the couch in the living room while I kept Staś's bed. That night, as I lay thinking of this marvelous deliverance, I thought of the night Sarah was born. I smiled with pleasure remembering the little clinic in Mallorca and Doctor Lizarbe, who looked like one of the lantern-jawed Hapsburgs painted by Velázquez. As Joan was being wheeled into the delivery room, she asked my mother, who was visiting, to come in with us. There, baby Sarah popped out like an olive pit from a bursting ripe olive. We all laughed and cried and congratulated one another, Joan and my mother and Dr. Lizarbe and the nurse and me. We felt love for everything and everyone.

I remembered another doctor, one I hadn't told Sarah about. I was fifteen at the time. He was bald and fat, with rimless glasses, and he came out with my parents and me into the marble hallway outside his office. He was trying to find a way to say something to me. We had already

descended the two steps to the front door of his private entrance. My father was bowing and scraping. My mother smiled and nodded. "Mein boy," he said, addressing me for the first time, "Mein boy, you should never have children. . . ."

After Sarah's birth, I painted a series of gory parturition figures, legs spread like spiders expelling tortured, screaming nubbins of flesh.

"Brigitte Bardot," my father called her when he saw Sarah. Even then she was strikingly beautiful.

In Regent's Park, true to her eighteen years, she told me that she wanted to cut off all her hair so that people would love her "for real reasons."

Helga could hardly believe her eyes when she saw Sarah. "My dear," she said, "I had no idea. You are the most gorgeous thing I've ever seen." She leaned over to touch Sarah. "I'm so happy that I will cure you. A beautiful girl like you should never be blind." She sat back and beamed.

Sarah and I sat in two patients' chairs in the middle of the room. Helga finally got up and walked over to a plate of bees. "Why didn't you tell me, Mr. What-do-you-call-it, about your gorgeous daughter? Did you have a good trip, my dearest?" she asked Sarah. "How do you like what's happening to your dear father?" She stepped behind Sarah, and I nearly grabbed her arm to stop her from putting bees in Sarah's hair. But she did, and Sarah winced. "There, that wasn't so bad, was it, darling?" she asked. Sarah said, "No," but tears welled up in her eyes. What am I doing to her? I thought.

On the train going home, Sarah said that the two beestings weren't terrible. She thought she could stand it. "And she's a charming woman," Sarah said. "A little nuts but a real sweetie."

When we got home, my friend Roy was sitting on the stoop at Eton Rise. He was on his way from Vermont to the Cannes Film Festival. That evening, in an Italian restaurant, we discussed the possibility of doing a film on Helga. I pictured the camera chronicling our cure, Helga's rounds of the London hotels, scenes showing the traditional diagnosis and subsequent lack of treatment, and, of course, all the cured patients talking of their bizarre experience.

Alone at Helga's the next day, as Sarah nursed her first stings at home, I brought up the possibility of a film. She listened intently, sitting forward in her chair, her eyeglasses flashing with each nervous movement of her head.

"I'm not interested in more publicity in the U.K.," she said. "The *Observer* and the BBC are good enough for me. But the U.S. is a different matter. I would love to show those American doctors what Helga Barnes can do."

Helga sat back in her chair, scheming. One of her hands was fidgeting on her knee. "Let's ask my Arabs to sponsor the film," she said. "I tell you what, Mr. Potok," she said, remembering my name, "I like the idea. As I've already told you, I will not charge for your daughter's cure. Now I will also treat you for nothing. How does that sound to you?"

"That's very kind of you, Mrs. Barnes but . . ."

"Yes, yes," she said, "I will talk to some people about it. . . ."

"I'm interested in making the film, not . . ."

"Yes, yes," she said. "Off you go now. Off with you. And tomorrow bring that exquisite child of yours again. Cheerio, old scout!"

We didn't speak of the film again for several days. We began meeting other patients on each visit, and Helga's publicity plans, like almost everything else about her,

required confidentiality. But the chance meetings with others receiving treatment were instructive, particularly to Sarah, whose generous opinions of Helga were now being tempered through observation.

As she opened the door for us one day, she was white with rage and ran back into the consulting room to continue screaming at a little boy who was curled up in a seldom-used soft chair.

"You nasty little boy!" she screamed. "How do you expect me to treat you if you whine and cry every time I get near you? One more time and out with you! To go blind by yourself somewhere!"

The boy's mother, a young, bony Englishwoman named Mrs. Dorset, hovered over the child and his brother, who sat on the edge of the couch looking down. Both boys had black hair and black-rimmed glasses. The ten-year-old sobbed into his hands as Helga turned to Sarah and me.

"Children aren't brought up the way they used to be. These sniveling brats don't know how to behave in public." She looked at the older brother. "Now *you*," she growled. "Show us what stuff *you* are made of." She put several bees on the back of his tender neck. "Just look at your brave brother," she jeered at the little one. "He will see perfectly again, not like you." Mrs. Dorset moved from sofa to chair, ready to break down herself but managing to smile politely, trying to find a balance, a way to *be* in this intolerable craziness.

We were silent witnesses, Sarah and I. I, the good liberal, outraged by injustice, didn't say a word. Here, the penalty for even the most timid rebellion was the end of treatment and, we all thought, blindness.

We met the mother and daughter from Manchester, wearing bright green and yellow Robin Hood hats. They sat

on the couch holding hands, touching shoulders. The young woman was the one going blind with RP.

"Meet my riffraff from Manchester," Helga said to Sarah and me. "This is the American chappie I told you about," she said to the women, "and his divine daughter."

She gestured the young woman to a chair in the middle of the room and began putting bees in her hair. The young woman howled, surprising us all. I had not seen another adult respond to the bees like that before.

Helga was beside herself. "You bitchy little idiot," she yelled, hoarse and out of breath. "I will not stand for this." The young woman continued wailing uncontrollably.

Her mother patted her hand, saying: "There, there, darling, it can't be so bad. . . ."

"Can't be so bad?" Helga screamed in disbelief. "Can't be so bad? What do you know about it, you old cow? I have a good mind to lay some bees on you, and then we'll see how bad you think it is."

"Yes, Mrs. Barnes," the helpless woman said, moving away.

"Yes, Mrs. Barnes; no, Mrs. Barnes," Helga mimicked. "Get out, both of you. I will not waste my time! Out I tell you, out!"

Her hands shook as she gave Sarah and me our bees, four for Sarah, ten for me. "Wow," Sarah said when we got outside, "I've never seen anything like that before."

"Neither have I," I said. "It was awful, but at least that won't happen to us. She likes us, really likes us a lot."

Sarah began to mind her beestings more and more. She felt weak, sometimes nauseated, and her plan to join an advanced ballet class, to systematically photograph London, and to keep house "in Staś's little dollhouse," petered out as

she suffered almost constantly from the bee sickness. She slept badly, and if I happened to wake up at night, I would often hear her soaking her wounds in the bathtub or applying Nivea cream from a big pot we bought, or, for sport, killing cockroaches in Staś's bathroom.

Our unique opportunity to spend this concentrated time together, to be cured together, began to be corroded by pain and anger. Staś and Edith tried to be especially nice to Sarah, but she became too irritated and self-involved to be able to respond to them with civility. "They're just humoring me," Sarah said, buried under the covers, facing the wall, a copy of *Our Bodies, Our Selves* at the foot of the bed. "I am a guest, and they're being nice because they have to. They have no way of knowing who I *really* am." The paper-thin moods of her adolescence, the fierce angers and the sluggish depressions succeeded one another rapidly. At first, we blamed the bees for everything. Eventually, we understood that the pain, the itching, and Helga's awfulness were only a part of it. The rest, provoked by the mad scene we had entered, had been building for a long time. We each had a list of disappointed expectations, and this felt like a time especially created to express formerly unexpressed resentments.

"You never gave me credit for anything," Sarah would say. "Everything Mark did was always better."

"That's not true," I would growl. "You're lazy and unmotivated."

"I can't ever be good enough for you! Nothing I do is serious or important. Like dance . . ."

"What about dance! Why aren't you dancing? You were going to. . . ."

"You're unfair," Sarah would say. "I'm sick from the goddamn bees. . . ."

"You just take, take, take. . . ."

"Ha! You're the one who never had time for me. You're the one who was always in his studio painting."

"You're sour and demanding, blaming everyone. . . ."

"And your damned blindness," Sarah would say. "It always has to be at the center of everything."

Sarah started going for walks alone, often returning home soaked to the skin from the London weather. She would then drop into the bathtub and go back to bed. I went out when Sarah was asleep or dozing. I walked gloomily along the ponds of the Heath or sat on a bench in Trafalgar Square gazing longingly at the portals of the National Gallery, or from Millbank up the long white stairs to the Tate. I thought of the Velázquez I had copied in the Louvre, the Goya at the Prado, the Matisse I made for Albers out of colored papers.

Once, Helga yelled at Sarah for wearing a long cotton skirt. "You are too beautiful to be out in a rag," she said. "Only cheap Australian girls in Earl's Court wear clothes like that—and do you know why?—to hide the filth underneath." Sarah was upset but said nothing. As a matter of fact, she smiled and nodded in agreement. We saved all our anger for each other.

During a break in our hostilities, Sarah and I visited a distant cousin who kept an elegant flat in London and traveled regularly all over the world. Vera turned out to be a striking, voluptuous woman. She was rich with inherited wealth and still spoke with a faint Polish accent. She was very interested in our eyes, asking detailed questions. I was aware that she watched me with an intense fascination, particularly as I got up and navigated about the richly brocaded couches or

fingered the precious figurines and the malachite eggs sitting on antique tables.

"I think," she said, "that people who are blind develop extraordinarily sharp senses. I mean all the other senses."

"It's not really true." I gave her my textbook speech of how blind people have to work hard to develop their hearing, touch, smell, but as I finished, I realized Vera couldn't have cared less about my explanations. She wanted to believe in her theory, which aroused her imagination and, with it, her sexuality.

"It would be one thing if you were totally blind and couldn't see me at all," she said, "but I can't bear the thought of your eyes distorting me."

"Why should that bother you?" I asked.

"I don't know," she said. "Yes, I do. It's because I've worked so hard at creating my visual image. Can you see me better if you come closer?"

"Probably." She moved her chair very close to mine. One of my knees was between her legs and one of hers between mine. I saw the sparkle in a blue-green eye, the smooth skin, the frizzy hair. She smelled of Ma Griffe. I looked down at her mouth and saw a provocative smile, a hint of pink tongue between full, moist lips.

I felt Sarah glowering from the couch. "There," I said, "I knew you were beautiful before, and now I'm sure of it." Sarah couldn't bear it and asked where the bathroom was. When she left the room, Vera said: "We must see each other while you are in London."

Sarah came back, and we all had a fancy tea, the fluted silver laid on a large marble coffee table.

"You have a very dishy father," Vera laughed.

"He's my father," Sarah said, "and he can't see very well."

Sarah felt much sicker the next day. When I called Helga to say that she wanted to skip a day of bees, Helga said: "I've been thinking about you and worrying."

"Worrying?" I asked, suddenly afraid. "About what?"

"I don't like the way you're not improving. . . ."

"But I've had some improvement. . . ."

"Not enough."

"What do you mean, Mrs. Barnes?" I stammered as my knees gave way and I sat on the edge of the bed, shaking. "You kept telling me not to worry, that you have never failed and you won't fail with me. . . ."

"I know, I know," she said impatiently, "but I am very discouraged. Not enough is happening. If something doesn't happen soon, I'll have to let you go. I don't know. I must think about it."

When I hung up I called in to Sarah who was half asleep in the living room. "Sarah," I said, "she's just terrified me. She doesn't think she can help me."

Sarah made a sleepy grunt.

"Sarah," I said, coming into the living room, "it may all be over soon. She wants to think about it and let me know. . . ."

"What about me?" Sarah asked, not opening her eyes.

"She didn't say anything about you. I imagine she'll want to keep working on you. It's different."

Sarah turned from the wall to look at me. Then she turned back.

Helga was very businesslike the next day. Tom Larkin, a fast-improving patient, was there, getting almost twenty stings in his bushy hair. "That should do you, you old scoundrel," she said to him. "He comes once a week," she told me, "for booster stings." She slapped Tom on the back. "Get a haircut, for Christ's sake," she told him. Now that I

had been threatened, I craved that familiarity of hers as I would have craved a reprieve from a rejecting lover. Tom left bantering merrily with Helga. When she came back, Sarah and I sat shrouded in gloom.

"I've been thinking Mr. Potok, about the publicity," she said quietly and carefully. "How can I accept publicity from people who don't improve? What kind of publicity would that be? Of course I don't know about your daughter yet, but as for you, it is discouraging."

"But what about my improvement?" I asked again.

"I've been talking to my chartered accountant," she continued. "He thinks I should not be keeping people who don't improve quickly. He says that it's bad for my reputation."

"But my improvement . . ."

"Yes, I told him that you had some improvement, and he suggested that if you want to stay you should write me a letter describing the improvement carefully." I perked up. "You should say how blind you were to begin with, how the bees have affected you, how you see differently now."

"Oh, yes," I said. "I can write that."

"And your daughter, too," she said. "I want her to write how she is seeing better."

On our way home, we stopped at a stationers to buy good rag paper and envelopes. They were light blue and felt substantial to the touch. We stayed home all evening, writing and rewriting our testimonial letters. The next morning we handed them in.

"Dear Mrs. Barnes," mine said.

I am writing you this letter to let you know how much the bee-venom therapy has already helped me, even though my treatment is hardly finished yet. When I came to London, I was

practically blind. Now I can walk all alone, I see colors, I can read print a little, and altogether I see things more brightly in dim light. Expecting everything to get better still, I am extremely happy to be undergoing this remarkable treatment. It is well known, of course, that no one except you, Mrs. Barnes, is able to cure retinitis pigmentosa.

Sarah wrote a similar letter, fabricating details about walking to a restaurant in the dark on unfamiliar streets and seeing everything clearly. Our letters were carefully read and turned out to be acceptable. I watched with a sinking feeling as our two light-blue envelopes were filed with the other testimonials.

"It is simply your black depression, Mr. What-do-you-call-it, which is holding us up. Christ, you must be difficult to live with," she said. "But I have not failed yet and don't intend to start with you. So, on we go."

I worried all the time now about being kicked out, and as we sat in the middle of her "consulting room," listening to those dreadful stories of hers, I began to fidget and even rise from my chair before Helga had excused us.

"You have to stop that, Papa," Sarah scolded outside. "You're being mean to her, and she will kick us out if you continue. Don't be so damned impatient and depressed," she added angrily.

One Sunday, we arrived very early in the morning, as requested. Helga let us in and then flitted about nervously, tidying papers, fidgeting around with seldom-touched bric-a-brac in a cupboard. She was breathing quickly and said nothing to Sarah or me, as if the picture were still incomplete and other props and persons still expected. Sarah and I sat self-consciously, looking in her direction,

waiting. When the doorbell rang, Helga raced to it, then chirped happily as she escorted a mustachioed young man with curly black hair into the room.

"How is your charming wife?" she asked, "and your wonderful parents? Your brother, how is your poor brother?" The man seemed cheerful. Before he answered, she said: "This is my dear chappie from Lima . . . and my two Americans . . . Mr. . . . Mr. . . . and his daughter. . . ." We all stood, shook hands, sat again.

Helga had orchestrated something special. The doorbell rang again, and I heard Tom's cheery voice. She had put out two more chairs, and we all squeezed into the center of the small room, surrounded by the empty couch, the upholstered easy chairs, as Helga faced us from her customary place.

"You start," Helga said, pointing to the Lima chappie. "Tell us how you are seeing."

"Better all the time," he said without hesitation. He had a Latin accent but spoke English well.

"Better all the time? What does that mean?" she coaxed.

"For instance, Mrs. Barnes," he said moving to the edge of his chair, "my wife drove us into one of those parking garages near Euston Station—"

"We don't need to know exactly where," Helga muttered.

"—where I usually see absolutely nothing. I might as well have my eyes closed in that darkness. . . ."

"Yes, yes," she urged.

"I saw beautifully," he said.

"Beautifully," she repeated, looking at me.

"It is such an enormous relief," he continued.

"And are you happy, cherub?" she asked.

"Of course, Mrs. Barnes. I am very happy. No one could do these things except you."

Sarah looked interested, understanding her role as appreciative audience. I boiled with rage and humiliation. It was all for me, this show.

"Where is that bloody Dirkson?" she asked, looking at her watch.

"And you, you old blighter," she said to Tom. "How about you?"

"Well," he said, looking elfish, "I have some really good news."

"Tell it, tell it," Helga cried.

"You know how my boss was about to make me a janitor?"

"Yes, yes, Tom," she said. "His boss wanted to get rid of him because he couldn't see."

"He is so pleased with my eyes now that he is about to make me a foreman. . . ."

"Foreman?" Helga was surprised and utterly delighted. "Did you hear? My little long-haired mechanic will be a foreman. And who is responsible for that, I ask you?" Everyone but me smiled for Tom's good fortune. "Are you paying attention, my American friend? Everyone is improving except you. You have lied to me, I am sure of it. You have probably been filled full of drugs and haven't told me about it. There is *something* in your water. . . ."

"No, of course not," I said. "I told you about everything. Except for antibiotics and such things, I've never been on any drugs. . . ."

"Papa," Sarah said softly, "don't you remember a few years ago you used to drive to Burlington for some drug?" Helga moved up on her seat. Everyone was silent. I blanched. I had forgotten an antidepressant I had taken experimentally.

"Aha," Helga bellowed. "His own daughter has found him

out! Her father is a liar! You have been caught, my friend. . . ."

The phone rang in the hall, and Helga went to answer, glaring as she passed. I wilted in my chair. My ears were buzzing loudly. Jorge Salomon, the Lima chappie, leaned over to me across Sarah, who looked flustered, as if she was just now realizing what she'd done.

"You must never lie to Mrs. Barnes," Jorge Salomon said to me, and I just barely controlled my right hand, which had formed into a fist. I turned away from him and looked at Sarah. I didn't know what to say.

Helga returned. Her cause was reinforced by unexpected allies, and she swaggered, in her glory.

"Ha!" she roared. "I knew it, I knew it! It is *always* the filthy patient who ruins the cure. The bees are only bees; they do what bees do. But you! If I had known, I would not have taken you in the first place."

I felt that even Jorge Salomon and Tom were sorry for their part in the melodrama.

"We all make mistakes sometimes," Helga said unexpectedly. "Still, I believe you lied deliberately."

"I didn't, Mrs. Barnes. The drug was so unimportant that I forgot to mention it."

"A likely story," she said. "I don't know why, but I'm going to give you another chance. I can no longer guarantee a cure, certainly not a complete one. But now that I know something about the drugs and the depression, I will simply have to work harder to help you at all. And don't you dare lie to me again."

Sarah apologized on the way home. "I said it because I thought it might be helpful. I thought if she knew, she might figure out how to treat you better."

We met Staś at the cafeteria in Kenwood, inside the Heath. We carried our tea and scones to a round white table on the terrace where Sarah joined Staś in trying to console me. Little birds chirped all around us and even descended onto our table to eat crumbs from our hands. I swept them off with my arm, and they squawked in the trees above us. "Goddamn trusting English birds," I murmured. Staś and Sarah both turned away.

MAY 21

. . . Sarah excused herself immediately after dinner at Edith's, and after slamming the door, she disappeared down the street. She is impossible! I sulked and bitched with Edith and Staś, until they finally drove me home. Sarah still not back as I tape this. What started out as a honeymoon has turned into a nightmare.

(From Sarah's journal) MAY 21

I had six stings today, three in my hair, two in front of my left ear, one in front of the right. They hurt terribly, and maybe I'll get so sick I won't have to go tomorrow. Papa is depressed and restless, anxious about everything. I can't stand him anymore! On top of it, I'm getting depressed, and Papa is not helpful! Dinner at Edith's. Wasn't hungry but forced myself to eat so I wouldn't have to answer questions about why I wasn't eating. I have to repeat everything at least twice for Staś. I left early, walked around, took the laundry to the laundromat, came home at two, killed a giant cockroach, and went to bed.

When we walked together, Sarah began to lag behind a few steps, until, one day on Rosslyn Hill, heading for the deli, I pivoted around furiously and told her that she should go to live with Edith or Vera, that this couldn't go on. She

ran off, and I heard her return very late that night. The next morning I found a note, written in large print, covering several sheets of paper. "Papa," it said,

> I'm sorry. We have both been just awful toward each other. It's horrible to bear all this together. I hate the bees. I hate Helga. I hate all the pain. I feel lonely and helpless. I guess I want you to be my Papa, to take care of me, to bear my pain as well as yours. I can't bear your being dishy and sexy, not yet. But you probably are, and I *will* understand. I can't bear your needing help from me or anyone else. I still want you to be the biggest, strongest Papa in the world. I'm sorry. I *am* growing up. I love you. Sarah.

I felt immensely proud of my daughter. She had come through. She had disentangled us with her love and understanding. I felt ashamed of my unbounded egocentricity.

I wondered why my stories of improvement weren't as convincing to Helga as the Lima chappie's. His sounded as insubstantial as mine, and yet she liked him and mistrusted me. I had always been able to charm my friends' mothers in school. I charmed my mother's customers. I charmed ladies everywhere, but not Helga anymore. Sometimes I thought that she was a Zen master who knew precisely what she was doing. In some strange way, she was, perhaps, teaching me about myself.

I even started to believe her claptrap about seeing drug remains, from years back, "in the water." Sarah and I scoured the libraries for information on the subject. I felt like old blind Milton slave-driving his daughters for the sake of . . . poetry? . . . truth? . . . beauty? . . . no, for the mysteries of piss. Mostly we found standard explanations of

the use of urine for analysis. The sediments found there could not, as far as we could determine, reveal much of anything farther back than twenty-four hours. Then we found some fascinating material.

There was an eighteenth-century cult called "the piss-prophets" who claimed to diagnose disease by observing urine samples. "Whoever hangs out a piss-pot for his standard," a contemporary critic wrote, "pretends upon sight of your water to tell your infirmities and directs medicine without seeing the sick person, believe them not! They are cheats not only for the sixpence or shilling for what they call casting your urine (which much better would be cast in their faces), but for drawing you in with some fearful story of your danger and making you take a packet with you of their stuff."

In place of the urine of a middle-aged man, a flask of cow's piss was once sent to a German quack named Meterbach. "Too great a pleasure in women," read the diagnosis. There is even a modern story of a farmer sending to his vet a well-known beer instead of the animal's urine. "This horse is unfit for work and should be slaughtered immediately," was the reply.

As for me, I went out drinking one night with a friend and polished off, much to my amazement, a half bottle of Johnny Walker Red. The next morning I remembered that Helga wanted "the first morning water." She and I had discussed the evils of alcohol, and she told me stories of patients she had chucked out when she found "a pint of whiskey in their water." I thought that now surely the jig would be up, as a good pint should have filtered down, and I imagined that a chemist should have been able to trace the various blends to their rivers of origin. But Helga found the water "wonderfully clear" and that day prophesied another improvement.

I put the "water question" aside as pure foolishness, but still I wondered why others were being helped by venom and I was only desultorily touched by it. I became obsessed for a while with the notion that an undiagnosed cancer lurked somewhere inside me and the venom was being depleted in curing *it*. Edith, in whose house I took refuge from time to time, thought that in my efforts not to be swayed by suggestion I might be physically rejecting improvement, erring on the side of negativism. "Stop evaluating everything, Andy darling," she said. "Relax and let the improvement come."

I began to feel that the more bees Helga put on my neck, the better my chances for exorcising all the things I now imagined to be wrong with me. She started using twelve bees at a time, and I hoped that the number would increase. But as she laid six in my hair one day, calling them "six of my best," I found myself cheering them on as they stung ferociously. Digging my fingernails into my thigh, I tried to will the poison into every area of my body, every distant tissue in dire need of relief and regeneration. There seemed to be something noble about one's tolerance for poison and pain, and I wanted to be able to absorb more than anyone had ever done before me. "Sting, you sons of bitches," I chanted deep inside myself. "Fill me with poison, move my viscous fluids, cleanse the lifelong accumulation of civilization's muck."

In spite of my decision not to do so any longer, I fretted constantly about the approaching Armageddon. I tried now to keep these preoccupations from Sarah, but I fretted about my single acid trip of years before and the two on mescaline, about smallpox inoculations and a childhood allergy to sulfa. On one such sulking afternoon, Ben Berman of the Retinitis

Pigmentosa Foundation called. He had called once before to express his interest in what I was doing. Though he felt committed to orthodox medical research, his two young daughters were going blind and he dismissed nothing out of hand.

"We're proud of you," Ben said. "We think you're pretty goddamn brave to be doing this." His voice seemed to ride the crests of waves through which it traveled.

"Jesus, Ben, I need a pep talk. We're pretty depressed."

"It's true, Andy," he drawled in his Baltimore twang, which sounded more exotic than ever. "Listen, we want you to make lists of all her patients. Names, addresses, phone numbers, so we can contact them all if things get better for you and Sarah."

"That'll be easy enough," I said. "I'll start right away. But my days may be numbered here, Ben. She is threatening to kick me out. . . ."

"Why?" he asked.

"It's hard to explain. She doesn't trust me. . . ."

"For Christ's sake, why?"

"I'm not improving, she says, as fast as she is used to. She's looking for excuses to get rid of me so I don't join a list of her failures."

"Are there failures too?" Ben asked.

"I'm only guessing. But there's something vague about her so-called successes. I don't know."

"Listen, Andy, the other thing is that we're in contact with a beekeeper in Vermont who wants to work with us. If she kicks you out, you can come back here and we can continue the experiment."

"That's wonderful, but she claims her bees are unique, Ben. That no one else knows how to feed them or breed them for RP."

"Our man in Vermont says that's bullshit. All bees eat the same stuff."

"That's great, Ben," I yelled. "That means if bees are the answer, it's all bees. Right?"

"Right. And listen," he continued. "I want you to find out all you can about the cure. Is there anything you can think of to do? Is there an assistant, a secretary, a nurse?"

"She suspects everyone and employs no one. Some patients volunteer, and they're all terrified of her."

"Where does she keep her bees?"

"I don't know. But she says they're not at her house. She goes somewhere twice a week, I think, to pick up bees."

"Can you follow her?"

"I can't see. . . ."

"Right. Can you hire someone?"

"I don't know. Let me think about it. . . ."

"Never mind. Don't do anything that makes her suspicious. But if something positive happens, we'll come over to talk with her. . . ."

"She'll suspect you. She won't talk to you. She's already mentioned the Foundation as a bunch of crooks."

"Never mind, Andy. When we're ready to talk, she'll talk. Everyone has his price. And listen, as soon as she says she's finished with Sarah, we want to bring her back to Boston to have Eliot look for clinical changes."

The conversation gave me new life. I felt buoyant. If Helga booted me out, a friendly beekeeper in Vermont would take over. Bees ate only honey, he said, not the rhubarb, dried eggs, whiskeys, fermented yeasts, cereals, or other garbage that Helga said she fed them. There are different strains of bees, Ben was told, but the chemistry of their venom remains the same within the entire species.

Once, in my innocence, I had asked Helga how bees are

made to eat these strange diets, and she had said: "You know, cherub, how a dog can be made to eat even when he's full. All you need is another dog nearby. Well, it is the same with bees. I hold a box full of buzzing bees near my noneaters. They will eat whatever there is, don't you worry."

I was comforted by the Foundation's support. I felt they were absolutely correct in not dismissing anyone's claims without careful consideration.

The Foundation was less than five years old. Prior to its existence, practically no work had been done on the retinal degenerations, a whole series of diseases that had thoroughly stumped researchers. The Foundation was born of American outrage that a blight such as RP was allowed to thrive in the land of the Big Vaccine. Mix equal amounts of American money and American science, they reasoned, and we'll bomb RP right back to the Stone Age. Local chapters from coast to coast were formed to sell buttons and trinkets, to run raffles, rummage sales, and auctions. They solicited money from industry, they infiltrated service organizations, they found friends on Capitol Hill. And right within the mecca of Harvard's Massachusetts Eye and Ear Infirmary, they installed a laboratory, the first of its kind, whose sole purpose was the study of retinitis pigmentosa and allied retinal degenerations.

On the November afternoon that the lab was inaugurated, there wasn't a dry eye on Charles Street. In a large auditorium, filled with well-wishers, Charlotte and I held hands as we listened to speaker after speaker predict victory over RP. "We are finally on our way," they all said as I looked at a fragment of Charlotte through a mist of retina and tears.

We toured the new laboratory, bristling with the pride of ownership. We were investing our brightest hopes in those few pristine rooms, and as I walked through, I touched the instruments, all the shiny new metal, the plastic, the titanium heads of the ultracentrifuges, the diamond-cutting knives of the microtomes that would slice donor eyes into minute layers to be examined under the electron microscope. Awed and hopeful, I peered at that enormous device, through which, someone was saying, they would focus easily on the outer segment of a single rod or cone.

On the walls around the space-age controls hung posters of rods and cones magnified ten thousand times. Through what little remained of my own photoreceptor cells I peered at the huge ones on the wall. They were like bulbous seed sacs and spindly reeds surrounded by the eerie seascape of the eye. I imagined these rods and cones as they swayed this way and that, aroused by light, recharged by darkness. They were supposed to grow, like a kind of neuronal escalator, constantly being born on one end and dying on the other. It was thought, the biochemist was saying, that perhaps a failure of the retina to metabolize the dead rod and cone clippings caused the debris and blindness in the RP eye.

The normal eye, the eye belonging to most everyone in the world, is the sense organ through which people gather most of the information about the world. It is a spheroid, one inch in diameter, whose complexity permits a person to see, under ideal conditions, a single lit candle seventeen miles away. The light is guided onto the retina, an assemblage of nerve cells a half millimeter thick, by way of the cornea, which sheathes the eyeball, through a clear watery pool called the aqueous humor, then through the crystalline lens that refracts it, through another gelatinous pool, the vitreous humor, and through a web of blood vessels and nerve fibers.

Having passed through this maze, the light registers a sharp, inverted image on the retina, where it excites the cells that transform its energy first into chemical and then into electrical charges, the language of the brain. Electrical impulses, generated in the retina, travel via the optic nerve to the back of the head, where they are interpreted by a visual center, the seat of perception. The system is, to say the least, intricate and uncanny, and continues to work, except in the case of a tiny minority of people, for the entire life of the body. The failure of any one of the parts, though, interdependent and essential as they all are, is potentially blinding.

Some parts of the eye are easier to fix than others. For instance, neither the cornea nor the crystalline lens depends on the blood supply for nourishment, as does almost everything else in the body, and they can therefore be replaced in one way or another without excessive threat of tissue rejection. Moreover, even this threat of tissue rejection for the cornea is much less than it was in the early days of grafting, and though the eye's lens cannot be replaced by an organic one, it can be replaced by lucite. The retina, however, is not only a part of the brain itself, embryologically derived from it and linked to the visual cortex by millions of connecting fibers, but it is also entirely dependent on the blood and therefore the proteins, hormones, vitamins, and other nourishment carried by it.

Sometimes RP doesn't exist alone but as one of several even more debilitating malfunctions such as deafness or mental retardation or both. Whether part of a larger syndrome or not, it is associated with a faulty gene or genes and thus transmitted to new life. The gene can be dominant as is Sarah's and mine, or recessive or sex-linked. The most common form of transmission is through a recessive gene, meaning that one parent must mate with another carrying

the same recessive trait in order to produce a child with the disease. This gene is carried unsuspectingly by one in eighty human beings, worldwide.

A few days after Ben's call, Helga mentioned the Foundation and made me suspect extrasensory perception. "I talked with someone from *your* Foundation," she said scornfully. "You don't know him, but he says he knows who you are."

"Really?" I said. "What's he doing here?"

"He's not here. He called from New Jersey or Boston, I think. He wants to come for treatment. I said no."

"Why, Mrs. Barnes?" I foolishly asked.

"Because I don't want any of your meddling doctors snooping around here."

"I see."

"What do you do for that Foundation?" she asked.

"I don't do anything for them. To me, they're like a central place where I can find out about other people with RP. I sometimes try to help other people going blind. . . ."

"They are a bunch of scoundrels," she said. "They raise enormous amounts of money and distribute it among themselves and their doctor friends. Why do you think they all get so rich?"

"This Foundation has a lot of people on its board who have the disease or who have children with it. . . ."

"Don't insult my intelligence!" she screamed. "Those thieves don't want to find a cure. The cure is right here, and they should know it. A cure would put them right out of business."

Roy came through London once more, on his way back from Cannes. Another friend, Chet, had come to blow glass in the Midlands, and all four of us camped out on Staś's beds and

floor. One evening we went to a Knightsbridge theater to see a new Polish movie, and even though the quality of the film was atrocious, I saw it relatively well, and afterward, walking through the dark streets, I had my new eyes once more, this time just for the evening. I walked ahead of Roy, Chet, and Sarah, and they saw me pirouetting around parking meters, lampposts, fire hydrants. They saw me easily spot curbs and evening strollers. We stayed up late that night, all of us convinced that I would take up painting again.

Sarah, too, was beginning to report what she took to be real changes. One morning, as we walked down the long dark circular staircase in the Chalk Farm station, she said: "It seems to me as if they turned on extra lights this morning." I ran back upstairs to ask an attendant about extra lights.

"You Americans," he barked, "you think electricity is cheap."

"I'm not complaining. I want to be sure that there are no extra lights."

"And why do you want to know that?" he queried suspiciously.

"It just seems brighter. I was wondering—."

"Of course there aren't any extra lights," he said. "And I'll wager it'll be another fifty years before the lights change at Chalk Farm."

My evening's improvement hardly caused Helga to raise her head to look at me. Even Sarah's description of the Chalk Farm incident made little impression. Helga was agitated and preoccupied, giving us bees quickly and dismissing us minutes after we'd arrived.

She told us one morning that she was negotiating with the Arabs.

E L E V E N

Helga's involvement with Arabs had been a mystery. We heard about them all the time but never saw any of them. Depending on her mood, she would regale us with stories vilifying them as drunken primitives, or when they were praising her know-how, her bees, and her wisdom, she spoke of them as gods, not only wealthy beyond our imagination, but kind, humane, and discriminating. She treated them for everything. From her choppy tales, interrupted by stray, dissociated thoughts, I pictured her whiling away long afternoons on thick Persian carpets at the Grosvenor House or the Dorchester, playing Parcheesi with their demented children, whose idiocy or retardation she attempted to cure with bees; or telling flamboyant stories of her life to veiled fat women who giggled politely but longed to be back in the desert, sipping Coca-Cola. When an Arab potentate, speeding back to the hotel from an illicit rendez-vous with a buxom English wench, turned his Mercedes over on the M1 in the pink of early dawn, Helga would arrive later that morning to lecture him on temperance and lay bees all over his bruised and weary body. She treated them for diabetes, myopia, idiocy, impotence. She tried to soothe their headaches and their menstrual cramps. "How they love me," she would often say. "There is nothing they

wouldn't do for me." And she would show us expensive handbags from Harrod's, gold brooches from Cartier.

Toward the end of May, she announced that she was going to Abu Dhabi for a few days. "I couldn't refuse," she explained. "They are sending a private plane for me and offering me *everything*. But can I share my secrets with those blacks?"

"Blacks, Mrs. Barnes?"

"Blacks, browns, whatever they are," she said. "They are not like us."

She had warned us all at one time or another about the serious side effects of sudden withdrawal from bee venom. "Some bodies cannot deal with this. They have to taper off slowly, as you will see for yourself when it is time to stop." But she prepared no one for her absence. As we patients ran into one another on the streets of Beckenham, we talked of this. "It's a bloody shame, that's what it is," said the mother from Manchester.

The day Helga left, I felt enormously relieved, as if London had finally been liberated from a satanic presence. I vacillated between wanting her back quickly and safely so we could continue our business, and fantasies of her destruction at the hands of ruthless terrorists somewhere over the Persian Gulf.

London had been under the spell of an exorcism trial. One Michael Taylor was accused of tearing out his wife's tongue and eyes, having been "pledged to Satan" the night before. The Reverend Raymond Smith testified that he himself had expelled over forty devils from Taylor's body. Not quite free of them, however, Taylor left his wife ("the darling of my life") to die in a pool of blood on their kitchen floor. The judge's ruling for acquittal was based largely on the Vicar of Wakefield's finding that Taylor was, in fact, possessed by

demons when he tore his wife to bits. The archbishop of Canterbury begged that exorcism not be condemned out of hand and the canon of St. Paul's added that the Church cannot bar exorcism even though too much unfavorable publicity was bringing it to disrepute. "One has to be a little agnostic about all this," he said.

I followed the controversy carefully, for the whole affair made me and my involvement in bee madness feel as rational as Hegel or Marx.

Sarah went off to visit friends in the south who were outfitting a boat to cross the Atlantic. I took Helga's absence as a long-awaited opportunity to get in touch with the doctors who, in one way or another, allowed their names to be used in support of her therapy. First I called a Harley Street radiologist, a Dr. Singer, copies of whose congratulatory letters Helga had Xeroxed for me. For years, she had been referring her arthritics to him for X rays and, in return, he testified quietly and privately to having witnessed improvements in them and in her RP patients as well.

"There is no doubt about it," he told me. "She is performing cures with retinitis pigmentosa, but I would be driven right out of England by the Medical Council if I were to say so publicly."

I told him how she was threatening me and Sarah, how angry she was generally these days, how all her patients seemed to be living in constant fear and dread.

"Ah, yes," he laughed, "that's my Helga. She is like a prickly pear," he said, "barbed on the outside, soft on the inside. My advice to you is to stay as long as she will have you. I can imagine that it's not pleasant, but the longer you stay, the better your chances of success."

Next I called Dr. Ryder, the only doctor who allowed his name to appear in full support of Helga. We met in the

creaky little library of the Royal Homeopathic Hospital on Great Ormond Street. Ryder was lean and, as Helga had said, hungry—hungry for a share of her cure. He was anxious to explore the bees' effect on my body and to be mentioned in whatever publicity I could muster. He didn't seem to know much about retinitis pigmentosa. As we talked, he browsed for RP information through one of the volumes from the near-empty shelves surrounding us.

"What's missing in the retinitis eye?" he asked. "These blokes don't seem to know."

"No one knows," I said. "They suppose it's chemical, but they're doing basic research still."

"Yes, yes," Ryder said in a pretty, BBC accent. "What do you suppose the bees are doing then? Stirring up the adrenal cortex?"

"Helga says 'stirring up the glands.' "

"Do you feel differently right after treatment?" he asked. "Some report feelings of euphoria."

"Euphoria? Only when I think my eyes are getting better. Otherwise depression. Do you mean that some people think the venom itself gets them high?"

"Yes, that's it. But never mind. Let's you and I set up a series of blood tests. Round the clock. Let's take blood before and after beestings, every couple of hours if we can manage it. One thing that should be simple to detect is elevated levels of cortisol." Bee toxin, he explained, increased the body's production of its own organic cortisone.

"What about other biochemical reactions? Can you monitor enzymes or hormones? If you could, wouldn't that give you more clues?"

"Mmm. Perhaps, perhaps."

"Say you found some enzyme or other in larger amounts than normal, and say I was seeing better at the time . . ."

"Yes, yes," he said, "that may be true. It's probably more difficult and expensive though. Let's start with cortisol." We arranged a day for testing. "Let's learn what we can about bee venom," he suggested as we both got up. "I know of a study going on right now at the University of London. Why don't you wander over there and talk with the investigators?"

I said I would.

"And do try to stay as long as possible with old Helga. Though God knows she's a bloody megalomaniac."

The excursions to the University of London and the various hospitals I visited in search of leads were hazardous. I felt old and infirm as I shuffled on the edge of dark, cavernous stairwells, while students, nurses, even patients hurried by. Walking around Russell Square, I bumped a baby carriage and heard the nanny swearing at me all the way to Gower Street, where I turned my ankle on a piece of sidewalk under construction. Inside the university building that housed the department of physiology, I trailed the dark walls with the fingers of one hand while the other one guarded my face. In a tiny office, I met one of the physiologists involved in venom study. Because her research found no significant link between arthritis and any of the substances she isolated in bee venom, she seemed skeptical and tired, though somewhat intrigued by this new condition that she had never heard of. She agreed to send me her published material and to "ask around about retinitis pigmentosa."

I sent off letters to several British entomologists to inquire about the feeding habits of bees and finally felt that I was no longer just a passive acquiescent patient.

I decided to try establishing a scientific baseline for my vision. I called Dr. Ryder for advice, and he urged me to try

a Harley Street specialist whom he hadn't met but who had been highly recommended. I would have preferred Moorfields, I told him—it was the best ophthalmological hospital in England—but I followed Ryder's suggestion instead.

The brass plaque on Dr. Bemari's thick front door was one of the largest on Harley Street. I know because I fingered them all as I bent over trying to read the shallow engraved names on the shiny metal. I knocked, and after a few minutes the heavy front door buzzed and opened. Inside, the place was spacious, a kind of shabby elegance, perhaps the leftover elegance of a previous owner, in which everything looked somewhat out of place, out of proportion, out of scale. A few waiting patients sat at a huge conference table together with Dr. Bemari's secretary, who pecked away at a tiny Hermes portable and turned from time to time to stuff an index card into a box on the mantel behind her. The place had a mannerist air about it, posturing like a stage set, and after waiting a few minutes, I left, happy to be outside on Harley Street, as if it were health itself, pristine and true, like wilderness.

Dr. Ryder prevailed upon me to try again. When I went back a few days later, I was escorted upstairs immediately. The doctor's office was enormous. He was on the phone at a desk in a corner. He was a little brownish man with a squeaky voice, who was speaking alternately English and some Indian dialect.

"Have you been here before?" he asked me, one hand covering the receiver.

"No, I haven't," I replied.

"Who sent you?" he wanted to know.

"Dr. Ryder," I informed him.

"All right, my friend. Sit you down," he said, motioning me to a chair, and, as I approached, handing me a thick cloth. Surprised but properly submissive again, I felt around for the chair and sat down, the cloth in my lap. As he continued talking on the phone, he began fumbling with the cloth, trying to put it over my head. It was a startling turn, and I struggled for a moment. Then I accepted it, whatever *it* was, as the strange norm of Indian ophthalmology. I say that I accepted it, this scene from a Peter Sellers movie, but just for the briefest moment I must admit I was afraid of being bound hand and foot in this black sari cloth to be shipped to his native land and dunked, head first, in the healing waters of the River Ganges. It is, they say, a slow healer, but God's ways are mysterious and unhurried.

Bemari now took my hand and put it on a wooden handle. "Hold this like an umbrella and close your eyes," he ordered. I was now entirely inside the droopy mantle held up in the middle by an umbrella stick. In the coziness of my tent, tingling with curiosity, I decided to see this, too, through to the end. A little excitement would do me good, I thought.

Eventually he hung up the phone and reminded me to keep my eyes closed. Then he asked: "You are here for an eye examination?"

"I'm glad you asked," I said, my voice raised to compensate for the drapery around me, "because in fact it's more complicated than that. I have retinitis pigmentosa. . . ."

"No, *no*, my friend," he admonished. "No, no, no. Do not tell *me* what is wrong with *you*. It is *my* specialty to tell *you*. I am a professor, a teacher of many students, and what I teach is how to tell, by looking into the eyes, what is troubling you. We seek clues in the eye itself to the rest of the body. The eye holds within its perfect roundness the

secrets of the heart, the brain, the liver. . . ." He was now pawing the umbrella, and as he spoke, I realized, with some trepidation, that he had climbed inside with me. He told me to open my eyes, and the bright light of his ophthalmoscope began looking for signs. He looked for a long time, and when he finished he extricated us both and sighed.

He mumbled, first to himself and then, clearly, to me: "Forty-five. Forty-five. Yes, the number is forty-five. . . . How old are you, my friend?"

"Forty-three," I said.

"There, you see," he squealed, jumping a little. "That is very close. I can read it in your eyes. I have also read, my dear American friend, the following facts: You do have retinitis pigmentosa. Yes, that is true. You also have poor circulation and acid in your stomach. How do I know all this, you might ask? Ah, my friend, these are the secrets of the eyes. It is all there, waiting to be deciphered." He rubbed his hands together. "Now, you must listen to me with diligence. You see, dear chap, if you have a carpet . . ."

"A what?" I asked.

"A carpet, a carpet—like this one here," he said pointing to the oriental rug on the floor. "If it is stained and filthy dirty, it is your duty to clean it up." He paused. "You must scrub your carpet until it looks new," he said, rocking back and forth in his chair. "It is, dear friend, just like your retina, this carpet." He pronounced *retina* as if it rhymed with *vagina*. "Your retina is dirty and filthy. It needs cleaning." He leaned toward me and whispered in conspiratorial fashion: "Your optic nerve is not damaged, and so you will never be blind. But you must do what I say to wipe your dirty retina clean." He sat up straight. "You must wash your eyes twice a day by putting lukewarm water into your cupped hands, so, then blinking in the water eight times

with each eye. You will see what marvels may be accomplished by this simple procedure." He demonstrated eight exaggerated blinks in the air. "Then you must gently massage your eyes with your fingers. Like so. Very soothing." His eyes remained closed. "Write all this down." He waited. I had no pen and couldn't see anyway. "A half hour before meals, you must drink a glass of lukewarm water, which will help the acid in your stomach." I never had, as far as I know, excess acid in my stomach. "Then you must take vitamins . . . let us say B and D." He looked up as if for divine inspiration. "Now, because your circulation is not what it should be, abstain once a week from eating meat. All the blood normally helping your digestion will rush up to your eyes. It will refresh them like a summer rain."

We sat silently for a while as he cleaned his gold-rimmed little glasses on a cloth. "Do you wear spectacles, my friend?" he asked.

"Sometimes," I said.

"Will you be good enough to show them to me?" I fished in my pocket and gave him my glasses. He examined them and said: "These spectacles are plus two hundred." He knitted his brow and raised his index finger. "I can give you new ones that are only plus one-fifty. Now, you tell me, my friend. You are an intelligent man. Would you prefer to keep the two hundreds like the two thick blankets of an old man, or the one-fifties, the one-and-a-half blankets of a younger man?"

I said I would keep my glasses for the moment. He looked disappointed.

I tried to cheer him up by telling him about Helga. It had been his show, but I had some pretty amusing material of my own. "I am being stung by bees," I began.

"Where, where?" he yelped.

"I don't mean *here,* doctor. I mean I go daily to a woman who says she can cure me with beestings."

"Curious," he said. "Very curious. But God's ways are strange and wonderful. You will be all right," he said, taking my hand in his. He extended my index finger and rubbed it gently back and forth. "This finger is like your optic nerve," he said, rubbing back and forth, back and forth, "and the palm of your hand is like your retina. The nerve is strong and healthy. . . ." His head was nodding now as he rubbed, and his chair moved slightly forward and back. He was in a kind of trance as he swayed, eyes closed. I felt embarrassed.

"The nerve will fight the retina," he announced, *"and the nerve will win."*

"What do you mean 'the nerve will win'?" I asked angrily.

"Ah, it is a struggle for health. . . ."

"It is *not,*" I said loudly.

"My friend, my friend," he pleaded, "I am the doctor, do not forget. . . ."

"Oh, Helga," I muttered under my breath.

"Medicine is not only fact. Far from it, far from it," he said. I got up, and he asked me to visit him again on my next trip to London.

"When you return," he said, "I can compare photographs. . . ."

"Photographs? What photographs?" I asked.

"The ones I snapped under the cloth," he said. I was slowly moving toward the door. "In England," he confided, "we charge ten pounds, preferably cash, if you can, my friend."

I paid and ran down the carpeted stairs, sideswiping Bemari's dowdy English secretary at the bottom. "I say, Mr. Potok," she said.

"Open the door," I commanded, and she scurried around

the corner to press the bell that released the door lock.

"How could you do that to me?" I asked Dr. Ryder on the telephone. "The man is a charlatan. Wipe him off your list."

"Well," he said as I heard him puff on his pipe, "terribly sorry, old chap, really, terribly sorry."

When Sarah came back from the south of England, I begged her, my Antigone, to do some more library work with me. We went again to the Swiss Cottage Library and came back with a pile of books on magic, quackery, and medicine.

We found some description of Bemari's methods. It was called "irido-diagnosis" and claimed that the configuration of the iris, as the lines of the palm of the hand, was the key to the body's functioning. Irido-diagnosticians divide the circular iris—suspended in the aqueous humor, perforated by the pupil and made of loose vascular connective tissue that, according to the distribution of melanin, shows up brown, or blue, green, or hazel—into some forty segments that, through some metaphysical chemistry, connect to the body's organs and systems.

One book traced the idea for this early-warning system to the wizard Valentine, a medieval magician whose life and thought have otherwise passed unnoticed. It has been taken up again in this century and, until very recently, flourished mostly in Europe, but together with many other alternative methods so long disgraced in the United States, it has now made its way to America, especially to California. Like the dashboard of a car, the iris indicates the body's unfastened seat belt, dangerous exhaust emissions, faulty brakes.

Signs are everywhere. Some show up on various parts of the body as lines, marks, lumps, or patterns, formed at birth or wrought by age and habit and illness. Others are conveniently placed in nature—God's hidden messages—

and fall into a dogma called the "Doctrine of Signatures," which proclaims everything as a sign for everything else. Plants and minerals are blessed by natural signs or symbols indicating their medical use. Yellow wildflowers are thus presumed effective in cases of jaundice; "scorpion grass," now called forget-me-nots, as an antidote to the scorpion's sting; kidney-shaped weeds for renal conditions; "eye bright," so named for its resemblance to an eye, for the maladies of that organ; the human shape of the mandrake root for almost everything troubling the species.

Sarah and I read about transferring one's disease to rocks and stones. We read of amulets and scarabs, healing chants and charms, of strange manipulations, putrid inhalations. We read about remedies whose secret ingredients and passionate rituals made us blush with recognition. We recognized the vigor of impotent healers in Charles II's frenzied physicians, who, on his deathbed, "drained his blood, scarified his flesh, tapped his veins, blistered his scalp, plastered his feet with pitch, blew hellebore up his nose, poured antimony and zinc down his throat, gave him julep for his spasms and purged his bowels." In the feverish attempt to maintain life in the royal carcass, "they administered bezoar stones and heart tonics and, as a last resort, Charles' own quack remedy, the King's Drops."

We found little about bees, although in 1716 a fellow named Salmon wrote in the *London Dispensatory* that "the whole Bee in Pouder given inwardly provokes Urine, opens all stoppages of Reins, breaks the Stone, is good against Cancer, Schirrus Tumors, the King's Evil, Dropsie, dimness of Sight. They treat the Humour and restore Health. Their Ashes, made in to an Oyntment cause Hair to grow specially in bald places."

"Hey, Papa," Sarah said, "your hair, too!"

Everywhere, we found claims for panaceas. Whether the versatile bee or the filings of the single horn of the unicorn (without which the savvy medieval traveler hardly ventured from the safety of home), they provided a cure for everything from the pox to impotence. Helga herself claimed cures for "arthritis and rheumatic disease, skin afflictions like weeping eczema, dermatitis, urticaria, and for asthma, hay fever, sinusitis, and diabetes. . . ." To me privately she added muscular dystrophy, multiple sclerosis, and dystonia, hereditary myopia, glaucoma, uveitis.

Even in the esoteric little world of retinitis pigmentosa, cures and cure-alls vied for patients. Friends began sending me articles from popular magazines, scandal sheets, and reputable scientific journals announcing new therapies, cataloging their many direct and indirect benefits, quoting witnesses and the newly "cured." The British press, too, began to carry articles on RP cures in different parts of the world. Collections were taken, funds raised, labor and management donating in a teary spirit of unity to send RP kids for spectacular treatment with placental-tissue grafts, soups of ribonucleic acid, heavy metals, leucocytes, megadoses of restorative elixirs and potent chemicals. They were being shipped to Oregon, Boston, or New York, to Moscow, Switzerland, Brazil, or India, to Bulgaria, Rumania, or California. And everywhere *someone* got his money's worth; *someone* produced for the hungry press, the donating bank managers, union leaders, tax accountants. DELIRIOUS MOTHER GIVES BABY LIFE OF SIGHT screamed the *Daily Express* or *Mail* or *Standard,* above pictures of pudgy Teresa, Leona, Georgina, with the Kremlin or the jungles of South America or the portico of a prestigious medical school in the

background. IMPROVEMENT IN EVERY CASE TREATED roared some vitamin-pushing monthly or the *Annals of American Science*. I imagined Finland Station crowds cheering at Victoria or Waterloo or Paddington as half-blind children returned from around the globe, sight promised for life, while Sarah and I, obscure and uncelebrated, were being methodically punctured by mutant bees raised in a suburban semidetached by a bitter, raging old lady.

In all of this, healing began to appear more complex than our imaginations had allowed. As we chuckled at the cures of the Egyptians, Assyrians, Babylonians, the Greeks, the Saxons, the medieval Europeans, we began to realize that turtles' brains, verdigris, and the saltpeter of Upper Egypt cured people. Fixed within their ancient paradigm, these remedies cured for the same reasons much of our medicine cures: faith and imagination and will. Sometimes they cured scientifically, because the prescribed goat liver throbbed with vitamin A. Mostly, they healed, as we still often heal, because of our bodies' own restorative power, unless those powers are incapacitated by too much tampering.

We read about Emile Coué, a French chemist of the early part of this century, who was impressed by cures he effected by mistakenly handing out capsules of distilled water. He opened a free clinic in Nancy and lectured extensively on the power of autosuggestion. His motto was: Day by day, in every way, I am getting better and better. Couéism stressed the education of the imagination, not the training of the will. There is, he said, a receptive ambience of the mind that can be brought to bear on disease through disciplined enlightenment. The power for self-healing is buried deep within, Coué thought, and we are all capable of peeling off the repressed layers of rationalism to uncover it.

Sarah's eyes burned from so much reading. She closed

them and leaned back against the wall. I suspected that we both had learned too much about suggestion and placebo to be affected by it.

Most of my life I had escaped RP treatments. What I couldn't always escape was the advice of my mother's customers and friends who, like her, could not accept the fact that this blight of mine was incurable. In the chic grayness of my mother's showrooms, they sat with her after a fitting and filled her head with fabulous stories of the "biggest doctor in New York" or Texas or all of Europe. To satisfy her, I occasionally chose from a long accumulating list, that included a rejuvenation clinic in the Bahamas and the latest marvel of Bulgarian ophthalmology. Once I chose a Park Avenue doctor because his office was reputed to be a prototype of modern interior design.

It was indeed sumptuous, with wall-to-wall fish tanks, whose inhabitants lived in a splendor equaled only by the environments created at the Museum of Natural History. Philodendrons crawled along thick and springy carpets, choice lemon trees stood among the Eames and Le Corbusier chairs, while soft indirect light soothed one's weary eyes.

Her auburn hair washed with streaks of gold, the doctor's secretary took my history and asked me to read a hand-held eye chart in a long hallway.

"Why here?" I asked. "Doesn't the doctor want to do that in his office?"

"This is not for correction," she said with a hint of a French accent. "It is simply to form a general picture."

"I can't see a thing in this hall," I said despondently. "I don't want to do the chart now." I felt humiliated by my eyes in front of this fancy, attractive lady.

The doctor himself was from one of those countries

supposed to have produced the very finest of that year's eye specialists. Head to toe, he was pure Gucci-St. Laurent. After examining my eyes, he dictated to his cashmere-and-tweed secretary, as he looked out the window, tapping on his clipboard with bronzed fingers. "Advanced retinitis pigmentosa," he said in a bewitching Mediterranean accent. "Heavy pigment distributed over both retinas, a pale spiculated optic nerve, constricted vessels, incipient cataracts . . .," on and on. He was saying nothing I hadn't heard before, but he wasn't even speaking to me. After a musical dictation, he turned to me. "You must move to Arizona," he said. "Perhaps New Mexico . . .," where the climate, I supposed, would have soothed my frayed and weathered retinas.

"I am a painter, you know," I blurted out for no apparent reason.

"Yes, I know. I own one of your prints. . . ."

"Really?" I said.

"It hangs in the hallway. Can you see it in that light?"

"No," I said, "not in there."

"Oh, dear," said his secretary.

"It's all right," I said. "I can still paint."

"Yes, of course," she said, looking down.

"Come back in a year," the doctor said. "In the meantime, it wouldn't be a bad idea if you started to learn some braille."

How I hated these doctor relationships. They made me feel poor and stupid and like a bad child who had gotten sick with a disease they couldn't fix.

Even Sarah, so new at the doctor game, had already accumulated her share of experiences. At one point, Dr. Berson, pursuing a tempting hypothesis, asked her and other teenagers with RP to volunteer occluding one eye for a

period of several years. He had observed that the retinas of laboratory rats exposed to strong light deteriorated much faster than the retinas of rats living in darkness. He arranged with an artist to paint a likeness of the patient's eye on the opaque contact lens so that, though effectively blinded, the eye appeared normal. The stakes were high: sacrifice one eye for years in the hope that it would be preserved for future use. Sarah thought about it for a few weeks, had several nightmares, and decided not to participate in the program.

Sarah was giggling now. "Papa, listen to this. It's advice to doctors," she said. "It's from the Turner book."

When called to a patient, commend yourself to God and to the angel who guided Tobias. On this we may learn as much as possible from the messenger so that if you can discover nothing from the patient's pulse, you may still astonish him and gain his confidence from your knowledge of the case. On arrival, ask the friends if the patient had confessed, for if you bid him to do so after the examination, it will frighten him. Do not be in a hurry to give an opinion, for his friends will be more grateful for your judgment if they have to wait for it. Tell the patient you will, with God's help, cure him, but inform his friends that the cure is a serious one. Suppose you know nothing, say there's an obstruction of the liver. Perhaps the patient will reply, "Nay, Master, it's my head or my legs that trouble me." Repeat that it comes from the liver and repeatedly use the word *obstruction* for patients do not understand it, which is important.

Later that day, Sarah came across a plaintive wail from a monk at the time of the closing of the English monasteries. "I have no other means for my maintenance but to turn physician. God knows how many men's lives it will cost."

A week after she left, Helga came back from Abu Dhabi. She called early in the morning to announce her return. "I have sold out to the Arabs," she said. "Everything. I leave in October."

"Really, Mrs. Barnes?" I said. October sounded safe enough. If I weren't cured by October . . . "Can you take all that heat, that desert?" I asked, not knowing what else to say.

"The heat? What do I care about the heat? They are building me a clinic. They have already started. I will see only as many patients as I like. They will give me a beautiful house to live in, a lot of servants, a lot of money. . . ."

"But it's so far away from everything you know," I said.

"That's all right," she answered. "I will put that filthy Abu Dhabi on the map for them. I have arranged to spend seven months of the year there, the rest in England, if the revenue man doesn't take it all away from me. These Arabs love me," she continued, "and what can those dirty Americans do for me except send me more blighters like you?"

When Sarah and I went for our treatment, Helga was flushed with rage. It seemed to have nothing to do with us. She stomped her hard black shoes on the floor, screaming that no one in the West cared about her; that people were begging the postman for her address, then lining up outside her door, waiting to be cured. I wondered what had really happened to her on the banks of the Persian Gulf.

I tried to imagine her life outside these rooms. I tried to picture a history, a childhood, the pangs and dreams of adolescence. Locked within the tangle of her craziness was her battered persona, a one-dimensional mask. I tried to picture her husband, their touching each other, sex. "Commander Barnes was a very proper man," she had said. "Our marriage was made in heaven." And once she complained

bitterly that a young Australian woman had dissipated her cure by too much sex. "Oh, yes, oh, yes," she had said. "You can do it sometimes just by thinking about it too much."

I wondered how she behaved with friends. Or if she had a friend other than the glamorous stars she claimed as friends. "How I loved Rita Hayworth and the Aga Khan," she'd say. "Charming people." Or: "As Sir Arthur Fleming used to say to me, 'Helga,' he would say, 'Helga, darling, don't make the same mistake I did. They will try to pry your secret from you, but don't ever give your wonderful secret away.'"

I tried to imagine her at her hairdresser's, where she had a weekly setting that even I would notice, as her hair would be divided into a sea of curls, then plastered against her head, like a ram. I wondered if she lorded over the young beauticians or if they giggled as she tried to look imperious under the huge hair drying helmet, mumbling stories to herself, her spectacles flashing.

"I fell going up the ramp to the jet," she said. "I really hurt myself, damn it." I hadn't noticed anything wrong, but as she got out of her chair, I could see her limp. It seemed a reassuring sign. "This morning I put thirty bees right back here on my hip," she said, "and you will see how quickly I will heal."

That night I dreamed profusely. I stood in a dark sanctuary before a pair of awesome statues, aglow with fluorescent greens and reds. Two pairs of eyes were buried deep within the faces, black like coals. They had extraordinary power with retinitis pigmentosa. I knew that as soon as the vibration stopped, I would see again. I shot up out of bed to test my eyes and crashed into the open door in front of the light switch. In the bathroom mirror, I saw my face with a certain clarity.

I went back to bed and dreamed again. This time the

dream was full of sound and fury. I stood on a small platform at the end of a boom, like the kind used by telephone linemen. I held the rails as the whole contraption began to jerk up and down, whiplashing me violently. It moved faster and faster, and I didn't mind. Watching me from below, taking my measure within a rectangular frame, was a sculptor who, at the proper time, would transform me into a work of art.

The next day, as I walked to mail some letters home, a car nearly hit me crossing England's Lane. It swerved, the brakes screeched, the rubber left black marks on the cement. The car stopped, and a voice yelled at me. "Watch where you're going, you clumsy bloke!" I stood dazed and trembling. I wished it had hit me.

By the time Sarah and I got to Helga's, there was hardly room for us in the house. Some dozen patients waited for Dr. Ryder to take blood. Helga was sweating and flushed with pride at all the people gathered at one time. Ryder did his job, taking 10 cc's from one and all. He was most diplomatic, greeting me as if for the first time. Then Helga got on to each of us with our bees. I didn't know the purpose of this one-time bloodletting ceremony. It felt like a cocktail party.

Outside, on a little square of grass between the rosebushes, Dr. Ryder told me that it was all a sham.

"I've done this for her before," he whispered. "I don't know why she periodically insists on it, because she doesn't even look at the results."

"Have you any results yet from my blood cortisol?"

"Oh, yes," he said. "I meant to tell you. We found nothing, no changes at all. It's very curious."

A few days later, Sarah was pronounced cured. It came as

a shock, for aside from changes that seemed to come and go, Sarah thought that nothing much had happened.

"There, gorgeous," Helga said, "it is all done, and you can be thankful. I can assure you that had you not come to me, you would be blind by your twenty-first birthday."

In front of Helga, Sarah acted properly thrilled, but when we got outside, she didn't know what to think.

"God, I'm happy to be out of her clutches, never to see that hag again. But, Papa, I don't think I'm cured."

"Let's keep our fingers crossed," I said stupidly.

"You know, sometimes I think there've been little changes, like my eyes getting less tired when I read, maybe also seeing better with my side vision. Oh, I don't know," she said. "The side vision was always okay. I think it was. But never another beesting!"

We called Staś and Edith, who took Helga at her word. "If Mrs. Barnes says Sarah is cured, then she probably is," Staś said.

We went to celebrate at the health-food restaurant Staś had become attached to, and the two of them watched Sarah's every move, inside the place and outside in the dark street. "She sees everything, Andy, darling," Edith said happily. "I'm sure there's a difference."

I called Ben at the Foundation. We made arrangements for Sarah's tests at Eliot Berson's ERG clinic. "Let's hope," we both told each other rather weakly.

Sarah and I agreed that our six weeks together hadn't been easy, but we felt that we had progressed on an upward-moving spiral. As good Hegelians would say, we were synthesizing our contradictions on ever higher planes.

"I'm going to miss you, Sarah," I said, at Heathrow again.

"Me too," Sarah answered. We were both too choked up to continue.

When I was miserably alone again, Helga's patients began to cross the street to avoid greeting me. The day after Sarah's departure, as I waited for the bus back to East Croydon, Mrs. Dorset ran out of the grocery store and, looking left and right, slipped a small piece of paper into my hand.

"This is my address and telephone number," she whispered. "If you would like to talk about anything, call me. I can't talk here for she might see us. She is furious with you and has warned us all not to keep company with you." And then she was gone.

T W E L V E

I had had over five hundred beestings, all in a small area on the back of my neck, an area some five inches square and usually not the object of so much attention. Over a period of two-and-a-half months, this slice of epidermis with all its subcutaneous tissue, its sweat glands and sense organs, was a locus where each day the body mounted its defensive forces against the invasion of poison. I rubbed my neck wildly, as close to the stings as I could without touching the wounds themselves. The pain and itching never diminished. As a matter of fact, they seemed to get ever more intense.

I called Mrs. Dorset, who said that she didn't know why Helga was so angry with me. "I've never seen her this furious, not with the Manchester ladies or my poor Toby."

"How are your sons?" I asked.

"I think there's some change, but it's difficult to say for certain."

I felt as annoyed with her as with myself for hanging on in spite of so little progress. I called Jorge Salomon, the Lima chappie, hoping that he, closer to Helga than any of us, would have a clue. I wanted to know why I had become the object of so much rage and what I could do about it.

"Could I see you?" I asked.

His hand cupped the receiver, and I heard the basso

grumble of a private consultation. Then he spoke. "Why don't you stop over tomorrow after your bees? I live a few blocks from Mrs. Barnes."

I walked over the next day, taking a circuitous route from Helga's, half expecting that she would follow me. Jorge Salomon and his wife had rented a house and car for the duration of his cure. His parents were financing everything, as Jorge himself was still a graduate student in business administration in a Florida university.

The blackness of his unruly curly hair made his eyes disappear, so that when he talked, I saw only the slight twitch of his moustache and an occasional flash of teeth.

"She used to like you, you know. She talked constantly of her 'American chappie,' what a gentleman he was, how charming and educated. For two months I heard about nothing but you. It changed quite suddenly. Now she rages about you because she thinks you're no longer trustworthy, not about drugs or doctors or reporting improvements."

"Do you really believe that? Don't you think it might have something to do with, say, money? You know, I haven't paid her a penny yet. . . ."

"Neither have I," he said.

"Hasn't she mentioned money?"

"She knows my family has it. We keep offering to pay, but she insists on waiting till I'm cured."

"Do you expect to be cured?" I asked.

"By the way, that's another reason she doesn't want to continue with you. She thinks you don't believe in her, that, in fact, you're spying for the RP Foundation. As for me, I think I'm seeing a little better."

"You told her you were *sure*. . . ."

"Of course I did," he said. "I understand the importance of exaggerating. She needs reassurance."

"Do you see better at all?"

"A little," he said, fidgeting with his horn-rimmed glasses. He wanted me out of there as quickly as possible. I heard his wife puttering in the kitchen. She chose not to join us and obviously disapproved of this clandestine meeting. These people had been told that I was a failure and that through association with me, they would be too. I wondered whether I would have acted the same way.

"I think I can read my watch a little better," Jorge Salomon said.

"What about the business in the tunnel and in the garage?" I asked.

"That was more or less true, but it's so hard to judge. I have no reference points. If I were in Florida now I'd know, because I always park in the same garage."

"What's your vision like?" I asked.

"I can see pretty well. It's like seeing through a cashew-shaped opening. I think the cashew is expanding." He paused. "Look, I'm desperate. I don't want to be blind. I *won't* be blind." He pounded a fist into his open hand. "And there is nothing but Mrs. Barnes."

"I think she can cure me too. That's why I'm so frantic about being kicked out. I came to you for advice. I came to appeal to you. You see, my days with her are numbered."

"Yes, they are. . . ."

"Did she say that?"

"Yesterday she said that today would be your last."

"What would you do in my place?" I asked.

He looked out the window into the miniature rock garden that came with the house. "Perhaps I'd bring her an expensive gift. Surely, I'd confess everything. I'd tell her that I tried to hide the drugs because I was terrified she wouldn't treat me."

"That's not true," I said.

"I'd say that I was desperate. I'd flatter her more, tell her how wonderful she is, how she helps everyone, how she's the only one. Things like that."

He had offered his advice and I resented it. His wife called in from the kitchen in a staccato Spanish. "I'm not particularly good at negotiations," I said, "but let me offer you a swap. My daughter is at this very moment being examined by Dr. Berson at the Mass. Eye and Ear. As you must know, Helga pronounced her cured. Do your best for me with Helga and I will keep you informed about Sarah."

"What can I do?" he asked.

"Tell her we met and you are convinced that I am not a liar and that I spoke kindly and respectfully about her." It was humiliating. I felt like a Jew begging a Pole for asylum.

"Let me think about it," he said. I wondered if he was a Jew and if he recognized me as one. His name sounded Jewish, but for all I knew he might have been a German whose parents emigrated to Peru to escape the Nuremberg trials. Going home, I felt like a blind beggar.

That evening, I went to see Bronka, a Hampstead neighbor who had been my landlady in Paris in 1955 when Joan and I first lived there. She prepared a gorgeous meal that I tried but couldn't eat.

"Relax, Andrew," Bronka said. "You look like you're headed for a nervous breakdown." I sipped a Pouilly Fumé that was making me nauseated.

"It is all probably very simple. A matter of money, and why shouldn't it be? She probably doesn't know how to ask for it since you are not one of her star improvers. And don't think for a moment that it is only those cranks who are mixed up about money."

A train, fresh out of Hampstead station, rumbled by,

almost through Bronka's garden. The crystal shook, and we had to wait till it passed to speak.

"When I first came to Paris immediately after the war, I was very sick. My nerves were shattered. I vomited whatever I ate."

Bronka spent part of the war in concentration camps, part hidden in various Warsaw cellars. "My brother was in the French Resistance, and as soon as he saw me he sent me to a Communist doctor he knew well. I waited half the day in his waiting room. Finally he took me and began his examination. He knew I couldn't pay, and he was brusque, even unkind. Each time the doorbell rang, he packed me and my bundle of clothes into a tiny bathroom until he finished with that paying patient. He was a good doctor, just not a very nice man. A few years later, Andrew, when I had some money, I went to him again. He treated me royally, like all those paying patients. I remember that he kissed my hand and asked about my family. As far as I could tell, he had no recollection, certainly no remorse, about the way he had treated me before."

The next morning, Jorge Salomon called me at seven. He had just come home from Helga's.

"She was furious that I spoke with you yesterday. She means to kick you out today."

On the train to East Croydon, I felt almost cocky about the battle brewing, even titillated by being the unaccustomed butt of so much rage. I was now convinced that our struggle would be about money. Staś had withdrawn two thousand pounds from his Building Society account a few weeks before in case of just such eventualities, and I decided that if Sarah showed any clinical changes, I would stake all of it and more. I didn't know what to do if she showed no change at all. From the top of the double-decker to

Beckenham, I thought I could see better. Over the pub whose protruding sign the bus nearly sheared off each time we turned that corner, I deciphered the last word of its name. It was THE KING OF BOHEMIA.

Helga turned her profile to me as I walked in the door. Her face was white. As she followed me in, she began to yell. "Liar!" "Cheater!" "Scoundrel!" "Thief!!" No one had ever done that to me, never in my life. Doctors found me compliant, teachers generally gave me A's. With blindness, I felt I was losing my energy, my control, my competence, but not, I thought, my charm.

"I won't treat people like you," she screamed as she pounded her fists. Like me? Who was more deserving? A decent enough husband, a good father, a painter who had been forging ahead toward the development of his middle years; Yale, class of 1953 (46 percent of whose estranged and alien fellow graduates were making over fifty thousand dollars per annum). Vera found me "dishy." I had good and loyal friends. If my eyes were fixed, I would be a mover, a winner! But at Helga's, I couldn't produce.

"Your daughter caught you in your lies. You have wasted nearly three months of my time and the precious bee venom. Do you think they are free? How much do you think it will cost to fix you up now? I couldn't even ask anyone for that much." She was pacing now, in and out of the room, and panting. "It would take thousands of pounds."

"How much?" I asked.

"A thousand pounds!" she barked.

"I could have it for you this afternoon." I felt wonderful to be able to say it. I was calm and controlled. Amarillo Slim was calling another gigantic pot.

"This afternoon?" she asked, sitting down in her chair. "By four o'clock at the Grosvenor?"

"Yes. I need to make one phone call. May I use your phone?" I felt like Orson Welles or my uncle Max.

"Yes, of course, of course," she said quietly.

I went out into the hall to telephone. "Staś, I'll need a thousand pounds by three-thirty this afternoon."

"I will get it ready for you straightaway," Staś said.

"Just hold on to it," I whispered. "I'm not sure I'll use it."

"Yes, yes," Helga said as I came back inside. "It's remarkable that this should happen today. A friend of mine is leaving on the early evening plane to Switzerland, and he could pick up the herbs that we'll need to feed your new bees. You will, of course, have a few days rest, a period of transition from the old bees to the new, and then we will start all over again. I know what I must fight against to get into your retinitis pigmentosa."

I said nothing.

"Four o'clock in the lobby," she said as she walked me to the door.

It seemed to me that I waited forever at the bus stop. I had to get in touch with Charlotte and Sarah immediately to know what to do. At each change on the way home, I ran from train to train, paying no attention to the people in my way. As I ran into Eton Rise, the phone was ringing.

"I have the money," Staś said. "Come to pick it up whenever you wish."

"Staś, I don't know what to do. She wants to keep me another three months. She says the new bees will finally fix me up. I don't believe her, Staś. How can anyone believe her?"

"You *must* believe her," he said. "You have no choice but to believe her."

"But the money, Staś, throwing all that money away . . ."

"Nonsense," he said. "It's only money, and it is well

spent. If you have any trouble paying me back, don't worry at all. I don't need it and would like to offer it to you as a gift."

"No, I can't do that."

"Have you heard from Charlotte yet?" he asked.

"No. I don't know where in Boston to find her, but I have all morning to try."

It was seven in the morning in Boston. I tried Dagmar's house and found them. "Andy," Charlotte said, "we tried to get you last night but you weren't home. . . ."

"I was at Bronka's," I said quickly and defensively.

"There is absolutely no change in Sarah's eyes."

"Oh, my God! No change at all? What about the dark adaptation test? Nothing?"

"They tested all day. They say that there's some room for error, but they couldn't detect anything."

When we hung up, my knees gave way. Sitting on the floor, propped up by an elbow on a low bookshelf, I began to lose feeling in my legs. I tried to stand up but couldn't. With great effort, I stood at last. I rubbed my legs and walked painfully back and forth. In April, I had been a pioneer; now, in mid-June, I was a beggar, a fool. Helga had more power over me than I could possibly admit.

My alternatives were unchanged, horrendous. Helga or blindness. Surrender to the latter still seemed abysmally boring and uninspired. I looked at my shape in the mirror, cheekbones beginning to protrude, tufts of graying unkempt hair. I imagined an ever-more-distant look in my unseeing eyes, unworldly, prophetic, paradoxical. Inspirational texts would sustain me. I would perhaps join some religious orthodoxy and hope for a better chance next time. Or I would pursue the path of rehabilitation, sheltered work-

shops, blindness agencies. As a provider of services, I would coax mirth and merriment from assembled groups of the blind as we transcended our condition together. On Saturday afternoons, I would organize blind bowling at some guild or Lighthouse or home.

I hadn't expected great transformation in Sarah's eyes, but I did entertain notions of slightly improved night vision, a somewhat enlarged field, a little better acuity, perhaps *almost* immeasurable, but *something*, enough to make Dr. Berson wonder. But as Sarah looked at the dimming glow of the dark-adaptation apparatus, she did no better than she had done two years before. She did no worse either, Charlotte assured me, and that, they said, may have been a hopeful sign. Wired to the ERG machine, she was unable to make the crests of alpha or beta waves peak any higher than before. Her fields, which I had imagined expanding like ink on a blotter, showed no improvement.

The telephone rang. It was Charlotte again. "I just talked with Ben Berman," she said. "He and Beverly spent the whole day yesterday with Sarah and me in Berson's clinic. Anyway, Ben thinks the ERG might be wrong. His reasoning is this." She paused as if collecting her notes. "There are known cases of RP people with only some four hundred thousand rods left out of way over one hundred million, who can still see at night. Their flat ERG's give no hint of their night vision. Ben thinks that the bees could have fixed, say, twenty thousand of Sarah's rods in one quadrant and the ERG would not have picked it up. He's not sure this means anything, but he offers it as a last hope for bees. Ben and I both thought it important to tell you this. They also want you to know that they think you're wonderful. I think so too."

Bronka and Staś and Edith were delighted with my

decision to stay. Vera said that had I gone back now, I might always regret it, especially if Helga could ever substantiate her cure.

I dressed up in my blue summer suit with ivory-colored buttons and took the train to Staś's office on Fitzroy Square. Edith and Staś met me at the door, and, one on each side of me, peering at me as at a newly discharged mental patient, they escorted me into a small conference room. Staś opened a safe and took out an enormous box of bills. The thousand pounds was all in fives, tens, and twenties.

Like force-feeding a Christmas goose, we stuffed bills into every pocket of my suit, and when I stood up, my arms hung at an angle like the wings of a fattened bird. They stood at the curb with me as we waited for a taxi and told me last-minute tales of muggings and armed robberies. Then they wished me well as I climbed in, my arms clutching my sides.

The lobby of the Grosvenor House was crowded with beautiful people. Men were dressed in white tropical suits, women in loose print dresses and wide-brimmed hats. I walked the length and breadth of the lobby looking for Helga, but she was nowhere to be found. I made myself visible to every nook and cranny, standing at the entrance to the cocktail lounge, beside the couches near the front desk, in the space in front of the elevators. Bulging and looking ungainly, I waited for an hour until she finally arrived, swearing she had been there all the time, looking for me.

"You can see, though, and I can't," I said.

"Yes, that is true," she said, surprising me. "It is probably my fault."

She was wearing lipstick, rouge, and powder. A large feathered hat sat on the top of her head and obscured portions of her face, one of the feathers dangling in front of

her glasses. She carried a leather bag, into which we began emptying the contents of my pockets.

"I will rush this money over to my departing friend," she said. "It is a miracle that he is going right away. Ach, how the price of herbs has gone up. This inflation is entirely out of hand. Anyway, angel, have a good rest for a few days. You deserve it. I will call you as soon as your new bees are ready."

We stood up. She shook my hand energetically and warmly, and then she left. I saw her waddle into a distance of some twenty feet and disappear into the floral design of the carpet. I sat back down on the settee and contemplated my next three months. I would certainly have to change. No more isolation and total devotion to bees. No more yogurt and wheat germ or mandatory eight hours of sleep a night. I would try to be more skillful documenting my London experience in my journal. I would try to identify and understand the emerging voice within the notebooks. I would look up friends of friends who were authors, painters, theater people. I would disentangle myself emotionally from Helga and stop hanging on her every word. I would not pay constant, total heed to my vision; if it improved, it would have to do so with authority, without question.

Two women stood talking an arm's length from me. They were both tall, one in white, the other in a light shade of blue or green. Both wore droopy cloth hats, in the shadows of which their faces seemed flushed with a Vermeer rosiness, a guileless yet profound sensuality. Next to them I felt small and insignificant. Now that my pockets had been emptied and I had been duped into continuing my folly, I felt like a gullible little boy whose legs, as they swung from the couch in the Grosvenor lobby, were too short for his feet to touch the floor.

T H I R T E E N

At Eton Rise, I was glad to be alone again. I wanted to stop thinking about my crisis of indecision and the flimsy reasoning that had settled it. I dreaded questions about an action I couldn't defend. I had no experience justifying acts of faith. I poured myself a drink and walked it around the apartment. I ran a bath, and while it filled, I carried a chair into the bathroom, on which I set a bottle of Scotch, one of soda, and my tape recorder. I would make my ritual cleansing as pleasant as possible. As the water gushed in, it obliterated all other sounds. I felt alone and peaceful as I stuck one leg into the tub.

The phone rang. Chet was calling from the Midlands asking to stay with me for the weekend. Before we hung up, I had told him everything, all that had happened during the day. Chet has an orderly mind. Whatever he does— glassblowing, blacksmithing, homesteading, or car fixing— he does rationally, patiently, in measured steps. Once he had watched me as I struggled frantically to mount some industrial junk onto an intractable assemblage I was making. Everything wobbled and shifted; nothing stuck or penetrated. I smacked the sheet-metal base with a hammer, I cursed and sat down, defeated. "Put it on saw horses," Chet said calmly. "Take your time. Step by step."

I now awaited his judgment like the swish of the

guillotine. "Sure," he said. "I would have done exactly as you did. You've got nothing more to lose. You're already here, so you might as well keep trying until the treatment is over."

I bathed, drank, and listened to my journals. My taped voice was transparent, betraying every nuance of mood from haughty, brash, and hopeful in the first weeks, to confused and fearful, as long silences crept into the narrative. Finally, I whispered my drama into the microphone, conspiratorially, secretively. On one tape I heard Charlotte's voice in the background, and I longed for her company, her warm body. I longed for sex. I wanted another body in the bathtub with me, even though, in so many ways, I had grown accustomed to my solitude, my self-sufficiency. As my sex, so cruelly welded to my retinal circuits, seemed to wane, and as the impotence I felt in daily activities infiltrated my bed, I withdrew more and more from everything that seemed threatening.

On my most recent trip to New York, Dr. Lubkin said she had been amazed that I hadn't sought psychiatric help during the past five years.

"You know," she said, "I have looked everywhere for a therapist who concerns himself primarily with the eyes. It seems only natural that a major psychiatric interest should arise in connection with sight loss. Do you know that I haven't found a single person, not one?" Her warm, understanding tone turned angry. "What are all those Freudians doing? After all, it takes no special genius to recognize the link between a pair of eyes and a pair of testicles. And if you take the eye, stand it on end and put a little fur around it, you've got the vulva." In all my experience, she was the only person who seemed to understand what going blind was really like.

Rather than risk being foolish, a failure, a blind bungler, I had started to withdraw from the contest, especially the sexual contest. I had started to probe the manner of being a recluse, trying it on, experimenting with it, to see what, if anything, I would miss and which renunciations would offer the greatest relief, which would be unbearable. At times, sacrifice seemed easy, particularly when the alternative was humiliating, even crushing. And sacrifice had its nobility. It had been quite foreign to me in my previous life, but it was considered characteristic, even expected, of the blind.

The more I soaked, drank, and illicitly shrank the swelling on the back of my neck with hot water, the more sensuous I felt and the more I wanted to share the tub with smooth female flesh, to use the Nivea cream to better advantage than to soothe my cratered skin. This thing that floated between my legs had a lot of life left. It was surfacing like a submarine, expressing a will of its own. Tingling with heat and desire, I jumped out of the bathtub to call Vera.

"It's all done," I said. "I've settled with Helga. I'm staying for three more months."

"Splendid, Andrew," Vera said. "I am positive you did the right thing."

"I've got a few free days. I want to see you. . . ."

"Mmm," she intoned sweetly with the smoothness of a flight announcer at Orly. "I've been waiting for your call. But damn it all," she added, "I'm going out right now. . . ."

"Tomorrow for dinner then?"

"Why wait till dinner?" Vera said. "Come early tomorrow. We'll start with breakfast."

I got out of bed at dawn, did twice as many push-ups as usual, gulped down twice the number of vitamins, and bathed again. I was out in Adelaide Road looking for a taxi

before nine, but everything on wheels sped by on the way to work. I walked all the way to Swiss Cottage and into St. John's Wood before I found one. I imagined, hoped, that Vera was still in bed. It would be the perfect affair, far from home. I would stay a week, all of it in bed. Should Helga fail to make me better, Vera would succeed.

I was wearing new white pants and a new navy blue shirt Bronka had picked out for me at Marks and Spenser. I never shopped alone anymore, not since I had come home with an expensive jacket I thought to be as gray and tweedy as I liked. It turned out to be liberally speckled with fluorescent greens and Chinese reds. Charlotte and I had taken it back, but there were no returns on altered merchandise.

As the cab drove through the city, I trembled a little with sweet anticipation. I remembered really shaking once when I was sixteen and a very large lady that my friend and I picked up started taking off her clothes in a California motel. I sat on the edge of the bed and trembled uncontrollably, my whole body convulsed with fear and anxiety. My friend had graciously offered me first try; but the lady had little patience with the strange ecstasy of growing boys. She threw me out into La Cienega Boulevard.

As the cab crawled through Knightsbridge, I began to fear my incompetence, my lost aggressiveness. I imagined Vera's lovers, one of whom might still be in bed with her as we drove, as swarthy giants who were capable of superhuman feats, while she, preferring two, perhaps three of them at a time, thirsted for night-long debauches and an incalculable progression of multiple orgasms.

I asked the driver to let me off in Sloane Square. I walked into King's Road and the antique mall that had sparkled for me two months before and that was now wrapped in

impenetrable darkness. I bought a dozen roses in the square
and walked the few blocks to Cadogan Gardens listening to
my metal-tabbed doctor shoes make bell-like echoes off the
stone facades of Victorian houses.

Vera wasn't in bed at all. She was dressed, bright and
cheery. She wore a light print dress and looked the only way
she could possibly look, at least to me: full and dazzling and
sumptuous. We had coffee and talked of bees and quacks,
subjects I hoped we would quickly exhaust. "Let's go for a
drive," she said gaily. "I'm sure there are places you'd like to
visit."

"No," I protested. "I've seen all I want to see. Let's just
stay here and talk."

"Oh come, Andrew, it will be good for us to get out, walk
a bit. It's such a lovely day." She smiled, looking whole-
some. "I know," she said, "let's go to Kew Gardens. The
flowers smell divinely now."

Her Aston-Martin was in the street. We climbed in, and
Vera took off with a roar. She wore a kerchief and driving
gloves. Her dress pulled halfway up her thighs. She drove
well, ducking in and out of lanes, nimbly subduing London
traffic. I sat deep in my leather bucket, my head back, knees
up, tilted as for dental work or space travel. We settled into
pleasant conversation about our family, about our interests.

I hated being driven. I thought of my arrival in Vermont,
between marriages, speeding over the narrow, hardly
passable back road to Charlotte's house. Even at night, after
putting Mark and Sarah to bed, I drove the few miles
following the shadow of the road shoulder or the plowed hills
of snow on the sides. Driving myself to her at night, I felt
powerful, invincible, immortal; and hours later, loved and
refreshed, I would drive back, my headlights finding enough
clues to get me home, though at times the road looked so

monochromatic and homogeneous as to make me wonder if my car was moving at all.

As Vera drove, I had to keep reminding myself that it was only my eyes that didn't work. I couldn't engage in their sophisticated language, a language I had loved beyond all others, and now, a few inches from lusciousness, I had no access to the eyes' ambiguities, no playful enigmatic dialogue, no sexual finesse. I felt particularly loutish without my eyes. Like a sniffing dog, I wondered what signs I was missing, whether her countenance was sparkling or dull, bored or preoccupied or aroused. I yearned for the absolute truth of the eyes' and body's involuntary code. If only I felt self-assured, I could profit, like Babel's Kerensky, from the liberation of surgical vision. All women would look beautiful if I willed it. All breasts would be smooth and full, nipples taut, bellies flat and enticing. I saw no blemishes, birthmarks, scars, or pimples. Until I touched, all bodies were perfect, all faces as ethereal or provocative, as aroused and loving as I wanted them to be. I didn't so much miss the sight of breasts or thighs or hips, which, like a paleontologist, I could reconstruct from fragments I still saw. I missed the stimulation of eyes and their swift, unmistakable messages.

"It's absolutely super that you're here," Vera said. We had arrived at Kew Gardens. She leaned over, touched my chin lightly with her gloved hand and brushed her lips, thick with lipstick, against mine. "Mmm," she said again, then opened her door.

We strolled over lawns, on paths, through bushy alleyways heavy with azaleas. Patches of my retina were animated by the beds of color, planted in formal patterns. But everything other than Vera was unfocused, not only blemished by the usual hazy spots but like a dreamy stage set

whose only purpose was to serve her. The garden's fragrances mixed with Vera's, the azaleas, the Ma Griffe, and the moist ripeness of the inside of hothouses. She had wanted me to smell all this loveliness. It was making me dizzy with desire.

We lay on our backs under a tulip tree and talked of Poland, of Zakopane and Rabka, where we had spent vacations as children. Thinking of Poland with Vera, I remembered things that remained dormant until now, like the pension near the sea where a little girl sneaked into the woods with me to watch me pee. I was six or seven, but on recollection, the moment was as erotic as it must have been then. "Maybe you were the little girl," I said to Vera.

"I wish I had been," she laughed. "But if you were seven, I was only two. Precocious, no doubt, but two? No, Andrew, I didn't have the attention span."

I told her about the big boats that anchored in the bay of Gdynia, bedecked with flags and banners, the rails crowded with tourists, about the stillness of the Tatra mountains where I had learned to ski. She had lived her few prewar years in Krakow. I told her of the parks that, to me, defined my Warsaw childhood. I told her about Lazienki, with vast light lawns and sparkling white palaces where Chopin's weeping willow grew, and of the somber Saski Gardens, whose towering chestnut trees dropped spiked fleshy burrs ripe with rich mahogany nuts as smooth as the wood of the grandfather clock in the Moniuszki Street dining room.

We had tea at the Maids of Honor Teahouse, with scones and jams and whipped cream. Nearly all our senses were close to exhaustion. In the late afternoon, we drove back to her house.

While Vera disappeared into her bedroom, I took some

books from the shelves and looked at fragments of details of once-familiar paintings: Poussin, Fra Angelico, Velázquez, Cézanne, Matisse. All her art books were bound in white morocco, and they were a joy to handle. I fell asleep with my favorite Catalan frescoes spread on my belly. Some time later, a hand playing with my ear woke me. Vera sat on the floor beside me, all her perfumes and pommades reapplied. A white silk dress with blue polka dots clung to her body, and as she moved, the silk glided across it, emphasizing every soft rise and fall of flesh. "Why did you stop painting?" she asked, as she removed the book. I heard the distant sound of heavy traffic, but the street below was silent, as was our snug den, muffled with thick draperies and hung with icons, prints, and fragments of old woven cloth.

"Haven't you heard? I can't see." I pushed my fingers into her thick hair and began to massage the back of her head and neck.

"Be serious," she said. "Why can't you paint even though you can't see? You know color, you can instruct others. And if that's impossible, why can't you sculpt?"

"Mmm," I said to change the subject. There was no need to pursue this, I thought. I turned to face her. Vera got up.

"I mean to talk to you, Andrew. We have time for everything. Now I'm going to get us a drink." She put the book back in its place and went to the kitchen. "When I was in school, I used to turn boys off because I wanted to call the shots," Vera said from the kitchen where she was emptying ice cubes into a bucket. "I wanted sex as much as they did, but they weren't interested unless they initiated it. I like to choreograph, Andrew."

"Oh, yes," I said to myself, "and how I will dance."

"Tell me why you can't sculpt," she asked as she returned

with a tray of Chivas Regal, a glass pitcher, and goblets. "You can feel shapes and textures. You can chisel, you can whittle."

"All right, I'll tell you. I probably could sculpt if I had an interest in it. . . ."

"But what could be more marvelous?" Vera asked. "God, I love sculpture," she said. "I love to touch it, to crawl into it, to straddle it. . . ."

I drank a large gulp of Scotch. "The whole world is sculpture," I said throatily. "Painting is magic, like music. You see, I like transforming the sculpted world into two dimensions. . . ."

"So why not paint?"

"Listen, Vera, the fucking creative urge is gone. Not to mention the fucking urge, which is going fast."

"What do you mean the fucking urge is going fast?" She sat up. "Tell me why."

"The eyes," I said wearily. "Not seeing, I feel undesirable, unmanly. . . ."

"It's not true," she said. "From the moment I met you I wanted to sleep with you. You must have sensed that. It doesn't happen to me often. I'm very choosy. You've been a part of my fantasies ever since. I don't even understand why your eyes matter. You don't need your eyes for this. . . ."

"I don't need them, Vera, but I'm obsessed by the notion that only normal people are exciting."

"Good God, why?"

"I'm prejudiced. . . ."

"Normal people are everywhere," she said.

"Is it my abnormality that turns you on?" I was exhausted.

"It's you, as you are. Eyes or no eyes. You silly ass, there's no need to see." Something changed in her voice now. It

was thicker, sexier. She was beginning to choreograph.

"Close your eyes, Andrew, darling. Close your eyes and listen, smell, feel. . . ." Vera lifted herself to the couch, and before I closed my eyes, I saw her frictionless dress glide up to her hips. I wanted to keep straining to see. "Oh, God," she said. "Tell me what you hear. . . ."

I should have sought Vera, not Helga, from the beginning. I could hardly hear beyond my pounding heart. "I hear your stockings rubbing together," I said through heavy breath.

"Mmm."

"I hear the silk . . . like water . . . flowing over silk. . . ."

I unbuttoned her dress, and all the polka dots bunched about her waist as she straddled me, like a sculpture.

"Describe . . . the . . . smells . . .," she said as she slid on my belly.

I couldn't describe anything anymore. Vera was smooth, wet, silky. I entered her, and we moaned with relief. I opened my eyes for an instant, a blink, and I saw beyond Vera, beyond the far arm of the couch and onto a side table, bathed in a pool of light. My breath was short. We were both coming. I couldn't help staring at the collection of objects, the small ivories, jades, precious little silver trinkets, bleached under the lamp to tints of salmon, shrimp, straw, and flax. The room glowed with crimson and pink. The velvet wine-colored couch, the ocher needlepoint of the pillows, Vera's body—all looked like a painting by Matisse. We were heaving. My eyes watered, wide open to the splendor of Vera, to the pools of color all around. I closed my eyes, and inside them I saw radiating circles of green and blue light. Then we lay still.

"Mmm," Vera said. "What a beginning. . . ."

"It was majestic," I said. "But listen, something is happening to my eyes. . . ."

"Just close them, darling," Vera said, running the tips of her painted fingernails over my eyelids and down my face. "Don't worry. . . ."

"No, I mean I'm seeing." Her heavy lashes opened wide. I felt her body tense a little under me.

"Seeing?" she asked.

"I see the colors, even in the dark corners of the room." I had to lift myself on an elbow as Vera squirmed off the couch.

"Are we witnessing the miracle of the bees?" she asked.

"Maybe." I finally understood that she didn't want to hear about it. "It's either that or you."

"Me? Why me?" She looked at me coolly. "That's all it takes? Christ, I'll go into business. I'm a hell of a lot easier to take than that crazy old lady."

The room began to vibrate familiarly again, to crumble into pieces. I felt stupid and sad, having forced this trivial mirage into the middle of awakened passion, intense, magnificent pleasure.

"I made the whole thing up," I said. I covered my eyes with my hands. The irony seemed too complex for the moment. I heard Vera slide into her dress again. Barefoot, she started to walk into the hall. She stopped and turned.

"You know what I think, Andrew?" she said, her voice dry and cool. "I think that all you're ever really concerned about is your goddamn eyes."

F O U R T E E N

At first, Helga mixed the old bees with the new. "We have to change slowly," she said, "lest we bust your liver."

"We certainly don't want that," I said, and she stopped rearranging the bees on the plate for a moment to permit herself a resigned sigh. The time ahead would not be easy for either of us. We weren't overjoyed to be together again. She swore she mixed the bees, but she seemed to suffer from momentary, though not infrequent, lapses of memory, and when I asked her how many old bees, how many new on a particular day, she said, "New? The new ones won't be ready for another week. What you think? It takes time to digest all those new herbs."

During the time I was supposedly being taken off the old bees, the lease on her Beckenham house ran out and she prepared to move to another suburb, Sidcup, about the same distance from London. Sidcup trains departed from Charing Cross Station, meaning a whole new routine for me, but I was thrilled with never having to see East Croydon or Beckenham again. In the three months I had traveled the route daily, I had grown to hate the ugliness around the East Croydon railroad station, the bus ride through the insipid suburban streets, the long waits for the off-hour transportation. Helga now asked me to come in the afternoons, so I

would board the Sidcup train about four o'clock, just as the first wave of office workers was beginning to crowd the platforms. The trains going were always full; I rode the half-hour trip back to London in an isolated car, arriving in an almost-deserted Charing Cross Station already being swept of its rush-hour debris.

Helga asked me to bring her the *Evening Standard* on my way. She usually found some little item buried inside the paper about the latest outrage perpetrated by a doctor or hospital. "Listen to this," she would say, picking up the *Standard* or *Express* of the day before, and she would read, slowly, often stumbling over words, about some hapless creature mutilated during surgery or plugged into the wrong tank of gas. "Killers!" she would rage suddenly, though her Sidcup rages were more often than not short-lived and subdued, probably because of the tiring summer heat and the lateness of the time of day.

I began receiving answers from the entomologists I had written to, and all of them doubted the possibility of bees eating preplanned menus. Most volunteered the word "quack" in reference to the person who had made such claims.

Helga's stories about patients had blurred over all this time into one or two archetypal examples, and the names of patients were beginning to be used almost interchangeably. She might inexplicably turn on one while elevating another to realms of perfect bliss. From the time I arrived in London, I had heard her talk, off and on, about another 'American chappie,' this one more special than most of the rest of us, on the level of the Arabs. He was a businessman who resided in London. "He has several flats, all of them luxurious. Oh yes, oh yes. He is so happy with the way his eyes are improving that he offered me a flat, *gratis!*" His

name was Nulty, but she called him "Nutty" which mispro-
nunciation had mistakenly led me to assign him a mythical
existence with "Dopey" and "Grumpy."

When I tracked him down late in the summer, Nulty
brought his Helga experience into proper perspective. He
was approaching the end of his fourth month with her and
planned to quit in a week. "Lemme tell you right now, she's
done shit for me, absolutely nothing. Sure I humored her for
a while, but lately I've been telling her the truth. Zero! A
row of goose eggs!"

I told him about Sarah and my continuing saga, none of
which surprised him.

"I would have told her to fuck off long ago except, what
are people like you and me supposed to do?" he asked.

Until now, I was unaware of a single patient who had
dared face her with the truth of not improving, except for
the poor goats in her books whose rectitude was dealt with
summarily, peremptorily, biblically. Compliance and obse-
quiousness ran rampant among the desperate. We were all
ready to kill for Helga, to lie, to cheat, to steal—but singly.
We would have stood, like Laetrile patients, before the
houses of Parliament to bring about Helga's recognition, if
we felt any solidarity. But Helga atomized us. No one dared
to stir up trouble, at least not the patients I had met.
Perhaps there were others, somewhere, willing to take a
stand against her, to criticize her, to accuse her of exploita-
tion. But how to find them? It would, I thought, be as
successful an organizing effort as trying to talk people out of
heart transplants by arguing cost effectiveness. We were
desperate and Helga knew it. She knew and we quickly
learned that desperate people live by different rules and
standards.

"Listen," Nulty said, "I'm quitting next week. I think it

should make an interesting scene. Why don't I call you to tell you about it?"

He called at the end of the week to say that Helga had not taken his initiative lightly. After trying to yell him into continuing with the treatment, screaming the familiar "You'll be blind in two years" as a last resort, she left his place, defeated and silent. "I had paid her a lot of money over the four months," he said.

"How much?" I asked. "If you don't mind . . ."

"Two thousand pounds."

When, a little while later, I asked Helga: "Whatever happened to that American chappie you talk about? You know, the one in Knightsbridge?"

"That rotten drunkard!" Helga growled. "Can you imagine? I arrived there one morning to give him his bees and found no one awake but the maid. I waited and saw two women, in their underwear, leave his room, that whoring alcoholic! When he came out, he reeked of whiskey. I told him right there that I would never treat him again. Imagine wasting my bees on a Teddy boy like that."

She had told me that Dr. Ryder was doing everything possible to entice her to stay in London. She said that he was writing an article about her for a popular magazine. "I am seriously thinking of opening a clinic with him."

"What about the Arabs?" I asked.

"They're still begging me to come, but I think I won't. . . ."

"Why?" I asked.

"Because," she said, "I can't be sure that they'll allow my Jewish patients to come to Abu Dhabi." It was a stunning explanation, entirely out of character.

One afternoon I arrived to find Dr. Ryder inside, in shirt sleeves with a cup of tea in front of him. "Dr. Ryder is

writing an article and he wants to examine all my patients," Helga explained.

Ryder looked inside my eyes with his ophthalmoscope. "Ah, yes," he said, "heavy black pigment," which evoked a coughing fit from Helga, who had told me several times that the pigment was thinning, disappearing. "How is your daughter doing?" Ryder asked me as he put the ophthalmoscope back in its case.

"She's having a very nice summer in Greece," I said. "But if you mean her eyes, they're unchanged."

"What do you mean 'unchanged'?" Helga blurted. "I got a letter from her saying that she was so very happy. . . ."

"She's happy," I said, "but she isn't seeing better. . . ."

"That's a lie!" Helga yelped. "I will find the letter." In fact, Helga had read me the letter when it arrived. It strained to hint at a clearly nonexistent improvement, which Sarah had manufactured for my sake.

"I know what she's doing," Helga spat out. "She's drinking, staying up late, and thinking about boys. That will ruin my cure every time!"

Ryder wiggled his fingers in front of my eyes to test my field of vision, but couldn't determine much of anything. He took out a notebook in which he scribbled his impressions of my vision. As I was leaving, Ryder stepped outside with me and I asked him about their proposed clinic.

"What clinic?" he asked in amazement.

"She says she wants to start one with you and to let you in on her secrets."

"We've never even discussed it," he said. "As a matter of fact, I've been urging her to move to Abu Dhabi."

She found new reasons each day for not going to Abu Dhabi. She said she had talked to some Iranians who told her that seven out of ten Arabs in the little desert paradise

were drunkards. She checked this with an English engineer who had spent time in Abu Dhabi, and he raised the ratio to nine out of ten.

"What good will it do if I cure those filthy blacks?" she asked. "They would drink it all away. And God only knows," she added, "what else they do in that ridiculous little place!"

She worried about being mistreated with no recourse to British justice. And she worried about "throwing away my wonderful reputation in Europe." But she was as unable to resist Arab flattery as ever, and when, one September afternoon, I arrived at her house, I saw a gorgeous silver Jaguar parked in the driveway. She ran outside to tell me that "those sheikhs gave it to me." It was indeed a stupendous car, with red leather seats, a uniformed chauffeur, "and a whole year's worth of insurance." To this day I don't know whether it was paid for by petrodollars or whether my dollars contributed to its purchase.

Still, as withdrawn and uninvolved as I tried to be now, I spent a lot of time actively hating Helga. I found myself walking the fifteen minute trek from Sidcup Station to her house fantasizing her demise. I imagined turning the final curve on Greenwood Avenue to find her driveway filled with ambulances and fire trucks, with colorful lights flashing as figures scurried in and out of the charred remains, dodging escaped bees. This image, in several versions, appeared quite frequently in my journal during August and September, and at times I worried, just a little, that some furious ex-patient would do her in and Scotland Yard, checking all clues, would subpoena my self-incriminating journals.

As a rule, during those late, lingering hot afternoons, Helga was hardly the Helga of old. Sometimes I had to wait outside for a long time before the door opened, as Helga had

fallen asleep inside, deep in her chair, smothered with newspapers. She was tamer and so exhausted as to barely have the energy to put the bees on the back of my neck. Or, as I sat in the middle of that torrid room, with a square of five-o'clock sun burning my back, and as I fidgeted and wiped my face and arms with a limp handkerchief, Helga would fall asleep in front of me. She would begin to snore a little until a fly tickled her nose and she would spring up mumbling and disoriented. I would peel myself off the leather seat, suggesting that she put the bees on me before I fainted dead away, and she, poking around the remaining plates, offered up tag ends of thoughts or tales of the day's events. In the intense heat, the bees stung terribly, and I often wanted to lash out at her, to scream, to destroy her house with my bare hands.

As I walked down the street, passing the curve that brought me out of sight of Helga's house, tears would often stream down my cheeks, behind my sunglasses. Clicking over the endless slabs of flagstone sidewalk, walking by the little rose gardens and the ticky-tacky houses, I passed all the young men with attaché cases, coming the other way and vanishing inside one house after another. In every way I could imagine, I was a long way from home. I spent hours at Foyle's, sometimes in the cellar with the Penguins and Pelicans, asking a bystander to read me a blurb from the back cover. I poked around the third floor where the new International Edition of Marx was beginning to appear, volume by volume. I could read none of it but the accumulating set looked luscious. At times I would send some innocently crouching figure in the stacks sprawling on the wooden floor, or inadvertently knock a book out of someone's hands. But I made myself go back often, and one

day, on the ground floor, I saw a half-dozen inviting bright-red paperbacks. Ivan Illich's *Medical Nemesis* had just appeared in London.

I bought a copy and took it to Victoria Embankment Gardens near Charing Cross Station where, on some afternoons, I listened to a band play. I sat in a rented park chair and, with my magnifying lenses an inch from the page, began slowly reading the first sentence of the introduction. "The m-ed-c . . ." No. Again. ". . . med-ic-al es-tab-lishment has be-co-m-e a m-aj-or th-r-ca . . ." No! ". . . th-re-at to he-al-th." I read with my left eye only. The right one barely picked up a suggestion of light gray lines splotched all over the page. On the train to Sidcup, I couldn't get my face out of the book, and when Helga noticed it in my hand, she asked to have a look. As I sat squirming in the heat, she looked through it, her lips moving rhythmically, and asked if she could keep it overnight. Reluctantly I said yes, and the next morning, at six, she called.

"Angel, where did you find that marvelous book? Do me a favor. On your way this afternoon, stop by Lewis's on Gower Street and pick up a dozen copies for me." When I arrived, she had my copy in her hand.

"Do you know," she said vibrant and manic as I had not seen her since Beckenham, "this man Illich used to be a friend of mine."

"He was?" I asked, not believing it for one moment.

"He was a priest, right?" she asked.

"Yes," I gulped. It still seemed unlikely.

"I knew him in Czechoslovakia. Or was it Hungary? He and I and Cardinal Mindszenty knew each other well," she said with a lot of animation. "People called us the Three Musketeers."

My eyes must have registered the astonishment I felt. "You don't believe me?" she asked. "Well, let me tell you that I never lie. I don't *need* to lie." She looked at the book again. "What do you know about Illich?" she went on. I told her what I knew, how I had admired him for his war on institutions and how taken I could be, especially at my most romantic, with his preaching of a return to pre-industrial society.

"Do me another favor, cherub," she said. "Write Illich a letter for me and ask him if he would visit me in England. I'll pay his way, of course."

Illich had a profound effect on both of us. I strained to see the text through my Coke-bottle lenses, while Helga was now often on the phone when I arrived, telling Ida Moore of the *Observer* or Mrs. Heathcroft about the amazing new book. With me, she periodically brought up various aspects of the book for discussion.

"You know that Allende?" she asked me one day.

Illich mentions Dr. Salvador Allende's resistance to the importation of American drugs and the opposition of the majority of Chilean doctors to his intended limiting of the national pharmacopeia to a few dozen items.

"They killed that wonderful Allende," she rasped, thirsting for revenge. "They killed him for his stand against drugs."

I think she would have happily martyred herself for the same cause. She was being radicalized by Illich; in him, her lifelong rage against the medical establishment found strong compelling support. In the final analysis, it was very much Helga's book, because its solutions to an overmedicalized society lay in a return to simplicity where presumably every quack could ply his or her trade as long as the enterprise stayed small. I too found an instant comrade in Illich, who

buoyed up my growing outrage with the impotence of medicine.

I hired a reader to find the books listed in Illich's copious footnotes, too small for me to see, even letter by letter. This book aroused both Helga and me out of a summer lethargy. Illich was arming me with ammunition I felt I would need to defend myself upon my return to the States. I would be so deft with deeply relevant statistics and so abundantly imbued with revealing quotes about the horrors of *their* medicine that my skeptical friends who had not understood how I managed to last so long with Helga, especially after Sarah's debacle, would be rendered speechless and ineffectual by my lithe and tricky salvos.

It also offered me an area of study that for the first time in a long time engaged me passionately.

My friend Bronka became very ill that summer and was taken to the Royal Free Hospital in Hampstead, which Staś called the "Hampstead Hilton." She had complained of severe side pains, which were diagnosed as kidney stones. When she showed no improvement on the medication prescribed, they rediagnosed her worsening condition as a pulmonary embolism and put her on anticoagulants, which, according to Illich, caused more harm than good. She lay there more afraid than sick as doctor after doctor visited, offering sketchy, sometimes contradictory opinions. When the superstar, the consultant, came through on rounds with a comet's tail of students following behind, they disregarded Bronka completely as they palpated, drew blood, turned her from side to side like meat. I visited her daily to commiserate and to watch Illich's "clinical iatrogenesis," doctor-induced illness, in action.

Bronka slowly recovered, in spite of the care. At the end

of a week, the only medication they insisted she continue taking was a pain killer and a barbiturate, neither of which she felt she needed, as she had no pain and slept well. She survived just as I was surviving, both of us strong enough to withstand the ministrations of healers.

Bronka looked rosy during her illness. Adversity sharpened her spirit, flushed her cheeks. Morbidity has a special energy and sensuality, as any romantic will attest, and I was beginning to suspect that even retinitis pigmentosa, whose morbidity was confined to a dime-sized, paper-thin tissue behind the eyeball, offered a unique opportunity for heightened perception.

I began to think of myself as a standard-bearer for differentness. I again took some interest in the immediacy of my condition and even used my cane in public on occasion. I made contact with the newly formed British RP Society and got together with people who needed to talk about their damaged lives—just as I had done before coming to London. One weekend, I went with Vera, once again intrigued with my eyes, to have a look at the Royal Institute's Rehabilitation Center for the Blind, which was much like St. Paul's.

I spent weekends with friends in Kent or Surrey or Sussex. But every moment I was alone, I tried to write. I told Helga about my writing, and much to my surprise, she seemed stunned, even affronted. She demanded to know what had changed to dissuade me from my desire to paint again. "This is just in case, Mrs. Barnes," I told her. Vera too kept urging me to think about painting. They both kept that dream alive.

The struggle with words seemed at times like a full-scale war. Learning to be skilled at blindness or at counseling was like a mock skirmish, compared with trying to push words around. Words felt as heavy as lead, hard as rock, unmova-

ble, and incapable of nuance or ambiguity. As I laboriously rammed them into place, like the massive blocks of the pyramids, I longed for the playfulness of paint.

Before I left England I wanted to have in my possession some empirical evidence of documented success or a consensus of failure. All the while, I had been going about collecting names of patients and keeping track of what they said about their improvement or lack of it. Now I would have been grateful for hospital records or an ophthalmologist's affidavit, but hard evidence in soft enterprises tends to disappear, and I couldn't get my hands on a single piece of it.

Tom Larkin was nowhere to be found. I got Dirkson on the phone.

"Look here," he said. "I'm not really sure if Mrs. Barnes helped. . . ."

"What?" I said. "Why are you saying that now? Why didn't you tell me before?"

"I might have been improved. I was never really sure. I'm not sure now," he said.

"Oh, God," I moaned. "What about your diagnosis? Are you sure about that?"

"Yes," he said. "They should have that at St. George's or Moorfields. . . ."

"I called Moorfields to ask, but they wouldn't tell me anything. Would you try to get some facts together for me? Other people have a right to know if you were helped, if you really have RP, anything. . . ."

"Yes, I know," he said without much enthusiasm. "I'll try but I can't promise. . . ."

"Jesus Christ," I yelled. "Why can't you help, Dirkson?"

"You see," he said, "even if Mrs. Barnes hasn't helped me

much, it doesn't mean she can't. She still has the power to do so, I believe. I have children who might turn out to have retinitis pigmentosa. If they do, I certainly don't want to be on the wrong side of Mrs. Barnes."

All the other London patients whom I had met continued to furnish me with ambiguous reports. Mrs. Dorset's boys were no proof one way or the other. They had been pronounced cured, just like Sarah, but they were still too young to notice any serious deterioration. Jorge Salomon continued to talk of his expanding cashews, but he too had nothing substantial to report. I called James McDole in Scotland. He had not been in London during my six months, but we had talked before on the phone.

"I think you are doing the right thing in trying to find out more about all this. I wish I could help you, but the only thing I can truthfully say is that she has changed my life. I really was nearly blind before the bee treatment and I am now carrying on my normal life."

"Are you sure it was the bees?"

"The only thing I can say is that it happened during the bees and it has remained for a year and a half."

"Are you sure you have, or had, retinitis pigmentosa?"

"I'm sure because an ophthalmologist in Edinburgh told me so some twenty years ago."

"Could we get the records of your visit?" I asked.

"Well, I'm afraid not," he said. "The ophthalmologist died."

I was as perplexed as ever. I berated myself for not getting on the Edinburgh train to see McDole in person, for not hounding them at Moorfields for corroboration of Dirkson's diagnosis and present condition. But I was losing interest.

On my next to last day in London, I called Mrs. Heathcroft, whom, I supposed, I had been afraid to call

before. She was an imposing figure, if only by reputation. Her picture had appeared in the *Observer* article. In it, her head was draped with polyethylene bags stuffed with herbs, to cure her asthma. She looked horrible, like a bloated Medusa or Lady Macbeth very near the end. In making photocopies of the articles, I was glad that the illustrations were almost indecipherable.

"Mrs. Heathcroft," I said on the phone, "we met briefly once outside Mrs. Barnes's place in Sidcup. I have been her patient for the last six months, and now that I am returning to the United States, I hoped that perhaps we could talk—"

"Does Mrs. Barnes know you are calling?" she interrupted.

"She's the one who gave me your telephone number," I explained.

"Does she know you're calling me *now*?" she asked in a very businesslike fashion.

"Right now? No, I guess not—" and I heard a click on the line, disconnecting us. I dialed again. It rang for a long time before Mrs. Heathcroft picked up the phone. "Ah, Mrs. Heathcroft," I said. "I believe we were disconnected. . . ."

"No, we were not," she informed me. "I will not talk to anyone about Mrs. Barnes or about my family's health without Mrs. Barnes's permission." And the phone slammed down once again.

Late that afternoon, as Staś, Edith, Bronka, and I were racing around the apartment packing all my belongings, Helga called. "Listen, cherub," she said. "The Blind Commission in Norway just asked if they could send me a slew of RP patients from Bergen. Can you imagine? Isn't it wonderful that I decided not to go to Abu Dhabi?" I put my hand over the receiver to direct Staś, who was holding up an African necklace I had bought for Charlotte.

"Beautiful," he said, "but tell me please, Andy, what are these things?"

"Ostrich shells and malachite and old gin bottles," I said.

"Beautiful," he repeated. I listened to Helga again.

"Anyway," she was saying, "I want you to write me once a week. You know that sometimes it takes months, maybe a year and a half, before a permanent cure happens. With you, it was difficult, but I assure you that it will happen. We probably pumped too much poison into you. So rest up, cherub, rest for six months and then come back to me. I won't charge you another penny."

"Fine, Mrs. Barnes," I said.

"And as for your daughter, these young girls are all alike. Tell her to get plenty of sleep and reserve next summer for me."

"You know, I called Mrs. Heathcroft today and she wouldn't talk with me. Do you know why?"

"She is a wonderful woman," Helga said. "If I can trust anyone at all, I can trust her. Do you know what I did for that whole family?" she asked. "Well, old Heathcroft was completely blind. . . ."

I had imagined that taking leave of Helga would be different. I had imagined a final gala banquet—why not at the Grosvenor?—that everyone close to me would attend. The table would be very long and elegantly set. Helga at one end, me at the other. The Amadeus Quartet would play Mozart. Flanking me would be my children, Charlotte, and Vera, all delighted to have taken part in this drama, this allegory; my mother wearing the necklace of pearl strands her brother had given her; my London family, all of whom I had finally met; and the people who were buying the movie rights, the serial rights to my story, my new art dealer, representatives of the Tate and the Modern. . . .

Helga went on and on, prattling, mimicking, scolding. If ever I entertained hopes that behind this dreary, predictable banality lurked a wise Zen master, I was wrong. Behind the threats and cockiness, the promises and braggadocio, there was nothing.

She called again late that night. Staś's flat was full of people saying good-bye. "Ah, it is the most wonderful thing in the whole world to be able to cure blindness" was the last thing she said.

F I F T E E N

Dear Mrs. Barnes,

 I haven't written to you before because there was nothing to say. I've been back home a few weeks and have to report that there is no change in my vision or Sarah's. It's sad that after all this time, nothing has happened. Should the situation change, I'll let you know. I hope that other patients have better news than I.

My regards,
Andrew Potok

I wasn't particularly surprised not to hear from her again. I imagined that she read the letter, cursed it soundly, and tore it to shreds, muttering "that ungrateful dog," and meaning every word of it.

 I now wanted to seek a new life, no longer concerned with eyes or cures, but a life in the making, built on the remnants of old wrecks and aborted starts, though free of remorse. But in London I had sat on too much anger, constrained by foreign soil, by Helga's demands for good behavior, by Staś's generosity and my own manners. In Plainfield, I felt ready to burst. I had been desperate when I left and I felt totally defeated on my return.

 Sarah was back at the university, an hour away; Mark was

starting his third year at Chicago. Jed and Maya still lived at home and attended the district high school, where he was involved in basketball, and she in her burgeoning social life.

Charlotte's work was on the verge of recognition—the Museum of Modern Art in New York was interested in it—and she locked herself in her studio daily, mucking about in clay and plaster. I tried to squelch my envy, but each time I grumbled about something, the only reasonable cause seemed to be my festering jealousy. Within a few weeks, the museum announced that they were accepting ten of Charlotte's porcelain pieces into their permanent design collection. We went to celebrate at Tubbs, our local roadside inn.

"Hey, Charlotte," Neil said from behind the bar. "That's great news. First round is on the house. And how're you doing, Andy?"

"Fine. Nice to see you, Neil," I said. I had to stop saying "Nice to *see* you." It was embarrassing. I hadn't *seen* him in years, not since he'd taken up that shadowy position behind the bar. I liked Neil. He was one of the few people in the community who always identified himself when speaking to me.

We sat at the table near the fireplace where a small fire hissed. Over old Dave Brubeck records, I heard the bustle of the early evening crowd: my friends, the pretty waitress, a few Goddard College teachers grumbling about self-assessment and competency near the door to the terrace. A group of jovial social workers from Montpelier shared a table, talking of diets and Title XX grants, having one drink only and a couple of pretzels. I, on the other hand, was home from Helga's wars, my ears still ringing from battle, my nerves jangled by the raw confrontations. Everything here seemed paltry and superficial.

"What happened to him? Can he see?" I overheard
George from the Texaco station ask at the bar. I'd never
been sure whether or not George knew about my blindness,
so I always felt uncomfortable around him. As I sat in the
passenger seat of the car while he pumped gas, or, on
below-zero mornings, as I fumbled with the other end of the
jumper cables while George, standing by his tow truck,
watched, I wanted to tell him but never did.

"Everybody's asking me what happened in London," my
youngest daughter Maya said. "I don't know what to say."

"Nothing happened," I snapped. "Say that."

"Come on Papa, why so crabby?" Sarah said. "You're
back, Charlotte's famous, we're all together. . . ."

"I'm sorry. I don't know. . . ."

"I was scared when you left," Maya said, almost inaudibly.

"Scared? Why scared?"

"I guess because you were going away. Jed was scared too.
I thought you'd see again. It was magic, and magic is scary."

"You know, don't you, that I didn't really want magic? I
wanted a new kind of medicine."

"I'm just glad it's all over," Maya said. Jed squirmed a
little and said, "Me too."

"Well, Maya, we tried," Sarah said. "We didn't find
much, but at least we looked."

I could have easily forgotten that it was Charlotte's
evening. I ordered another Scotch to help me remember, to
get me out of myself.

"I want to feel good," Charlotte said. "Things are
beginning to happen to me, but I can't feel good with you
like this."

"Don't feel bad," I said weakly. "I'll get over it." It was
one of those frightening moments, repulsive and seductive,
when I wanted to say: "No more! I give up." My misery was

like a caul around me, choking me, protecting me. Others' good fortune isolated me; their bad fortune underscored mine. I was regressing, out of control, and I hated to admit the reasons why. I didn't know how I could get through this time.

"You didn't fail," Charlotte was saying. "That goddamn crazy woman failed."

"After six months I'm back to where I started," I said. In fact, I was moving years back, way back.

Liz came over from the jovial table. Barry from the Goddard one. They congratulated Charlotte and put their hands on my shoulders, giving me little significant squeezes. "Our own Charlotte," Liz said.

"The Potoks are on their way," Barry added with good humor. But it was only one Potok, the Potok by marriage, like my mother. The light of the candle flickered in my Scotch, the only thing I saw. The darkness isolated me as I imagined a spotlight isolated performers. I was seen, stared at, yet I couldn't see. I burned with self-consciousness. I wanted to run but couldn't. I wanted to drive like everyone else.

Anita and Roy joined us. "Goddard's going to fire half the faculty," Anita said. "It's unbelievable, but the bastards are going to do it."

"You know how impossible it is to find teaching jobs," Roy said. "Roger's been looking for two years and he publishes regularly."

I listened and sympathized. "It's really awful," I managed to say.

He must have looked at me then and realized, because of the last few years of our friendship, that my woes took precedence over everyone else's, that through the years of my hysterics and depressions, I needed tending, and he

said: "Well, Andrew, pretty soon you'll have your Ph.D., which will help with jobs."

"Listen, Papa," Sarah said, "you could work for the Foundation."

I had directed attention back to me and felt embarrassed. "Had the bees worked, I might have been their bee expert. . . ."

"You blew it," Barry said.

Other friends joined us. We now occupied half the room, some five or six tables pushed together. From several tables down Bob shouted: "Oh, c'mon, Potok, lighten up! Go easy on yourself, for Christ's sake!"

I could hear Charlotte finally having a good time, talking softly, laughing about "other things at the Modern." The Scotch was making me groggy, but I was stuck until everyone else was ready to go.

Finally in stages, people got up to leave. There were more projections into Charlotte's future and more meaningful pats for me, more viselike grips around my shoulders, dry kisses and wet. One moment, we were all standing, and the next, I was alone except for a couple on the other side of the room. Then Charlotte came back. She must have forgotten me, and now she offered me her elbow. "Let's go, honey," she said. I dragged behind her, mumbling a good-bye to Neil. I stumbled down the outside steps while Charlotte held me upright. All I wanted to do was sleep.

The beekeeper, Charles Mraz, Ben Berman's "man in Vermont," came to visit me, bringing a large bundle of books and articles about the therapeutic use of bee venom. "It's amazing stuff," he said. "I'm surprised her bees didn't help you." He told me stories of the extraordinary strength and longevity of most beekeepers, who get stung thousands

of times a year as a matter of course. He himself had successfully treated people for joint diseases and just about everything else, including, he added in a whisper, cancer.

Sarah and I went to visit Mraz one day, and he urged us both to take up bee treatment again. We looked at each other and shuddered. He offered us a hive to take home, then suggested we try a couple of his bees right there, and, masochists to the end, we agreed. But before touching our bodies with a bee, Mraz took some ice from the freezer and numbed the spot on our necks he intended to treat. We hardly felt the sting at all, not until the skin warmed, and by then the worst was almost over. A vengeful hatred for Helga welled up inside me. We could have been spared a lot of pain.

Sarah and I each took a bottle of bees home with us. Sarah taught her roommates to extricate one bee at a time with tweezers and had herself stung for a week, until she felt that the whole business interfered with her sanity as well as her schoolwork. I kept my bottle on the kitchen counter for a couple of days and watched Charlotte circumnavigate the area in the mornings, giving my bees a filthy look. I waited for her offer to learn to nurse me with the bees, but the offer never came. Two days after the bees' arrival, I stormed out of the house with the bottle and heaved it as far as I could into the field where, on landing, it hit a rock and exploded.

I was asked to give a talk at the Boston University Medical School about my time with Helga. Posters went up the week before my presentation announcing THE BEE MAN FROM LONDON, and the offices of the Department of Socio-Medical Sciences were swamped with requests for clarification. First-year medical students were required to attend, but on the day of my lecture, the auditorium overflowed with the

curious, who, I think, expected a clown in a furry bee suit and compound insect eyes.

For me, these lectures—there were several—were an opportunity to give some meaning to a lost six months, a time with few redeeming moments. In this medical school, among friends and students, I wanted to rediscover the path, like a lapsed Catholic lighting candles in the church of the true faith.

In preparing these talks, though, I found I wasn't nearly as repentant as I thought I'd be. As my experience began to crystallize on a series of oversized index cards, I saw that I had a message of some relevance to impart. Having returned from the unspeakable "other side," I had to convince these budding doctors that it could have happened to them.

I realized that I had to lay a foundation of credibility, and so I quoted the more reasonable of Charles Mraz's bee material, being careful not to spare a single prestigious institution involved in bee research. I cited statistics comparing effectiveness and efficiency inside and outside the medical establishment. I quoted Nobel laureates, and picked the most illustrious of Illich's sources to underscore my point: often it makes no difference where you go for help; your chances of survival are about equal to never having gone anywhere at all. In that large, windowless auditorium, where 150 blurred faces stared up at me, I urged them not to judge their future patients harshly and to understand that people's response to life-threatening or way-of-life-threatening events is unpredictable, especially in the face of the wanton promises of miracles from science and medicine. After the first of these lectures was over, after all the students who had come to the front to talk had left and I walked to lunch, I had a glimmer of understanding of the

new plateau I had reached. I had now said it all in an ordered sequence: from knowing I'd be blind to experiencing it, from denial to anger to grief, facing it on different levels, joining it, fighting it, pretending it didn't exist or that I could make it all go away. The time for synthesis had arrived, because the sum total of the ignorance and impotence of the various systems I'd explored had finally liberated me from hope.

In mid-April, taking a break from my nearly completed dissertation, I happily launched into some badly missed physical work. Hoeing manure into my garden, I hurt my back. The spasm caused some discomfort, but I went to Boston the next day as scheduled, to give another in a series of talks at BU. By the time I arrived on the third floor of the medical school building, I could hardly move. I gave my lecture and was rushed next door to a doctor who suspected a slipped disk. I flew back home on the tiny Air New England de Havilland, inside which even healthy lower backs snap as one inches forward in the aisle, bent and twisted, to a seat. At home, in great pain, I went to bed. The local doctor prescribed Valium and pain-killers, both of which I swallowed with rebellious glee. When I called a New York orthopedist, he suggested immobility for at least six weeks.

A rather small intervertebral disk and two tiny retinas were scarcely a pinpoint on the total vulnerable square footage inside the body, but the possibilities for pain and deterioration were immense. When Anita came over, offering to read to me, I asked for the Book of Job. But I was not mollified. Job knew that God had made a terrible mistake in singling him out; but in spite of it all, he didn't allow himself the bitterness and fury I was feeling. I wanted to wail and scream, to take everyone down with me if I had

to go. Let others turn their goddamn cheeks and suffer with dignity. I didn't want to spend my life blind and in bed!

From the Library of Congress I ordered books they recorded about personal misfortune—it was one of their larger categories—like biographies of Helen Keller, Roy Campanella, Saint Anthony; anything described in the catalog as a "poignant story" about "unshakable determination" or the "refusal to accept limits" and going on to become champions, or saints, or surgeons. I drank a lot of Scotch, smoked a lot of homegrown, took the prescribed codeine, and wondered each morning why I wasn't either cured or dead. During one of these nights, I had a dream, as clear as total sight. It was a single image of an eyeless face pouring out coils and tendrils of color-saturated words, painted words, which whorled into complex, many-layered scrolls, like fugues. On awakening, soothed and peaceful, I postulated the transformation of my ancient creative core, the birth of the new self from the ashes of the old. And yet, after the immediate loveliness had vanished, the dream made me sad. It could be, I thought, that such a core survived, but I had long ago lost access to it and if it did exist, did I have the energy to go digging around for it, buried as it must have been behind mounds of accumulated emotional garbage?

I tried to write, but with every weakness of thought and language, every overwrought locution, every vagueness and generality, I felt hopelessly transparent in my ineptitude. At first, everything I attempted was crude. I imitated other styles, but seductive as they were in anticipation, once they were regurgitated as mine, they glowed with phoniness. Heavily, heavily, I wrote about such matters as manipulation, exploitation, alienation, lumbering through my experiences in search of granitelike examples, full of rhetoric and moist exclamations of perfect joy or abysmal sorrow.

The process itself was slow and cumbersome, especially in bed, without the use of my Visualtek. With a portable lectern sitting on my belly, and an oversized sketch pad propped on it, I scratched large letters with Magic Markers. Charlotte or Liz or Anita would read a few paragraphs aloud, and I would listen over and over, to catch a uniform thread, force, and direction, until a voice emerged and locked into my consciousness, indisputably, for better or worse, as my own.

In the past, when I didn't have a clear idea about what to do with an empty canvas, I could squeeze out a dab of buttery ocher, push it around with a knife or a rag soaked in turpentine; I could brush in haphazard lines, crossing, spiraling, circling, until forms appeared with a life of their own, demanding their own organic exploration. Something always happened. At times rich ideas were born, though those fortuitous beginnings were exercises, like scales, like the flexing of muscles. The real business of painting, like the business of words, began after.

During most of the day, the four windows of my bedroom crackled with the glare of the spring sky, while in the late afternoon, the sun deposited fiery squares of white-hot light on the carpet and the quilt on my bed. If I squinted at the southwest windows, I could see the celery tops of a tree line near the woodshed. The windows facing the bed directly were scratched, as if by the illegible scribbles of a child, with the branches of a maple in the lower driveway and the budding ends of lilacs a few feet from the house. The volume of the room was thick with debris, the clutter of fragmented vision. There wasn't only a gauzy screen between me and everything else, but all the interstices and crevices of space were crammed with the dappled smudges of things, like stacks of dirty ice cubes, wall to wall, floor to ceiling. I felt

that looking into it, driving my eyes to try to see through this unrelenting mess, justified my need for order. My body ached for the cleanness, the knifelike precision of light. By obsessively arranging things, by cleaning and clearing away, I felt that someday I would get to the great garbagey space in front of me.

My London journals, which I had transcribed at Eton Rise from tapes to handwritten notebooks, I now gave to a typist. When she returned two days before schedule to pick up the next installment because, she said, "I couldn't wait to see what happened," I suspected I had something of general interest on my hands. "It's powerful stuff," she said, standing by my bed, looking down on my immobile body.

I sent a piece of the journals plus a few typed pages of my new narrative to Mary, who had sent me the *Observer* article about Helga in the first place. Within a week she called.

"It's good, Andy," she said. "I'd like to show it to Ellyn. . . ."

"Really? It's hardly ready for that. . . ."

"That's okay," Mary said. "You don't have to wait for a polished manuscript to show an editor. Let her have a look. Ellyn will tell you what can be done with it. And Andy," she added, "I cried when I read the part about your sight fantasies. . . ."

Prematurely, yet automatically, I began to take myself more seriously. Making an application for a bank loan, Charlotte sat on the edge of the bed and read: "Profession?" I didn't answer for a frantic moment; then, flushing a little, "Writer," I said.

It felt powerful to be able to make people weep, though weeping was easy: all I needed to lubricate my own tear ducts was a mention of refugees or missed opportunities.

But I was bored with the pathos of my story. I didn't really want to make anyone weep. I wanted to make an artful order of the chaos of my experience. As I stared blindly into the Marimekko fabric Charlotte had tacked over the glary windows, I thought I could foresee the day when I would be in touch with the uniqueness of my vision and temperament. In this organizing process, the process of writing, I began to make ever more sense of my experience, of St. Paul's, the work with blind people, the graduate work, and Helga. The more I wrote, the less I had to continue to define myself by my eyes.

Even as I wrote though, I felt touchy and irritable. I felt envious of anyone who could count on old skills. And just as other losses had hurt me once, my inability to get information now loomed larger and larger. I had accepted not driving or painting, not making sense of movies or parties; but, wanting to write, I couldn't bear the slow and random ooze of information, the weeks required to read a single book, the inability to skim or skip. When a new Updike, a Christopher Lasch, another biography of Beethoven appeared, I'd have to wait for years until it was recorded—if it was recorded at all.

Probably it would always be one thing or another. If only this, if only that. If only I had been able to see at the party up the hill, I wouldn't have felt like such a wimp. If I could have moved about from room to room, I wouldn't have stood uncomfortably alone or been prey to people I didn't want to talk to. If I only hadn't thought she was someone else and called her by the wrong name, perhaps a lovely spell would not have been broken. But it did begin to penetrate: I couldn't see. I couldn't move easily from room to room. I would call people by the wrong names. I would have to

settle for small bits of information, carefully selected.

My back wasn't improving. Charlotte came up the stairs a few times a day with trays of food we would share, quietly and alone. The unspoken etiquette of our embattled marriage called for a truce when one of us was really down. The peace allowed some love back in. Friends came to read aloud and share their own problems. Maya came up after school for help with her math, and I found that I was less irritated by the silly mistakes she made when I was flat on my back than when fully wound up, pacing, blaming, storming around. It became a pleasure to help her. My poker group, which had been a man short for six months, did not take my bad back as much of an obstacle, and we arranged to play at my bedside. I was placed at the foot of the bed while the others sat on pillows around a tabletop. When my pain became unendurable, someone would turn me to one side or the other, or deal me out of a few hands. Full of drugs, stiff and in pain, I parted with a lot of money; it took months to recoup.

After three weeks of this regimen, I felt that I could not stand another day. Like the friends of Job, my friends Roy and Richie and Tom carried me on a flush door into a borrowed VW van and drove me to Montpelier to see a chiropractor. Where drugs and orthodox ministrations had failed, this elderly Vermonter, using his strong hands and arms, crunched and realigned my vertebrae so that that very day I walked out of his office, not seeing exactly where I was walking, but feeling nimble and spry. I sent off a letter to the first-year medical students at BU informing them that I had again heard the call of alternative medicine, but that this time it had worked.

In Boston, Freda and I arranged a reunion of our group,

which had continued to meet without me for a couple of months after I had gone to London. As I sat in her kitchen before the others arrived, and Freda puttered, wiping counters that were already spotless, she confessed that she had felt betrayed by my leaving. "I came to terms with it eventually," she said, "but I was angry, very angry at the time."

"I can't believe I was that important," I said.

"Well, you damn well better believe it. You were the center of the group." Even though Freda called me in London regularly, worried about me, wished me well, I had put an irremediable distance between us, because of my selfishness and my refusal to accept responsibility. Dagmar had given me hell on the phone before I left, then wrote me a long forgiving letter in London. Freda had given me her blessing, like everyone else, but she resented my leaving.

After lunch, we went out to sit on the porch and watch the others arrive. Sheldon, as usual, was escorted inside by one of his sons. Craig and George walked, heads cocked to one side or the other, listening and pointing a cluster of good retinal cells at traffic. Kevin came by taxi. Frank, Jenny, and Moira shared another. It took no time at all to feel the warmth of this company, the security of shared experience. Sheldon and Moira were the only ones with canes; the rest of us stood in a tight group, moving about a little, and like fish in a crowded tank, jostling, recoiling, nuzzling, we touched one another hesitantly, more to orient ourselves than to show affection. Finally, the canes folded, and like beached whales prodded out to sea again, we were settled into tall dark chairs around Freda's long dining table. In our element, we relaxed into animated conversation, as if six months had not stood between our meetings.

"Well, are you seeing better?" Kevin asked peevishly. He was chairman of the board of a small chain of newspapers. He was all business, with great faith in authority.

I wanted to apologize, to make amends for all the hoopla, the unfulfilled promises. "Not at all," I said.

"What about those improvements you described?" George asked.

"They're hard to explain. I could have sworn they were real at the time."

"I know what you mean," Sheldon said. "I felt the same way with the vitamins. After the second or third shot, coming back on the train from New York, my wife thought I was nuts. I walked from car to car. I helped people take their luggage down from the racks. But it all vanished as we pulled into Boston."

"I know what you mean, too," Moira said. She had joined the group after I left. "I was in a program that experimented with a drug—dimethyl sulfoxide—a couple of years ago. I not only saw better, but they even measured the improvement."

"How's that? What do you mean?"

"I went from twenty/two hundred to twenty/one hundred. I saw better at night, and my field improved."

I thought of my self-styled charts and the tests I had devised at Eton Rise. "You were scientifically tested?" I asked.

"Yes. At a university hospital. It was like that for a couple of months, then it started getting bad again. . . ."

"What a horror," I said. "Mine was different. One day I thought I saw better, the next day it was gone."

"It was such a tease," Moira said shakily. "Those couple of good months weren't worth it."

I remembered how energizing the improvements were and the special ache of the despair that followed. "I brought an article from a medical journal," she said, pulling it out of her bag and handing it to Freda. "Just the underlined parts, okay?"

"Terrible Xerox," Freda said.

"I thought the great sighted majority could read anything," Kevin said.

"Sorry to disappoint you, wise guy," Freda said. "Here we go folks. It says, quote, fifty patients with retinal deterioration were treated, dot, dot, dot, let's see, and the subjective evidence gathered was encouraging. This subjective evidence consisted of improved or stabilized visual acuity, improved or stabilized visual fields, and improved night vision, unquote. Okay, dot, dot, dot, quote, Of the fifty patients treated, twenty-two improved in visual acuity, nine improved in visual field, and five improved in dark adaptation. Two patients have continued to regress, and the rest have had no measurable or personally noted changes in vision."

"There's a footnote on that page that's the meat of it, I think," Moira said.

"Okay, I've got it," Freda said, pulling the Xerox in and out of focus, straining to see it. "It is well to . . . I mean, quote, It is well to remember at this point that similar early evidence of efficacy was also found in the use of vitamin A for retinitis pigmentosa, but it was ultimately found to be ineffective after a three-year double-blind study. The desperate hopefulness of these patients apparently manifested itself as early subjective improvement under a new treatment. I can't read the rest. It comes right off the page."

"He says in the article," Moira added, "that hopefulness

was somehow responsible for the improvements, that it affected an individual's immune responses and that those immune responses could have halted the downward course of RP."

None of us knew much about immune responses, so we assigned George the task of looking it up, until we realized that this wasn't a regular meeting and we'd probably not meet as a group again. "I move we make this group go on forever," George said. "What's the word for it in the trade? Open-ended?"

"Total dependence," Kevin said.

Freda started pouring coffee and slicing cake. "All I know about immune responses," Frank said, "is that they're real physiological reactions, mobilized antibodies or something like that."

"With Helga's patients," I said, gulping down a piece of cake, "some simply lied about improvement, either on their own or forced to by her. Did I tell you that Sarah and I were asked to write testimonial letters? Some of her people probably never had RP to begin with. There's one guy, though, who sounds like a case of sustained immune responses."

"There's a bunch of cures now, more all the time," Kevin said. "People are flocking to Russia, to Switzerland. . . ."

"You wouldn't believe what's going on in England," I said. "Communities are raising huge amounts of money to send people to Russia or Switzerland. They're being warned by the British Medical Council, even some minister or other, but they're going in droves. Like me. No one could have stopped me."

"Sure," Sheldon said, "all someone has to do is offer a little hope."

"That's precisely what the Swiss doctor says. Something like: 'With a disease that offers no treatment, I at least offer hope.'"

"Hope?" Craig snarled.

"If I've learned anything at all," I said, "it's that hope is pernicious. I've gotten to hate hope. The other day I saw this cripple on TV, an ex-athlete I think, who said that hope was keeping him alive. I wanted to shake him. . . ."

"Why, if it makes him happy?" Sheldon said.

"Because with what he's got, he's never getting out of his wheelchair. . . ."

"So he believes in team spirit and coaches and God. So do I. It keeps me sane," Kevin said.

"So what are you saying, Andy?" Freda asked. "That it's better to give up?"

"Don't call it 'giving up,' call it 'accepting.' Jesus, listen to me. Maybe I really did learn something. A model blind man." I stood up and bowed. No one saw me except Freda, who applauded. "None of us is going to miss out on a cure, if there is one," I said. "But there isn't one. We should go about our business, learning to live with what we've got."

It turned out that we were all adjusting anyway. Sheldon did housework at home while his wife got her first full-time job. To their surprise, the change suited them both. Craig, who had counseled college students while painstakingly hiding his impairment, was about to take a job at St. Paul's to counsel people like himself. George was thinking of graduate work and agreed to learn mobility and braille as a first step. Moira, a mathematician, could go on, with minor adjustments. Kevin had to learn to forgive his wife for playing tennis. "You can still be the capitalist pig," Craig had told him. Frank and Jenny had just been married and had to map out their future, decide about having children. We all

had to help our families adjust to us, help them help us to stop wanting our old selves back.

Toward the end of the year, George called me to say that he was going to the Soviet Union to try the RNA treatment. "I guess we all have to work on closing our private circles. Naturally I hope that this works, but if it doesn't, I hope I'll finally feel that I can immerse myself in something other than my eyes."

Before going back to Vermont to immerse myself in writing, I went over to the Berman-Gund Laboratory, now one of several centers studying retinal degenerations. Dr. Berson had written to me in England, assuring me of his support and best wishes. "I would have loved to detect some improvement in Sarah," he now said. "We looked very hard. Probably we should have a look at you too, just to be sure."

"I've been away for six months indulging my whims," I said. "What marvelous things have happened here in all that time?"

"Our kind of work moves slowly," he said. "We were on to a protein whose absence affected the retinas of cats, for example. It took a year to do all the investigating. It'll take a lot more time for the data to be published, corroborated, discussed. And in the end, it will probably just eliminate one more possibility."

The ways of American science are exacting, even tedious. Everything has number values, and whatever passes the first few hundred steps goes up the ladder through orders, families, genuses, and species, from rats to cats, through dogs and monkeys, until, with everyone exhausted, it is gingerly tried on erect vertebrates with opposable thumbs. I guess that's the way it should be and I should be grateful for the care scientists take, but to me, anxious for results, the process seems to crawl at the speed of evolution.

Dr. Berson was collecting and collating reams of electro-physiological material, getting an ever clearer picture of the many RP types. Dr. Szamier peered daily into his huge electron microscope, to see the deteriorated rods and cones of Royal College of Surgeons rats. Dr. Edwards grew cultures of photoreceptors and pigment epithelium cells in stainless dishes, while Dr. Schmidt made intricate biochemical analyses of everything that crawled. They were the best in their fields; they were patient and understanding.

The lab didn't look particularly busy, but then nothing but time made cells grow in culture; no one was required to crank a handle to spin a centrifuge. The scientists did go to work daily; they took breaks for lunch, went to conferences given by their colleagues on related subjects, and gave conferences of their own. They spent weekends in Woods Hole or the Berkshires, read novels, scoured the country-side for antiques, worried about their cars and teenage children. In the laboratory, I'm sure they sometimes daydreamed, discussed the Bruins or the Red Sox, stared out the windows into the murky Boston sky. I would have preferred an eighteen-hour workday for them, a foreman perhaps to make sure that none of them dozed off.

One particularly hopeful area they all spoke about was the establishment of an eye bank through which they were beginning to receive intact young human retinas of RP people who had died prematurely of other causes. When I was there, they were examining the retinas of a patient who had been seen by Dr. Berson just before death, thus giving him the opportunity to compare visual function with visual structure. To Berson's surprise, vision seems to remain after much of the structure of the rods has broken down. Perhaps there are little-used subsidiary visual systems, perhaps some people merely learn to use what remains, others not. It's this

unknown region, though, which, I suppose, varies from patient to patient and which provides the possibility of fluctuation in vision. Before the immunological system is even provoked, the potential for differentness exists, and it depends, perhaps, on mood and constitution, perhaps on will. At St. Paul's, we had witnessed a dramatic example of the great difference between visual equipment and actual sight. A fellow trainee, named Steve, turned out to be hysterically blind, psychologically unable to see. He had passed all the required ophthalmological examinations and was found to be as legally blind as the rest of us. We certainly experienced him as one of us, and only later did he recover his ability to use his sight.

As I left Berman-Gund, I felt glad that it existed, but I felt that the cure for RP might as easily come from there as anywhere—from the labs of people working on the retina or not from labs at all. It would be nice, I thought, if the Foundation's money and those good and able scientists were to be instrumental in facilitating what is known in the trade as a breakthrough.

News of Helga has reached me periodically. I've seen copies of letters she wrote to other patients. I've had a couple of articles about her read to me, and I have a transcript of a BBC television program recently aired. Nothing much has changed, only the cast of characters. The letters say pretty much the same as they always have: Helga cures, no one appreciates, and to teach people a lesson, the fees skyrocket. She ends one such letter, to the British RP Society, swearing that the next time they make "clever comments" about her, she will rain down on them, from a "crane carrier," thousands of leaflets endorsed by doctors, specialists, and patients.

In a *Daily Express* article, another doctor, a stand-in for Dr. Ryder, announced his discovery of the miracle-working "Bee Lady" and was photographed being stung by her bees. THE BEE VENOM HEALER PREPARES AT LAST TO PASS ON HER PAINFUL SECRET, the headline stated. Like Ryder, Dr. Gregory Robak is a homeopath. "If I—an orthodox doctor—had been told that bee venom could cure arthritis, asthma and blindness, I would have laughed," he said. "But I have been checking over cases treated with bees, and what I have seen is fantastic." He too had seen patients resume driving again. "They no longer trip over objects," he said, "and are able to take up with their normal lives." As to the bees' effect on his very own myopia, he said that "before treatment I could not see clearly beyond my hand without glasses. Now I can see twice as far, twice as sharply."

"For years I have hated the medical profession," Helga confesses, "because they all want my secret without giving credit. Gregory is different. He has an open mind, and I think he is honest. I am going to show Gregory everything from breeding bees to putting them on all parts of the body for treatment. At the end of two years I will give him my feeding secret." Gregory, of course, has since gone the way of all the rest, back to the tedious practice of medicine.

On a BBC news program Helga claimed 100 percent success while dissatisfied patients claimed that she was a fraud. The fees had gone up to three thousand pounds, in some cases to a reported twelve thousand!

"It says in your literature that you're invariably successful," the interviewer stated.

"Always!" Helga cried. "Not invariably; always!"

I heard once from Dr. Ryder, who wrote that he had lost track of Helga and that the bee treatment, to which he had

lent his name and thus attracted people like me, turned out
to be worthless.

Mrs. Dorset wrote several times to report on the boys,
whose improvements remained questionable. She hadn't
lost hope and saw Helga from time to time with the boys for
booster stings. Neither Tom nor Dirkson ever answered my
letters, while Nulty, who did, graphically expressed his
hatred of her. Jorge Salomon, the "Lima chappie," corre-
sponded with me for a while. He and his wife were thinking
of having a baby, and he asked me to send him genetic
information about RP, which I did. The last I heard from
him, he doubted if he'd been helped, but he held back any
blame fearing that his brother and sister, in treatment with
Helga, might suffer if his criticism reached her. James
McDole continued to see better, and I wondered if his
improvement survived the BBC broadcast.

Vera left England shortly after I did. For a couple of
months in London, she and I had played delightful games
with each other's sexuality, using those aspects of it,
whether real or imagined, that we wanted to, needed to,
explore. I had longed to break out of the constraints that
blindness had put on my senses, while she endowed that
blindness with a kind of spirituality that gave free reign to
her wildest impulses. In my first couple of months back
home, as Charlotte and I stalked each other, unable to touch
or commiserate or take pleasure in each other's existence, I
wrote Vera at Cadogan Gardens suggesting that we run off
together, leaving no trace. Luckily, the letter was improper-
ly addressed and returned unopened. A year later, a friend
of Vera's, passing through New York with a repertory
theater company, phoned me to say that Vera was in one of
the Micronesian islands where she was living with a

paraplegic aborigine who had no feeling below the waist except at the very tip of his penis. A few months later, I received a postcard from Vera, from the Falkland Islands.

It took a long time to finally take real pleasure in Charlotte's work and her success. Her pieces had evolved from earthy organic forms to a light, ironic commentary on throwaway objects. In thin white porcelain, she had transformed paper cups and plates, milk cartons, and Chinese-food take-out containers into whimsical poetry. In the past few years, I had acted hurt, pitiable, when she asked me to criticize the shapes she was making, but now, with considerably less sight, I volunteered my services. By holding a piece for a long time, feeling it with fingers or lips, carrying it from one kind of light to another, by placing it on different surfaces, filling it with things, I could make useful suggestions about proportion, scale, the thickness and taper of the walls of cups and bowls. Much to the surprise of both of us, I could still draw well enough to illustrate a point.

We began drawing together, setting up still lifes or posing for each other, each of us embarrassed to show the smudges and scribbles, the spatial non sequiturs. I found that I could worry a detail to death, shading folds, remembering ears, imagining the designs of my wood stove; but all my accumulated fragments remained discrete, connected only by hope or a strong imagination. During one of these drawing sessions, Ellyn called from New York.

"Are you sitting?" she asked.

"No."

"Well, sit down," she said, and waited. "We want to offer you a contract for your book. Everybody here wants it as much as I do."

Shortly after I had finished the St. Paul's chapter of this book, I was awakened at one-thirty in the morning by the telephone. I ran downstairs, fearing the worst.

"Guess who?" a voice said.

The house was cold and I was bare-assed and annoyed. "I have no idea. It's late."

"Aw, c'mon, guess," she coaxed.

"Tell me, for Christ's sake. I'm freezing. I want to go back to bed."

"Bed. Mmm," she said. "It's Kathleen."

"Kathleen who?" I said. I knew no other Kathleens, but I couldn't believe it.

"Aw, c'mon, honey, how many Kathleens do you know?" I was trembling. "Kathleen Dougherty. D'you forget me already? D'you forget St. Paul's?"

"But why . . . I mean how come now . . . ?"

"Oh, I don't know. I've been sitting alone, drinking, thinking of you. I often do. I didn't have your number. I mean I've got it somewhere, but how am I supposed to find it? I called Vermont information, told her I was blind as a bat, and had her look you up in every goddamn town in the state."

"It's just such a coincidence," I said.

"Why?" she asked. "Were you going to call me?"

"It's not that," I said. "I've just been writing—"

"I knew you were going to write a book. I just knew it. Am I in it?"

"As a matter of fact you are, Katie. But listen, don't worry. No one will know it's you. I'll change your name. . . ."

"No, don't do that," she said quickly, soberly. "Use my name. It's okay, really."

Katie said she was lonely and depressed. She didn't know what to do with her life. She was doing nothing. "I need

help, goddamn it, Andy," she sobbed. "I've got to find some goddamn thing to do. I just sit here in this goddamn trailer, and I'm scared to move."

I didn't know what to say. How should I know what anyone should do? "What would you like to do?"

"There's nothing. I know you're gonna say, 'go to school' or something like that. I can't go to school, honey. I'm no goddamn good at that kind of stuff."

So much for rehabilitation, the new skills, the confidence. "Are you alone, Katie?" I asked.

"I've got a husband. He's never here. I see Ray sometimes, but that's just sometimes, and he's got a family."

"How's Ray?" I asked, buying time to try to figure out something constructive to suggest.

"He stopped boozing. He's become a counselor to alcoholics. Christ, honey, I wish you could come down here and spend just one day with me. I know you'd figure something out."

"I'd like to, Katie. But you're in the country, and you know how hard it is to get rides. . . ."

"I'm just going to sit in this goddamn chair and die," she said.

"I'll try to come," I said.

"Do you have my phone number?"

"Yes," I said.

"Take it down again," she insisted. "And my address. Got your brailler handy?"

"I can still see big letters," I said.

"I forgot my goddamn braille," she told me. "You can type letters to me. I'll find someone to read them aloud."

"I will Katie. I love you, Katie."

Sometimes I think that my having come to accept blindness must have been the slowest "rehabilitation" on

record. "His won't be easy or fast," Miss Hennessy warned
Charlotte a long time ago. But I've had opportunities Katie
hadn't dreamt of. If she were a nice middle-class lady, she
could have been "actualized," moved along the Monopoly
board of "human potential." She could have hopped on to
the women's movement, she could have qualified for some
small sinecure. I wondered about her powerful friends,
about well-connected Frankie and Lieutenant O'Reilly,
whom she had sometimes accompanied on what they called
"panty raids"—finding illicit couples in the act to settle
divorces or just to get something on someone. I thought that
perhaps, after St. Paul's, she might have been transformed
into a tweedy court stenographer, or a legendary whiskey-
voiced moll. But for whatever reason, she had been
discarded, useless and alone.

One way or another, most everyone in my St. Paul's group
survived. Only Rosemary and lovely young Margie didn't.
Rosemary, weakened by her diabetes, had a lethal heart
attack, while Margie, with her teased blond locks, her long
shapely body and puffed eyes, underwent more eye surgery.
I visited her in the hospital, where from under her bandaged
face, she tried to smile. Though unimproved, she did
recover. Rumor then reached me that she had met a man
and fallen in love. A year or so later, her kidneys failed, and
alone again, just thirty, she died in a Boston hospital.

I once thought that I was the most exotically maimed and
deprived person imaginable. But with astonishing rapidity,
others have caught up and surpassed me. Mine is no longer
the most unique, complex, or insurmountable problem the
world has ever known. Once I wouldn't have agreed to share
the rotten-luck award with left-brained musicians or right-
brained lawyers, not with flaccid movie heroes or bedridden
athletes. But in my unexpected life, I'm no longer alone. My

sorrows, my losses, and my incongruities tend now to vanish in the general sorrow and disappointment. Cut off from what I once thought to be my birthright, I simply join the poets without a book, architects without a building, businessmen without funds, suffering from bad luck or a lack of brilliance or energy or vision, their dreams exploded or changed by time. Except that I am an author with a book, "one of our authors," Ellyn had said. Other people's loves and work have gone awry, their health fragile, their children stoned or lazy or dumb. They, we, are being cut down by accidents, by cancers, by immobilizing sadness.

I am still, though less so, in the "no-man's-land" between blindness and sight, still quite indistinguishable from the sighted in appearance. Strangers don't know and friends often forget that I am ever closer to being totally blind.

The other day, Charlotte and I walked out the kitchen door to look at the sun setting through a break in the clouds. It shone at a long oblique angle, transforming one side of the gray-boarded horse barn to warm glowing orange, and setting the trees ablaze with color against the purple of the mountains, under the ashen sky. I remembered it better than I saw it, but the pleasure it gave me was real. Not too long ago, this would have thrown me into self-pitying despair. I would have cursed the colors and everyone who could see them.

I know that inside my eyes there are cells that are migrating or extinct, particles of useless biological garbage swimming around, disappearing, lost. There are, I imagine, dangling shreds and hopeless short circuits, but somehow, through this mess, I manage to interpret the world, skewed but close enough. I know I will lose all my sight and soon. As much as I want to hang on to every vestige, I know I can't. But I also know something that should have been clear to me

from the beginning: the only thing that could replace the creative activity in the center of my life would be another creative activity. The exhilaration and satisfaction I once found in the mix of paint and canvas, hand and eye—in ordinary daylight—I am beginning to find in words.

As I sat in my little studio—called my office now—working on the last chapter of this book, I heard an unrecognizable car pull into the driveway, and from across the road, I heard the kitchen door open and slam closed. I liked working with the knowledge that visitors were intercepted, phone calls answered, everything kept at bay, by someone else; it was like falling asleep hearing the comforting sounds of conversation float up the stairs. A moment later though, footsteps crunched the gravel, passed the car, and continued in my direction. Then a knock on my door. I moved my chair away from the typewriter, my eyes bleary from the hundred watts focused there, and as I stood, I saw the silhouette of a small person with baggy pants, pinched at the waist by a dungaree jacket, all of it topped with a large visored cap.

"Yes?" I said, annoyed at the intrusion.

"Andy Potok farm," he stated, consulting his notebook. "Twelve acres of corn planted."

"Right," I said.

"Well, Gagnon's my name. Used to be French. I check random farms for Soil Conservation."

He stood under a huge piece of paper on which I had outlined my chapter with Magic Markers. LAST CHAPTER, it said, and under that, "Back Home." I could see that Gagnon's cap had a message over its visor: perhaps INTERNATIONAL HARVESTER or HOOD'S MILK.

"I'll show you where the corn is, and you can go have a look," I said.

"Can't do it alone," he said. "It's got to be measured. That's a two-man job."

"Look, Mr. Gagnon, I'm in the middle of a chapter." He shifted his weight from one foot to the other. His expression didn't seem to change. "Also, I'm nearly blind." He didn't move. We faced each other in a long, uncomfortable silence. "How long will it take?" I asked.

"Not long," he said. "Maybe an hour."

I turned off the lights, the typewriter, the gas heater. Outside, I felt my way around his pickup truck and climbed into the high front seat. We drove up the road, parking at a break in the stone fence. We both slid down to the ground, and he hunted around in back for his measuring equipment, pulling out a long length of chain. As we walked to the corner of the tall yellowing corn, he explained how we would go about doing our job. My blindness didn't seem to register at all.

"You stand here," he said, "and hold your end of the chain. I'll walk along the edge of the corn with my end, and when I've walked off the whole length I'll plant one of these red flags in the ground." He showed me a handful of little red plastic banners stapled around a foot-long rigid wire. "Then we walk again and stop when you come to the flag." I figured my chances were slim to see the red at all, but I now felt game and anxious to try.

We began, and as the chain tightened, I knew he was planting his flag. "Here it is, Andy," he yelled. "Walk right toward it." I followed the rut made by the plow, but as I approached the area where the flag should have been, I saw nothing but the muddy autumn colors, the fallen cornstalks, the rusty maple leaves blown by September winds and collected in the furrow. The red was lost inside all that. We had walked too far now, and I knew I had missed it. Finally,

Gagnon stopped and shouted: "You walked by it, Andy. Turn around and you'll walk smack into it. Hey, you just stepped on it!" I stopped and looked around my feet. The little spot of red would simply not come into view. Then, with a quickening of my heart, I saw it.

"I've got it," I shouted. "I've got it!" I picked up his flag and stood, proud and still, until he paced off another chain's length, then I walked on to find the next banner. I grabbed leaf by leaf until I found it, and we seemed to be setting a kind of rhythm, jerky and slow: place, hunt, find. . . . I stepped on the flags a good dozen times or passed them by without noticing, while Gagnon, puzzled, then patient, finally understanding, yelled directions and guided me as if he were at Cape Kennedy and I were Venus-bound, congratulating my successes and forgiving my failures.

"Hey, way to go, Andy," he yelled. "You're doing real good now."

At one point he waited for me so he could take back the dozen or so flags I had collected. "Boy," he said, "am I going to have trouble converting this surveyor's chain into rods. Four rods to a chain, they tell me." He took out a little booklet from his back pocket, put the flags down, and holding it at arm's length, a finger pointing carefully at his place, he read. "Says here twenty-five links to a rod, one hundred links to a chain, ten square chains to an acre. Jesus, I'll be up half the night."

We walked on. The last side of the L-shaped field now lay in the shadow of the pine and tamarack. The rhythm of our movement depended more on chance now, the small banners sometimes flashing miraculously on my retina, sometimes refusing to appear. But we made it. We had done more than measure the field; we had conquered it.

Gagnon had to continue up my road to the town of Orange

to do one more farm before the light gave out. "What do you mean blind?" he said from behind the steering wheel. "Why, you see almost as good as me."

I walked slowly back to the house. Charlotte was probably out of her studio by now, chopping vegetables on the butcher block, a glass of sherry by her side. She might have put a Schubert piano sonata on the record player, which I would interrupt with an account of Gagnon and the corn-field.

I remembered that Sarah was coming for dinner from Burlington. We hadn't seen her in a month, and I missed her. She would have to arrive very soon, I thought, because it was getting dark.

The last time Sarah and I talked, we talked about children.

"When you're ready," I had suggested, "why not adopt children?"

"You mean because of the RP?" she had said. "For Christ's sake, Papa, how can you say that? You're nearly blind and you're doing damn well."

It was true. I liked my life now. Vermont was good to write in, better when broken up with frequent trips to New York.

As I approached the house, I smelled the wood smoke from the chimney. It was my job, but Charlotte had made a fire inside. The kitchen lights were already on. I stopped and heard a gentle breeze sway the mountain ash out front. But I was wrong about the music. Charlotte hadn't chosen a piano sonata, but the Schubert quintet with two cellos, my favorite.